HOUSTON

THEN & NOW

First published in the United Kingdom in 2014 by
PAVILION BOOKS
an imprint of Anova Books Company Ltd.
10 Southcombe Street, London W14 0RA, UK

This book is a revision of the original *Houston Then and Now* first produced in 2003 by PRC Books, a division of the Anova Books Group

All notations of errors or omissions should be addressed to Salamander Books, 10 Southcombe Street, London W14 0RA, UK.

ISBN-13: 978-1-90981-506-3

Printed in China

10 9 8 7 6 5 4 3 2 1

ACKNOWLEDGMENTS

Many thanks to the staff of the Houston Metropolitan Research Center's Texas Room: Will Howard, Doug Weiskopf, Nina Oliver, Ellen Hanlon, and Ron Lee for their priceless research assistance. Particular thanks to Joel Draut (first edition) and Timothy J. Ronk (second edition) in the Research Center's photo archives. Also a very special thanks to the authors whose works were both a valuable resource and a pleasure to read: Betty Trapp Chapman, Marguerite Johnson, Marie Phelps McAshan, Sister M. Agatha, Jim Hutton, Dorothy Knox Houghton, Barrie Scardino, Sadie Gwin Blackburn, Katherine Howe, as well as the many contributors to both the National Park Service's National Registry of Historical Places and the Texas State Historical Association's New Handbook of Texas. Many thanks to my wife, Stephanie, for help on the home front.

HOUSTON
THEN & NOW

WILLIAM DYLAN POWELL

NOW PHOTOGRAPHS
BY KEN FITZGERALD

PAVILION

HOUSTON

THEN & NOW INTRODUCTION

In the 1830s, New Yorkers Augustus Chapman Allen and John Kirby Allen found themselves present in a rare time in history: the birthing of a new nation. The two moved to East Texas in 1832 to become land speculators, just as the Texas Revolution was erupting. During the war (1836), the brothers did their part for Texas independence not fighting on the front lines but by supporting the cause through shipping, logistics, and trade.

Back then, Texas land was measured by units dating back to the Spanish crown. A "league" of land was 4,428.4 acres. When the war ended, the Allen brothers bought a half-league along Buffalo Bayou. For this land, they had a vision. Every nation needs a great engine of commerce to drive it forward, they reasoned. The United States had New York. England had London. And since The Republic of Texas was so new that it had no such "great interior commercial emporium" as they called it—the Allen Brothers would build one.

And so it began. The Allen Brothers named the city after the first President of the Republic of Texas, and war hero of the Battle of San Jacinto, Sam Houston. And in 1836, they began the true work of creating a thriving new metropolis: marketing. Early promoters of the town stretched the truth so thin you could see through it under the shade of a pecan tree. Claims of Houston's cool sea breeze, tales of the active bayou along which merchant ships came and went and artists'

The founders of Houston didn't set out to create one of the nation's largest cities. They hadn't aimed to create one of the most culturally diverse urban regions in the Americas, give the energy industry a world headquarters or create a place from which man would conquer the moon. What they set out to do is what any self-respecting capitalist does when history presents opportunity: make a nice, fat profit.

depiction of Houston's rolling hills were promoted worldwide.

Like many a real estate speculator before them, and since, the Allen Brothers didn't let reality get in the way of vision. Cool breezes wouldn't flow through Houston until the city saw its first air conditioning unit in the cafeteria of the Rice Hotel in 1922. Buffalo Bayou was, at the time of the city's founding, a slow ride for the rare steamship that made its way to what was initially just a handful of people and log cabins. And the drawings of Houston that sported apocryphal hills and valleys must have surely confused those who arrived to see a grassy coastal plain. But the Allen brothers didn't need reality on their side; they had ambition.

Houston was incorporated on June 5, 1837—becoming the county seat of Harrisburg County (renamed Harris County a few years later), as well as the capital of the Republic of Texas. It was a hardscrabble life early on, as infrastructure and amenities developed tediously slow amidst the wood-frame buildings and horse-drawn carriages. The capital was moved inland to Austin in 1839, and Houston soon had the basics in place to get on with its original mission: making money.

First came cotton. Shortly before the War Between the States, Houston was shipping out more than 100,000 bales of cotton annually. And after the cotton came oil. The Lucas Gusher at the nearby Spindletop oilfield soon made Houston the capital of the American oil and gas business. The business of petroleum exploration, production, refining, and transportation transformed the Texas economy in general—but Houston in particular. In 1914 the Houston Ship Channel was completed, enabling direct ocean-vessel access. The combination of abundant crude oil and a deep-water port meant a strategic location for refineries.

By World War II, Houston had established itself as an industrial stronghold. Its port was the third largest in the country. More than thirty refineries operated on the ship channel alone, and forty major oil companies called Houston home. It was already the largest city in Texas—with suburbs sprouting up in every direction. The Texas Medical Center, which would grow into the world's largest medical complex, had received its charter. As the twentieth century progressed, Houston came into its own in terms of infrastructure, culture, and all of the things one expects from a modern big city. But, most importantly, Houston lived up to the Allen brothers' vision as a capital of Texas commerce.

People come to Houston today for the same reason they did back in the 1800s—to get ahead. While progress may not always be pretty, necessitating an awful lot of parking lots and strip malls, the resulting economy is a true thing of beauty. If Houston were its own nation, it would have the world's thirtieth largest economy (with a GDP of approximately $385 billion). Twenty-six Fortune 500 companies are headquartered in Houston.

It's the only major American city not just to recover all of the jobs lost during the 2008 recession but to also gain an additional 100,000 jobs. Americans tend to follow the money when it comes to climbing the corporate ladder, and so many people have moved here recently that international moving company U-Haul declared Houston its top destination city for families renting one-way moving vans—for the fourth year in a row.

The buildings, streets, and institutions that comprise Houston's cityscape have changed drastically since its rough-hewn founding in 1837. Modern skylines have eclipsed the city's architectural pioneers. Local empires have risen and fallen. And lifestyles have compressed to fit the demands of modern urbanization. But the fundamental promise of Houston as a place to get ahead is exactly the same. The Allen brothers, who could certainly appreciate seizing an opportunity wherever you find it, would surely have approved.

William Dylan Powell, 2014

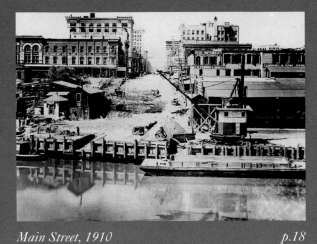
Main Street, 1910 p.18

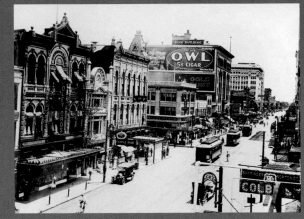
Main and Preston, 1915 p.22

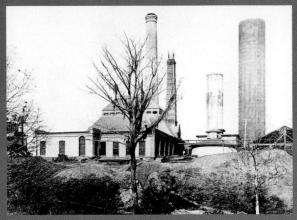
Houston Water Works, 1879 p.38

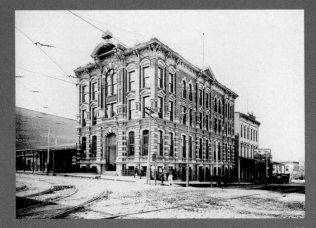
Old Cotton Exchange, 1884 p.50

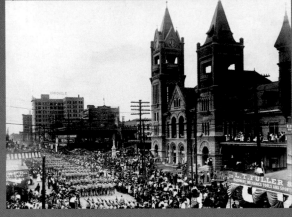
City Hall and Market Square, 1909 p.52

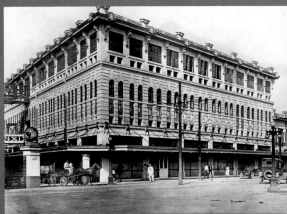
Moorish Federal Building, 1889 p.60

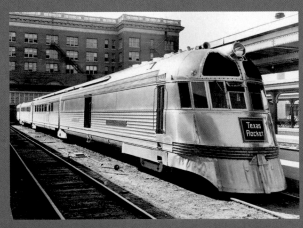
Union Station, c. 1940 p.68

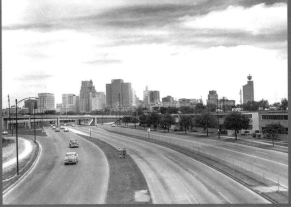
Allen Parkway, 1955 p.86

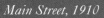
Magnolia Brewery, 1912 p.88

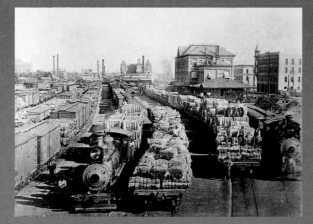

Grand Central Station, 1915 p.92

Rice University, 1912 p.98

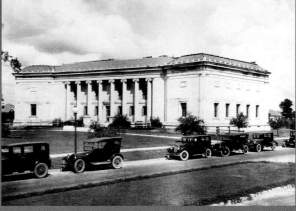

Museum of Fine Arts, 1924 p.102

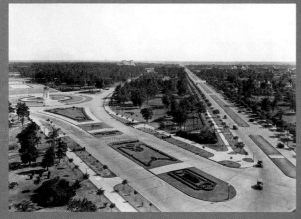

Hermann Park, 1925 p.106

Glenwood Cemetery, 1871 p.124

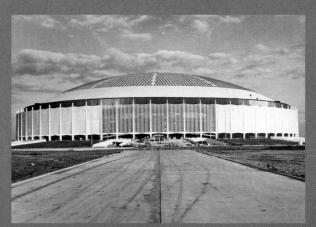

Astrodome, 1965 p.126

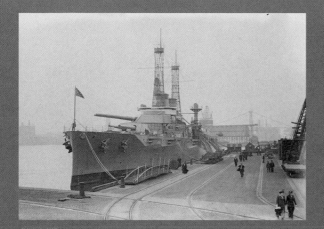

USS Texas, 1920 p.134

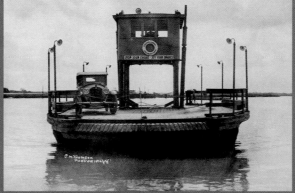

Lynchburg Ferry, 1920 p.138

NASA Manned Spacecraft Center, 1962 p.140

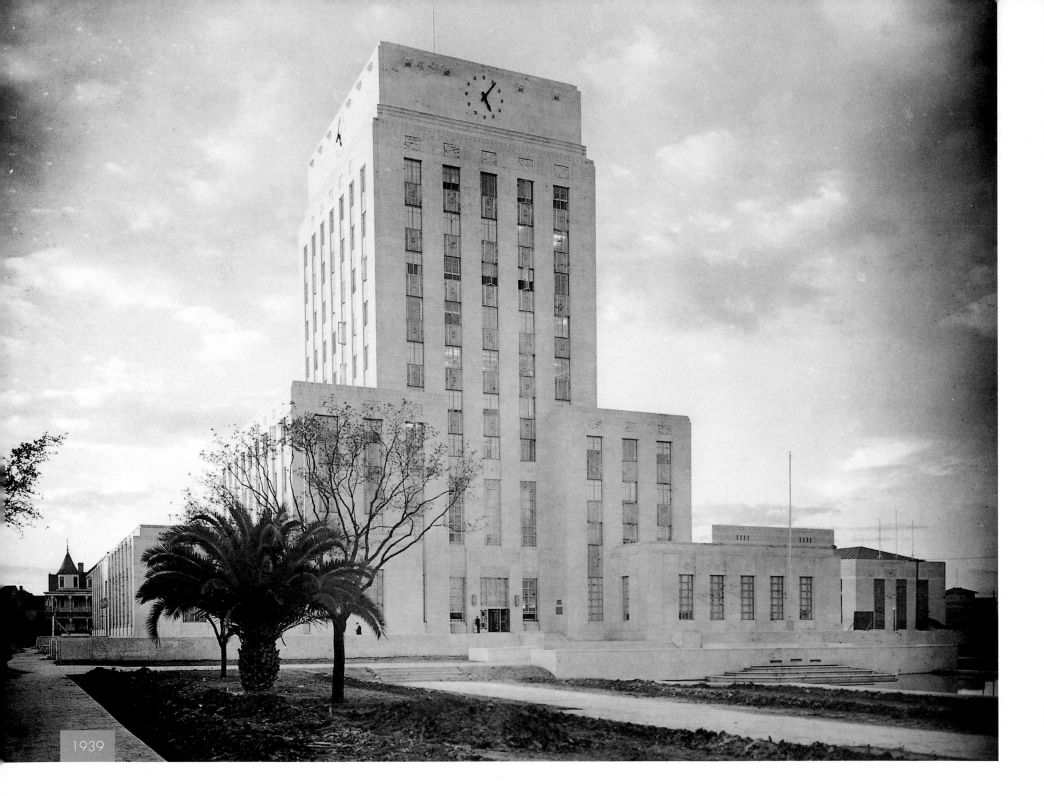

CITY HALL

The mayor hated his new building but City Hall has stood the architectural test of time

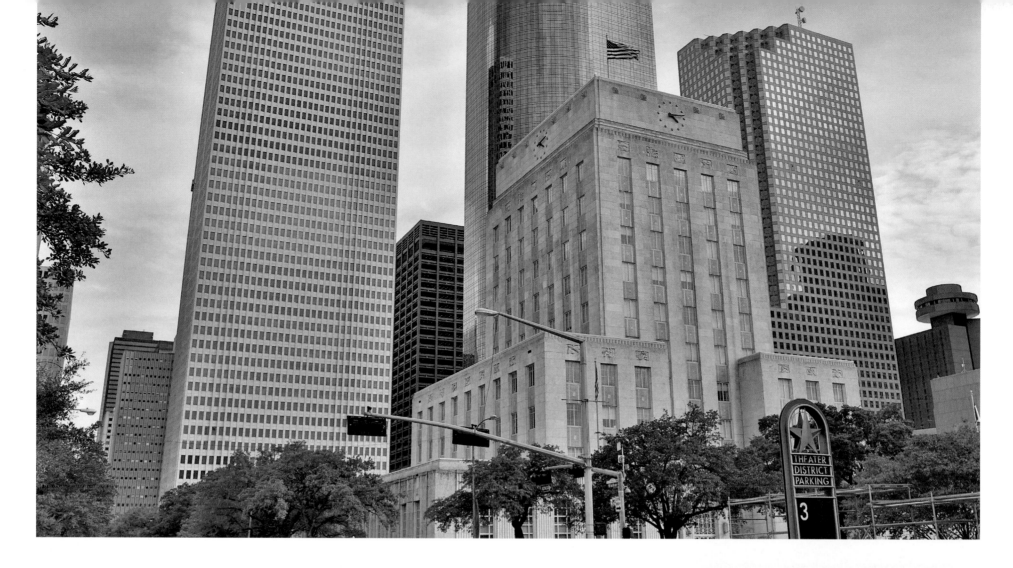

LEFT: Houston's second City Hall was designed by Austrian-born Joseph Finger. Its construction in the wake of the Great Depression was a long struggle. A Public Works Administration grant and bond funds got it through with a 1939 completion. The mayor at the time, Richard Fonville, hated it. He'd wanted something much more conventional. At its completion in 1939, City Hall's Cordova limestone façade and clocks seemed both modern and timeless.

ABOVE: This small building is still the official city hall, though its role has become less administrative and more ceremonial. Houston's city government has now expanded into 500 different buildings housing more than 23,000 employees. While pillars of steel and glass close in around the old dear, the building still manages to look as modern as it did in the 1930s. The bronze-colored building to the right is Enterprise Plaza, home to Enterprise Products.

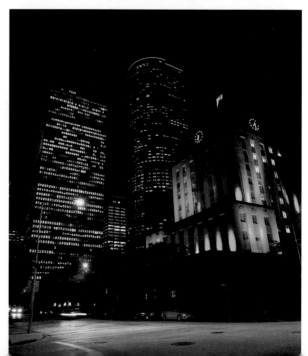

RIGHT: City Hall now has a lurid light show at night.

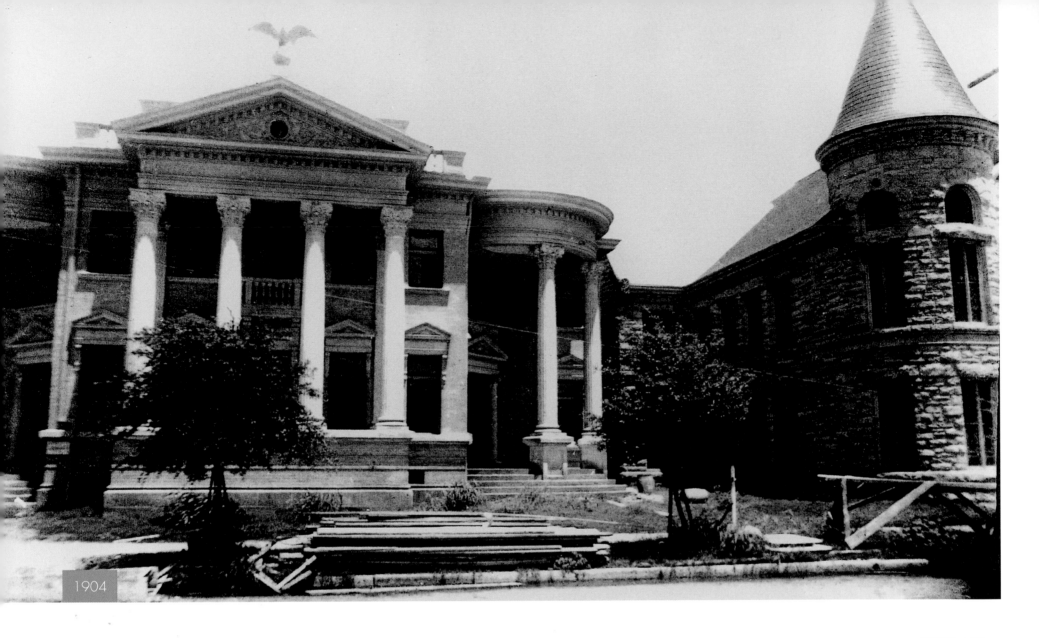

1904

CARNEGIE LIBRARY

Houston's primary lending library soon needed to find a bigger space

ABOVE: Andrew Carnegie built over 2,800 libraries, including this Italian Renaissance structure completed in 1904 at Main and McKinney. Chartered by the Houston Lyceum and Carnegie Library Association, its roots rest in the Houston Lyceum, a members-only group that had migrated around town since the 1830s. Its directive was not only book lending, but also the hosting of weekly debates and lectures. Houston's

original Carnegie Library soon outgrew its building and the new, Spanish Renaissance-style Houston Public Library (pictured right) was erected three blocks west in 1926. After the death of the library's first librarian, this building was named the Julia Ideson Building. It was designed by Ralph Adams Cram, who also designed the campus plans for Rice and Princeton Universities. It remained Houston's primary library until 1976.

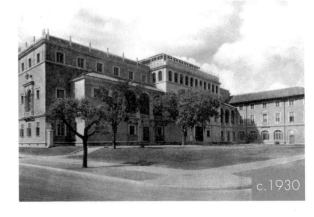

c. 1930

10

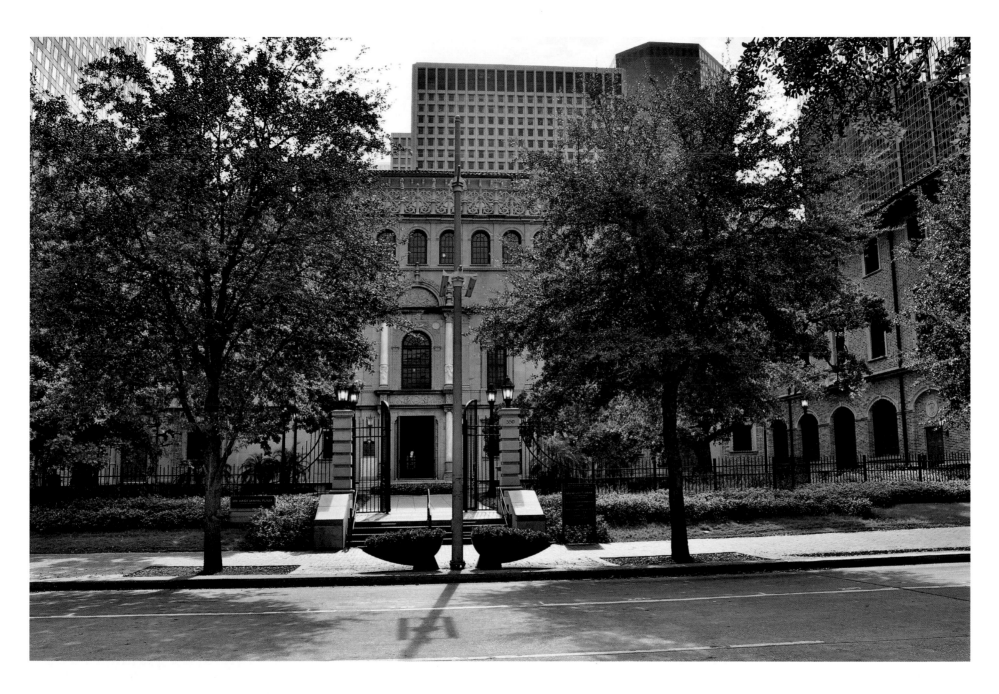

ABOVE: The city soon outgrew this building, too, as its primary library. It now houses the Houston Metropolitan Research Center (HMRC)—a historical research facility preserving regional collections, archives, and manuscripts. A part of the Houston Public Library's Special Collections Division, the HMRC's mission is to locate, preserve, and make available to researchers the documentary evidence of Houston's history, including the majority of archive photos used in this book.

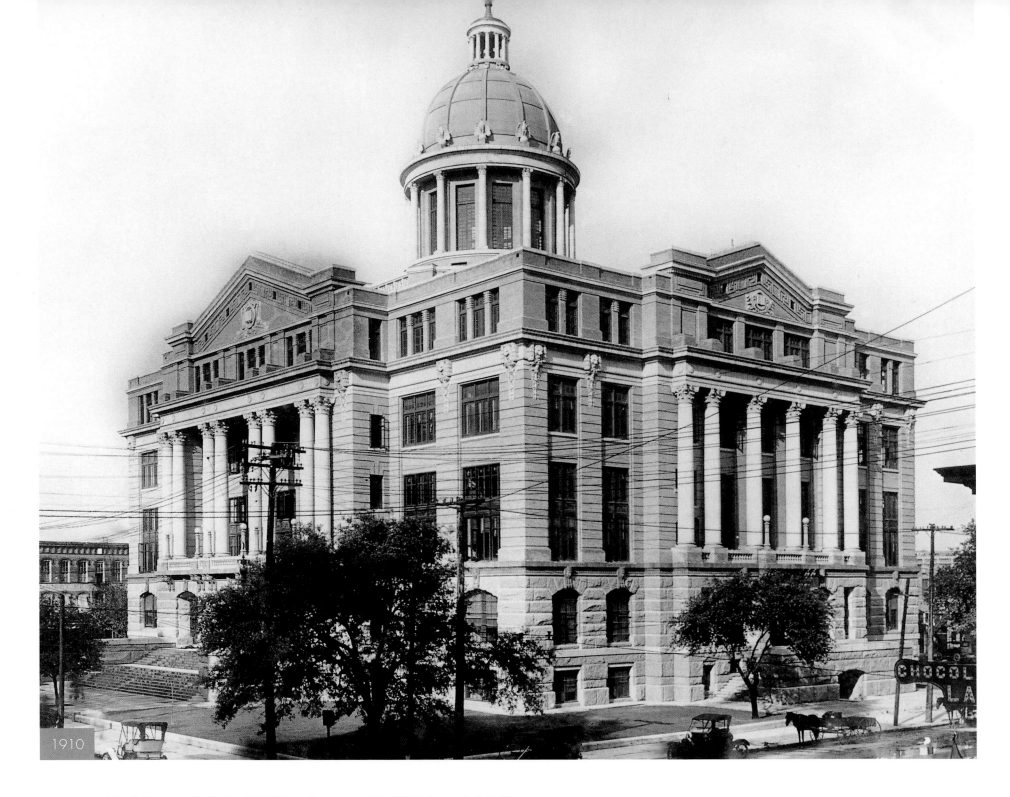

1910

HARRIS COUNTY COURTHOUSE
The fifth Harris County Courthouse narrowly escaped the wrecking ball

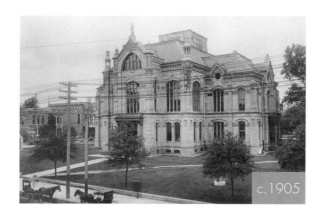

c.1905

ABOVE: This was the fourth Harris County Courthouse, which completed construction in 1884. The four-story Gothic Victorian structure cost $98,000 to build and was designed by a team which included noted Galveston architect Edward J. Duhamel—who won a public design contest to design the old City Hall and Market Square. The building originally had a grand spire, which was removed just after the turn of the century. Eventually the 1884 courthouse fell into disrepair, and by 1907 plans were underway to replace it.

LEFT: When court sessions were first held in Courthouse Square in 1837, it was the Eleventh District Court of the Republic of Texas. Session was held right under the trees, much to the defendants' anxiety. In fact, the "hanging tree" still stands. The 1910 Harris County Civil Courts Building there today is the fifth courthouse on this spot. The five-story Beaux-Arts style, pink Texas granite and brick building was designed by Charles Erwin Barglebaugh. Barglebaugh had worked directly for Frank Lloyd Wright at one time and also designed Houston's Hogg building and the Sanger Department Store in Fort Worth. The 1910 courthouse cost $500,000 to build and featured an extravagant interior rotunda with a grand winding staircase. It was dedicated in 1910, on the seventy-fifth anniversary of Texas independence. Interestingly, corporate leaders in the 1927 Niels Esperson Building a half-mile away shuffled so many documents back and forth to this courthouse that an underground pneumatic tube system was installed to transfer documents.

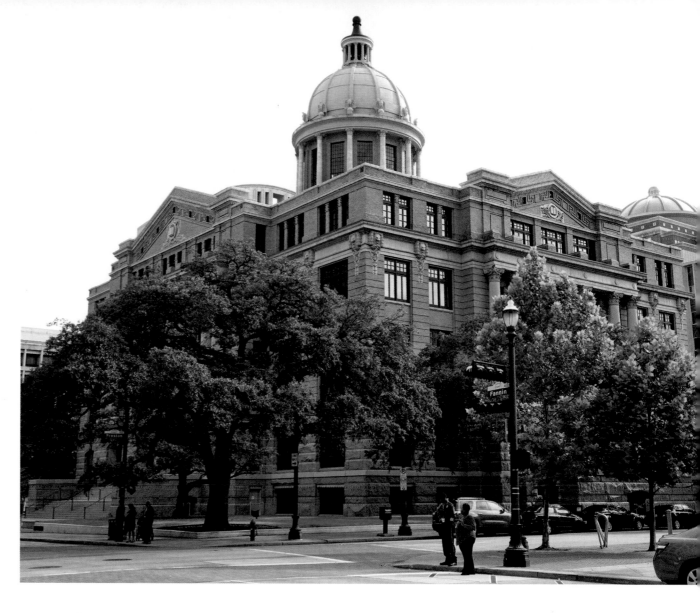

ABOVE: The building avoided demolition in 1938 by only a handful of votes. Why isn't a seventy-story office building in its place today? In large part because of the stipulation assigned by the Allen brothers that Courthouse Square's ownership will revert to their legal heirs should this particular piece of land be used for anything but a courthouse. In the mid-twentieth century, extensive (and rather unforgiving) efforts to modernize the building were undertaken. More recently, the grand old courthouse received a major restoration, renovation, and upgrade. Beginning in 2003, the Court Commission began initiating extensive work that included the painstaking recreation of the building's plasterwork, rebuilding its stained-glass dome, replacing intricate decorative metalwork, opening the rotunda, replacing the building's interior marble, and more. Those responsible for the $65 million restoration did an amazing job. Completed in 2011, the building is a marvelous example of architecture from its day.

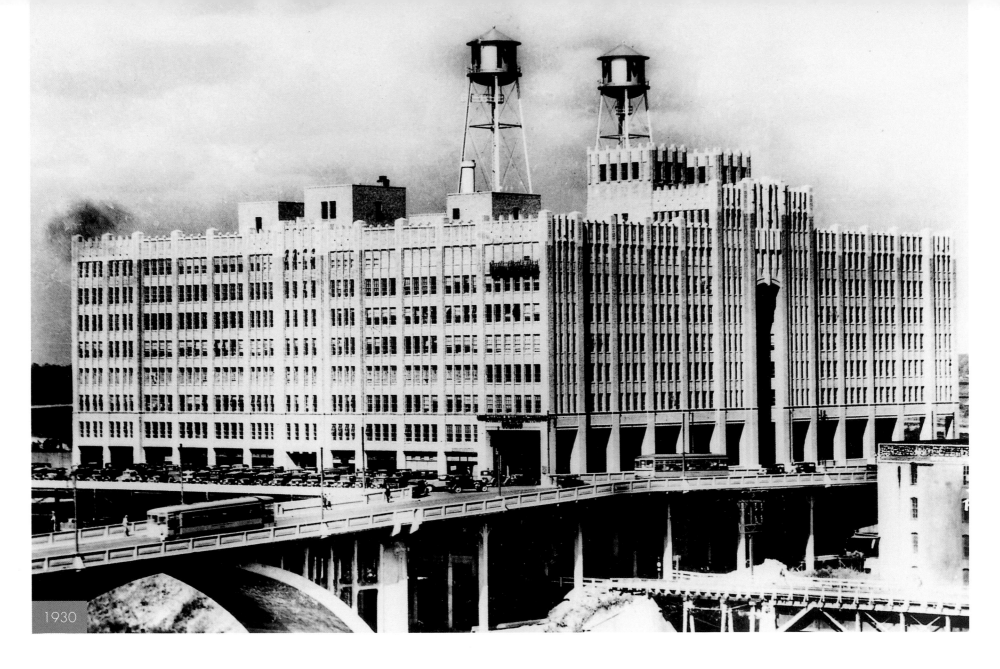

1930

MERCHANTS AND MANUFACTURERS BUILDING

Modeled on Chicago's Merchandise Mart, the building struggled to find tenants at first

ABOVE: This site at the confluence of Buffalo and White Oak Bayous was once the site of a prison camp for the Confederate States of America—housing around 350 Yankee soldiers during the War Between the States. The location as a commercial facility has its roots in 1924 with Houstonians Rex Dunbar Frazier and James R. Cheek—who wanted to build a hybrid wholesale, retail, and logistical center. The developers hired renowned Austin-based architects Giesecke & Harris for the project. The Merchants and Manufacturers Building

was completed in 1930 and modeled loosely on the Merchandise Mart in Chicago. But the old building seemed doomed almost before its opening. The project's primary financier died in 1929, the same year a flood would hit the facility hard—driving away a number of tenants. Times were hard. The Great Depression would stamp its boot on real estate ventures nationwide and throughout the 1930s Houston was no exception. Even WWII did little to revitalize the building's economic performance.

14

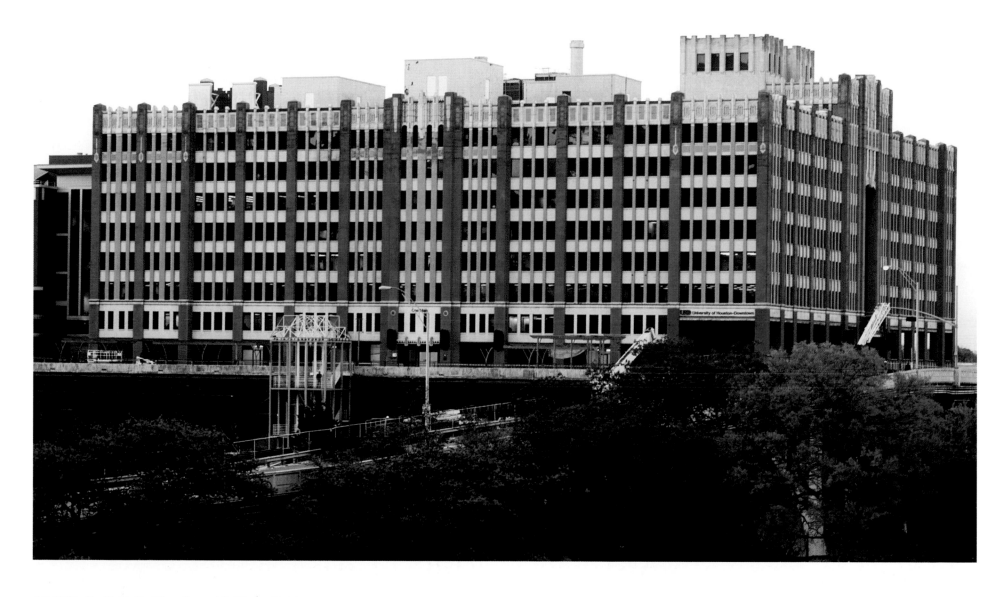

ABOVE: In 1948, Dallas oilman H. H. Coffield saw potential in the building and scooped it up for a cool $2 million. Some doubted the likelihood of turning around the 18-year-old building's fortune, but Coffield was confident, purchasing this building and several others around town, remarking: "You can't miss a bet in Houston." He was right to the extent that Houston thrived in the following years, but the city was growing outward and not inward. The old Merchants and Manufacturers Building delivered lackluster financial returns and low occupancy, making Coffield nervous. But this all changed when news hit that South Texas Junior College, a mile south of the complex, was outgrowing its building. The college purchased the building in 1968 for $4 million. Today, knowledge is still the building's stock in trade. When the University of Houston absorbed the college in 1974, it assumed ownership of the building, which is now the campus of the University of Houston-Downtown (UHD). Over 10,000 people attend UHD pursuing a variety of graduate and undergraduate degrees.

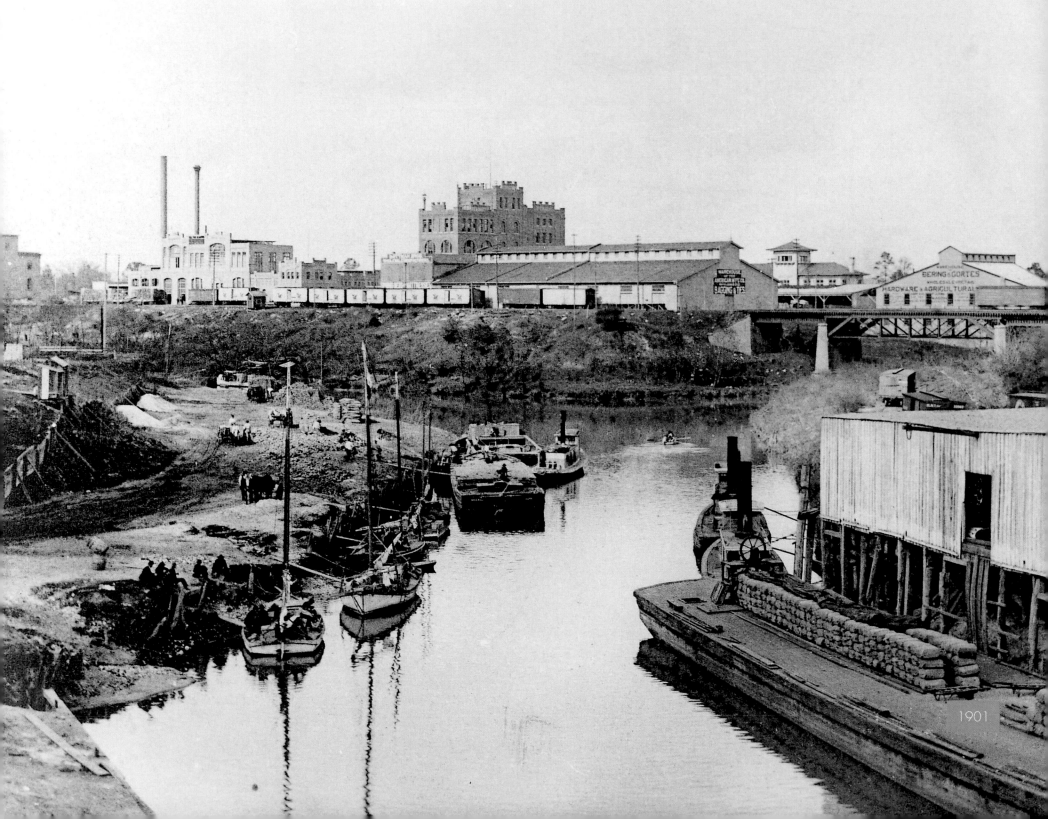
1901

ALLEN'S LANDING

Originally the focus of Houston's waterborne trade

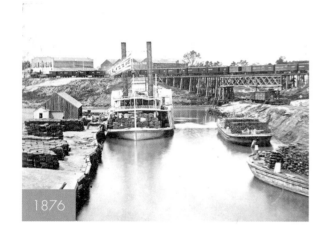

1876

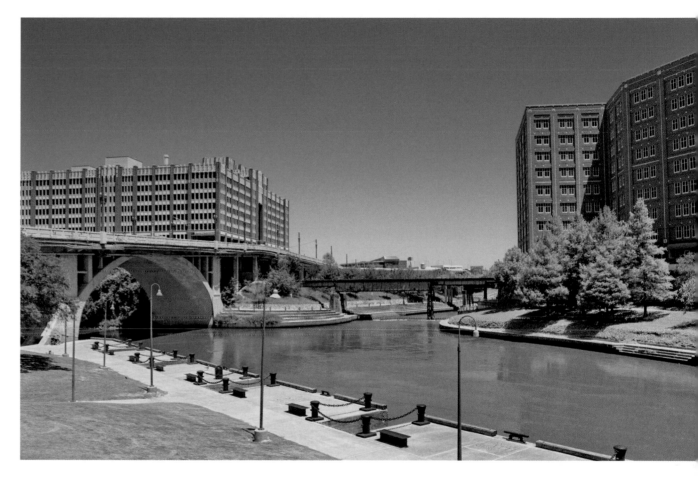

LEFT: In the heart of town at Buffalo Bayou's south bank, what we call Allen's Landing today was the birthplace of Houston's water commerce—and ground zero for the fledgling town at the time. During Houston's early years, the city's busy commercial waterway was much touted as a benefit of setting up shop in the bayou city. In the beginning, this might have been a slight exaggeration. Perched on the confluence of the Buffalo and White Oak Bayous, this spot received its first ship, the *Laura M.*, from Galveston in 1837. The poor vessel accidentally bypassed the ragtag collection of shelters that was Houston at the time, having to circle back in the weed-choked waters to find the place. The port was officially established in 1841. By the time this photo was taken, the vision of Houston as having an active commercial waterway had taken hold. Industrial concerns had sprung up on the waterfront and the town had become a notable, if still modest, center of trade.

ABOVE: This photo from 1876 shows the steamboat *Lizzie*, loaded with cotton and moored with some barges on the bayou at Main Street. The captain of the *Lizzie* was a man by the name of Sterrett.

ABOVE: In 1910, the federal government would approve a budget to dredge a ship channel to the Gulf a few miles east of this spot—moving the center of gravity of Houston's waterborne shipping activity. When the ship channel was completed, deepwater vessels could trade directly, soon making Houston a major port city. So the spot where Buffalo and White Oak Bayous came together returned to its origins as a sleepy little place on the banks. Only a metropolis has grown around it. Today there are more urban hikers,

artists, canoe enthusiasts, and kayakers than horses and cotton at Allen's Landing. But a replica of the old Port Promenade can be found at what was designated in 1967 as Allen's Landing Memorial Park. At 1001 Commerce Street, the spot is known as the town's "Plymouth Rock," and has received millions of dollars' worth of trails, landscaping, amenities, and public artwork. Each year the Dragon Boat Festival holds its regatta along the banks.

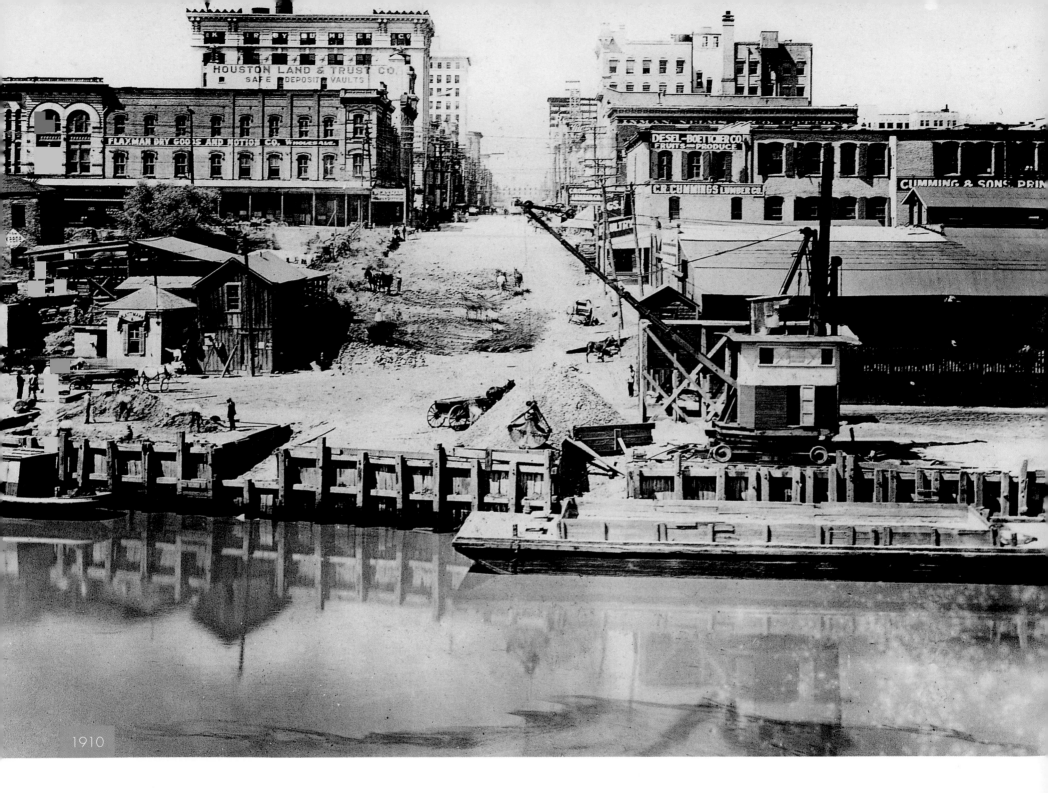

1910

MAIN STREET
Once an area of docking, this part of Main is now an area for parking

18

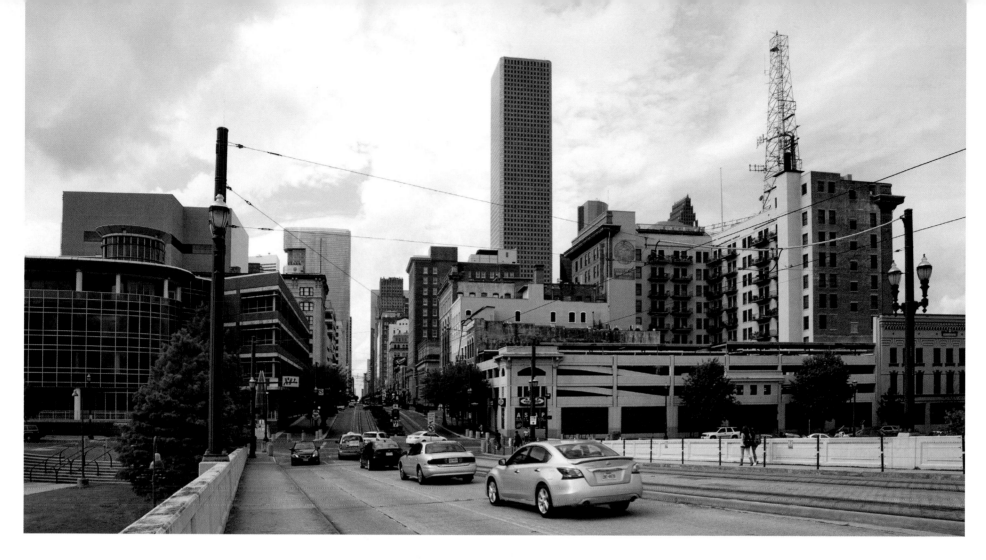

LEFT: Main Street was always an anthill of activity. Steamboats parted the bayou as they docked to deliver everything from steel pipe to designer hats. The smell of sawdust, coal, and horses from the landing drifted down Main Street to mix with the aroma of fresh coffee, French perfume, and smoked meats. At the turn of the century, literally hundreds of Houston manufacturing facilities used the landing on Main Street.

RIGHT: This shot of Main Street at about the 600 block facing south at Texas Avenue shows a bustling metropolis in 1923. On the left, you can see Ladin's—a popular ladies' clothier. Next door was the Queen Theater, which opened in 1914. The Queen was the first theater in town to sport a Wurlitzer organ to accompany either silent films or live stage performances. Note the quaint old manned traffic signal up the road!

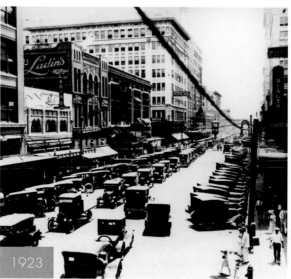

1923

ABOVE: METRO rail cars now zip up Main Street over the bayou—still a bustling spot in town but not necessarily the center of attention. The opening of the ship channel and the Main Street viaduct in 1914, which allows Main Street to cross Buffalo Bayou, has made the area more suitable for parking than docking. Now this area of Main Street smells more of diesel fuel (but still coffee) as people come and go from their work. The modern building at the end of the bridge on the left is a part of the University of Houston-Downtown.

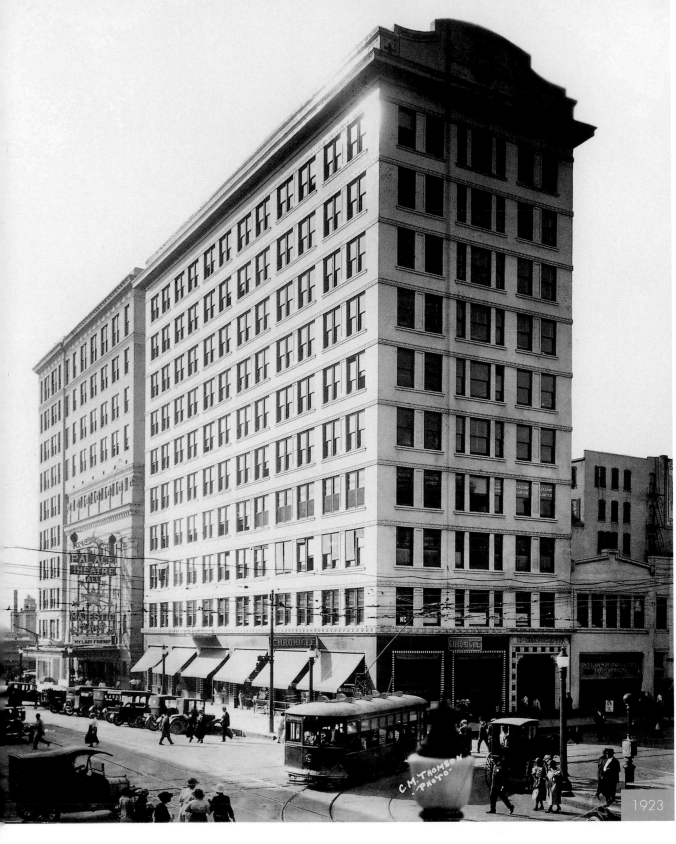

1923

HOUSTON CHRONICLE BUILDING
Like the newspaper, the building has been revamped many times

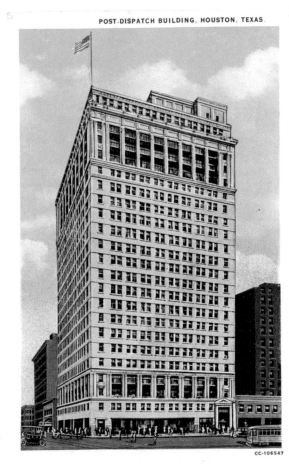

POST-DISPATCH BUILDING, HOUSTON, TEXAS.

CC-106547

ABOVE: This old postcard shows the old *Houston Post-Dispatch* building, the *Chronicle*'s rival newspaper for several decades. The *Post* was started in 1880 and lasted until 1995 when all of its assets were purchased by the *Chronicle*. Short-story writer O. Henry worked at the paper in 1895 and 1896. This is a depiction of the 1926 Ross S. Sterling building the *Post* used as its headquarters at 1100 Texas Avenue. Today, the building has been beautifully restored as the Magnolia Hotel.

LEFT: In 1901, Marcellus E. Foster was covering the Spindletop boom in nearby Gladys City (by Beaumont) as a newbie reporter for the *Houston Post*. While he was on the scene, he got caught up in all of the excitement and gambled a week's pay—which for Foster was about thirty bucks—on a piece of an oil well. The well hit, and left him with what was then a huge chunk of money. When he got back to Houston, he pitched some friends on his idea of starting a rival newspaper in town. Many chipped in, and on October 14, 1901 Foster started the *Houston Chronicle*. Operated from a less-than-impressive building on Texas Avenue, the startup paper cost two cents a copy. In its first month he'd pulled in almost 5,000 subscribers (pretty darn good considering only around 45,000 people lived here at the time). Not ten years after Spindletop, it enlisted Jesse H. Jones to build this ten-story office at Texas and Travis.

RIGHT: Jones fell in love with the paper, and eventually bought it. The building expanded considerably, swallowing several nearby structures including the old Palace Theater. During the 1970s, four separate structures were brought together in a complicated renovation of the *Chronicle*'s Texas Avenue headquarters. Today, the remodeled building is more than 100 years old. And it is connected to Houston's downtown tunnel system—a lifesaver during hot Houston summers. Now owned by the Hearst Corporation, the *Chronicle* is Houston's largest newspaper and one of the ten largest in America. While mainstream, corporate media has not been served well by the evolution of digital media the *Chronicle* is still Hearst's biggest newspaper and has a Sunday readership of more than a million readers. With news bureaus in both Austin and Washington D.C., hundreds of thousands of Houstonians rely on the *Chronicle* to stay connected with major news and their community. The *Houston Post* closed in 1995. That big building looming over the Chron's shoulder is the Calpine Center office building.

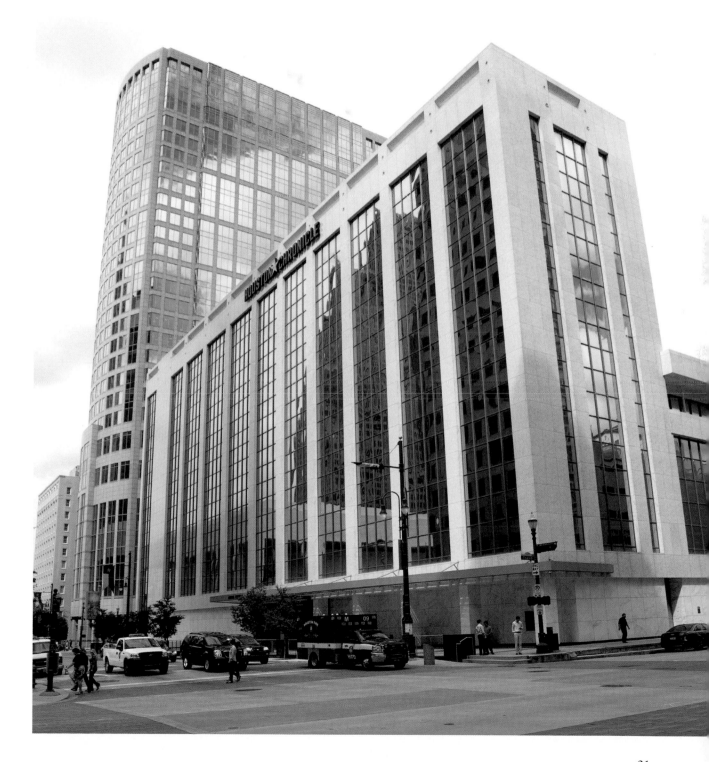

1915

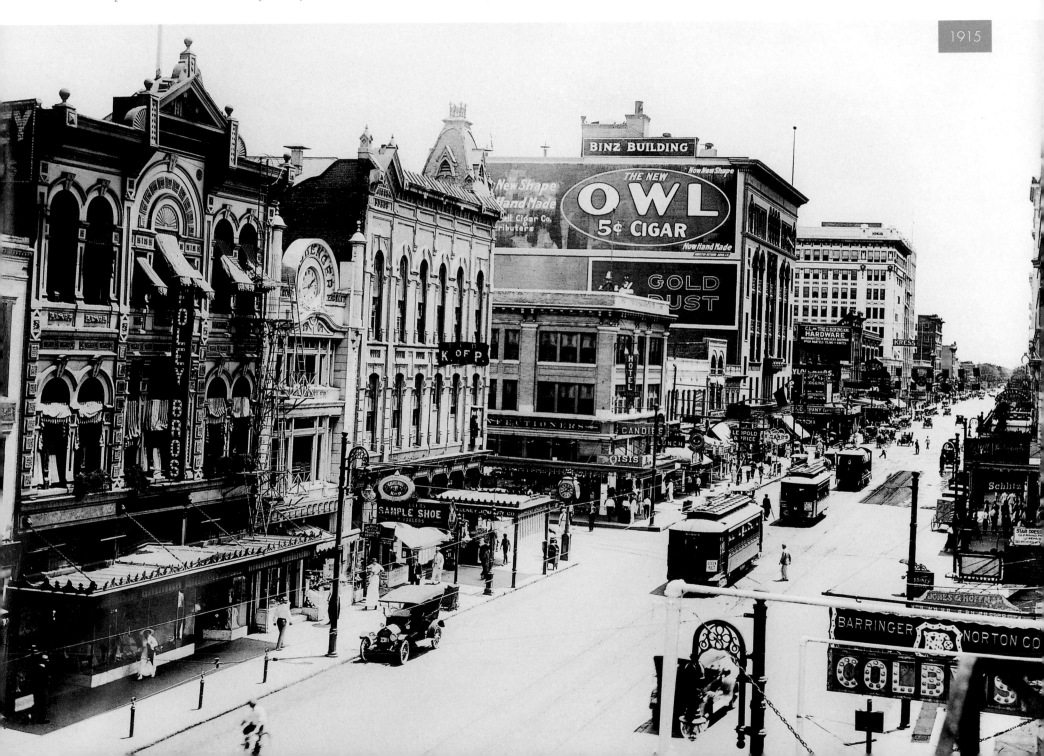

RIGHT: This shot shows the corner of Preston and Main. Francis R. Lubbock—the ninth Governor of Texas—purchased this land from the Allen Brothers in 1837. As shown here, at the turn of the century, the horse and buggy still shuffled shoppers around town (along with the electric streetcar; you can see the tracks in the mud). In 1909, the retail building you see here was razed to make room for the Scanlan Building.

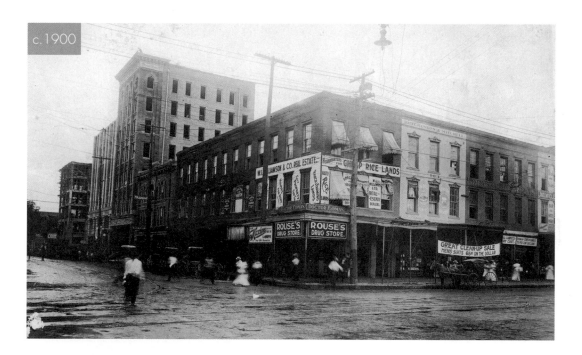

LEFT: In this 1915 view of Main Street, trolleys, automobiles, and pedestrians together made for a busy thoroughfare. Flush with newfound oil wealth, Houstonians found some of the city's finest retailers here. The bayou brought goods from all over the world to the head of this very street, and Houston's ambitious retailers made the most of them. One of the entrepreneurs was Irishman William L. Foley, who started Foley Brothers Dry Goods Company (left of picture) with $2,000 borrowed from his uncle, while the Binz Building is prominent further down the street (see page 28).

RIGHT: For a time, the retail trade downtown fell on hard times. Houstonians were moving out to the suburbs, commuting to their downtown offices in the interest of more space and comfort. But today, Houston's downtown has seen a lifestyle center and retail resurgence (though some areas are surging much faster than others). The Foley's brand lived on until its 2006 acquisition by Macy's. Barringer-Norton tailors (pictured at right in the archive photo), previously at 506 Main, now does business as Norton Ditto. The building on the far right is the Citizen's Bank building, built in 1925.

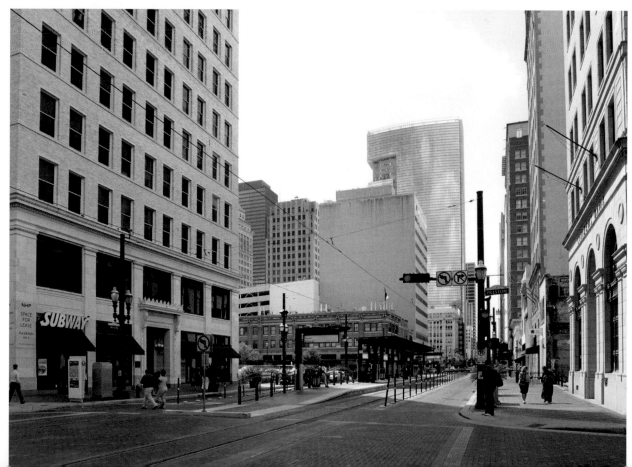

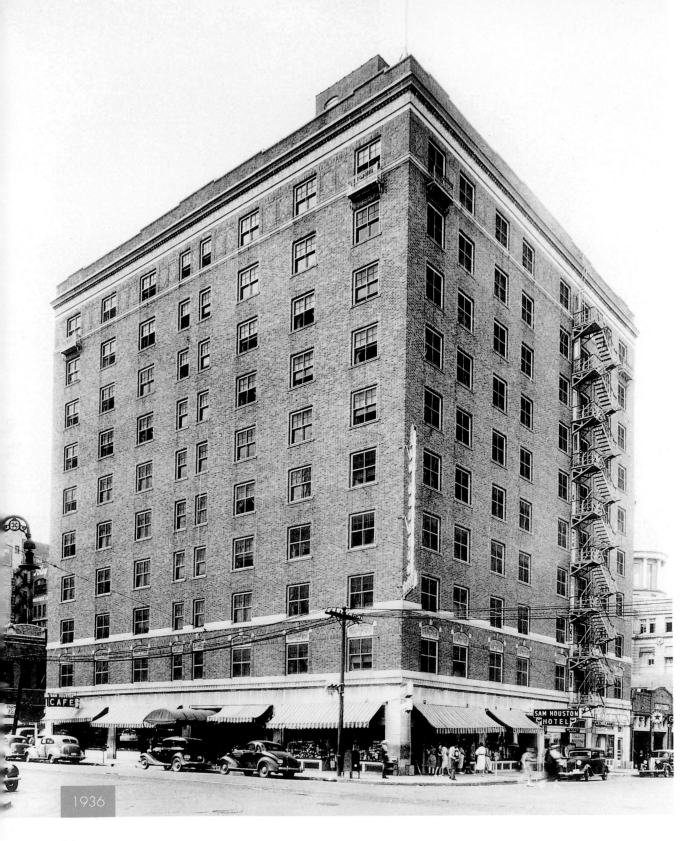

1936

SAM HOUSTON HOTEL

Once in sad decline, The Sam Houston is again worthy of the name

LEFT: The Sam Houston Hotel was built in 1924 as buildings and bankrolls around town grew tall in the shadow of Texas's oil boom. It was designed by the architecture firm of Sanquinet, Staats, Hedrick and Gottlieb—whose principals designed the Flatiron Building in Fort Worth and the Scarborough Building in Austin. The hotel's proximity to Union Station was an added attraction. A true luxury experience, each room cost two dollars and sported both a private air conditioner and a bathroom. The first floor was originally occupied by a café, a beauty salon, and construction concern. For decades, people came and went from the Sam Houston on business of all kinds and it became a regular destination for travelers in the region. Eventually the hotel lost its reputation for high-end hospitality. By the late 1970s, it was in a sad state and eventually called it quits.

RIGHT: Downtown has undergone a lifestyle renaissance in recent years and the old Sam Houston Hotel at 1117 Prairie attracted new investors. Rebranding itself as Alden Houston, it reopened in 2002. The hotel was sold again in 2012 and switched back to its original historic name: the Sam Houston Hotel. It underwent another big renovation in 2013 and is today one of the most charming hotels in the downtown area. The Sam Houston is more exquisite than ever. The building has retained a few of its original interior appointments, including a beautiful granite staircase leading up to the second-floor restaurant, *17. The hotel bar, Sam Bar, is intimate and chic. Over the years, the business district has grown around it so that The Sam Houston is within walking distance of many of the major business destinations such as Chase Tower, Shell Plaza, Chevron and Houston Center. Note the Lone Star flag flying high atop the roof, paying homage to the hotel's Texian heritage.

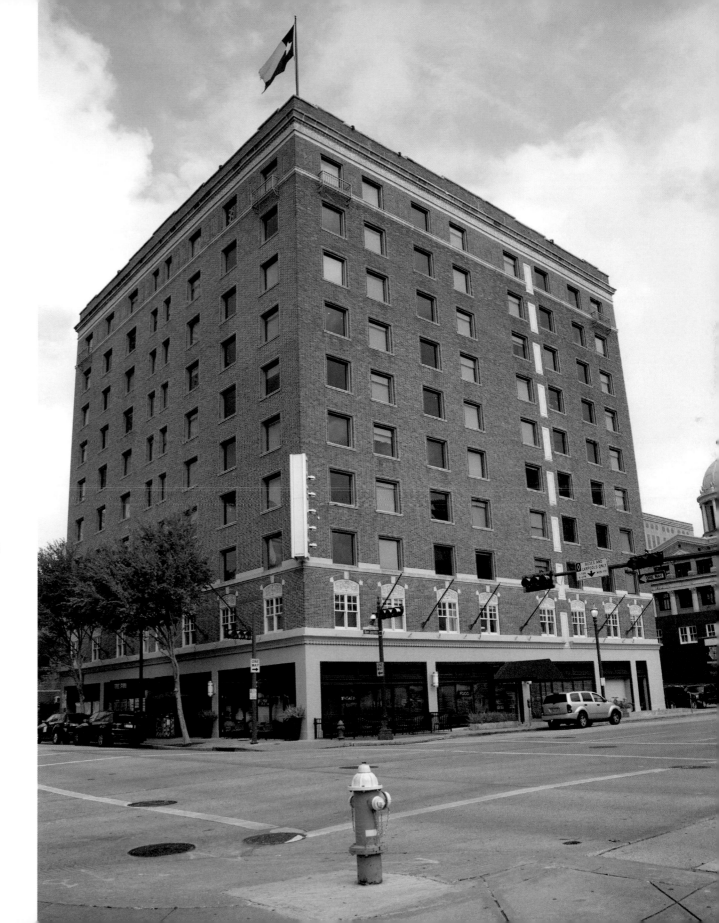

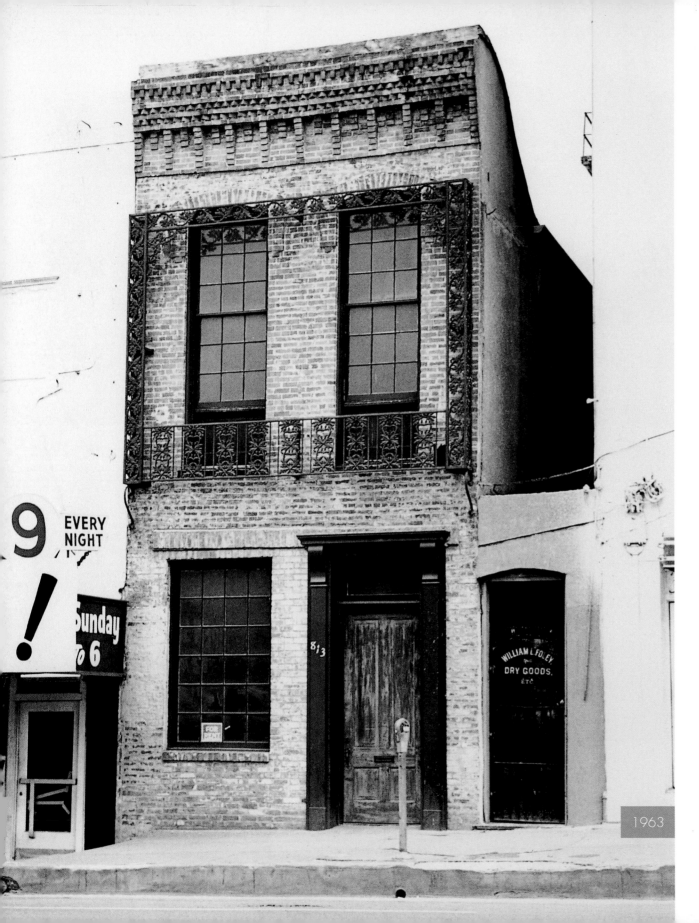

1963

KENNEDY TRADING POST
From raising flour to raising glasses

LEFT: The Kennedy Bakery (trading post) is recognized as Houston's oldest commercial building still standing on its original site. Nathaniel Kellum built the structure in 1847 and in 1860 John Kennedy, an Irish baker, moved into the narrow structure at 813 Congress. Kennedy was an Irish immigrant who came to Houston in 1842. Poor when he arrived, the hardworking Irishman quickly amassed his own Houston bakery, gristmill, retail store, and several thousand acres. But the old trading post was his first Houston business. These were still frontier days in Houston, and the barter of goods was a serious affair. Native Americans would come to Kennedy to sell their wares and the only language common to both parties was often the language of capitalism. They would place what they had to sell on Kennedy's counter, and let him know when he'd placed enough money upon it for the transaction. During the War Between the States, Kennedy used his bakery to make hardtack for Confederate soldiers.

RIGHT: Kennedy was a solid supporter of the Confederacy, and when the cause fell his fortunes took a hit (like most people in town). He'd owned a big building at Travis Street and Congress, which he'd leased to the Confederacy as a munitions depot. After the war, returning soldiers hid and dumped the guns, shells, and other weapons out of the depot. Many were thrown in the bayou. On occasion over the years, the tides would recede and someone would go down and mess with these underwater armaments; on a few occasions, they exploded. At one time, the old building served as a Pony Express station. It stayed in the Kennedy family for a remarkable period of time until finally sold in 1970. Today it is the esteemed La Carafe, considered to be Houston's oldest and most charming bar. The building may be narrow, but it has a vast reputation. In addition to its flavorful atmosphere and terrific wine list, legend says that the building is haunted. But haunted or not, it's one of the best places to raise a glass in the state of Texas.

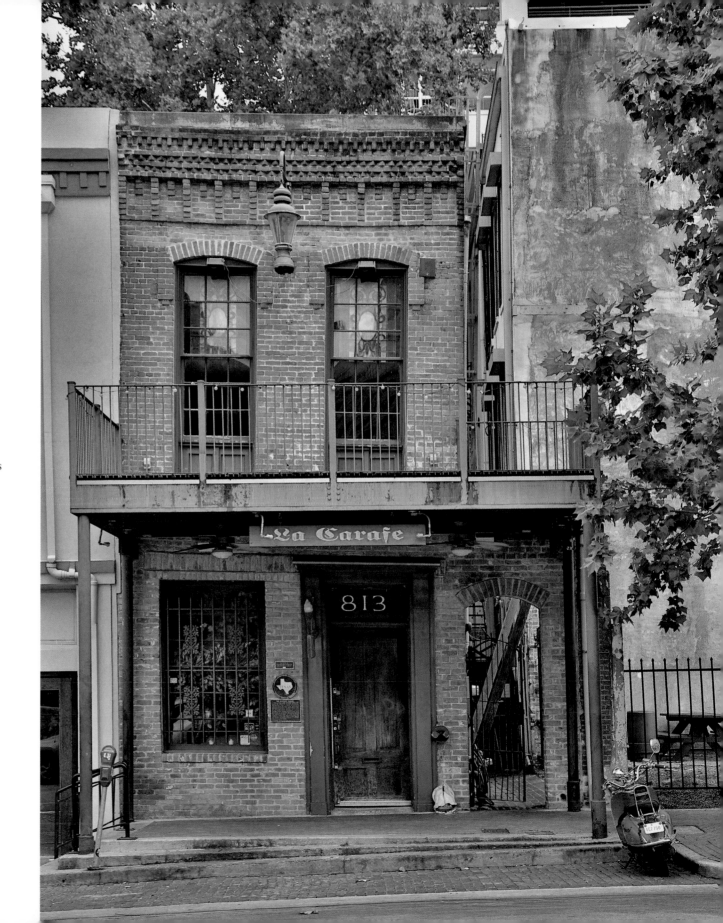

BINZ BUILDING

It was the marvel of its age, the Binz Building was the city's first "skyscraper"

LEFT: The original Binz Building, on the corner of Main and Texas, was Houston's first skyscraper. At six stories, it was an absolute marvel at the time of its construction in 1895. Riding up its elevator and overlooking the town's landscape became a popular pastime. The building was named for Jacob S. Binz, who was one of thousands of industrious immigrants comprising Houston's prolific German community at the time.

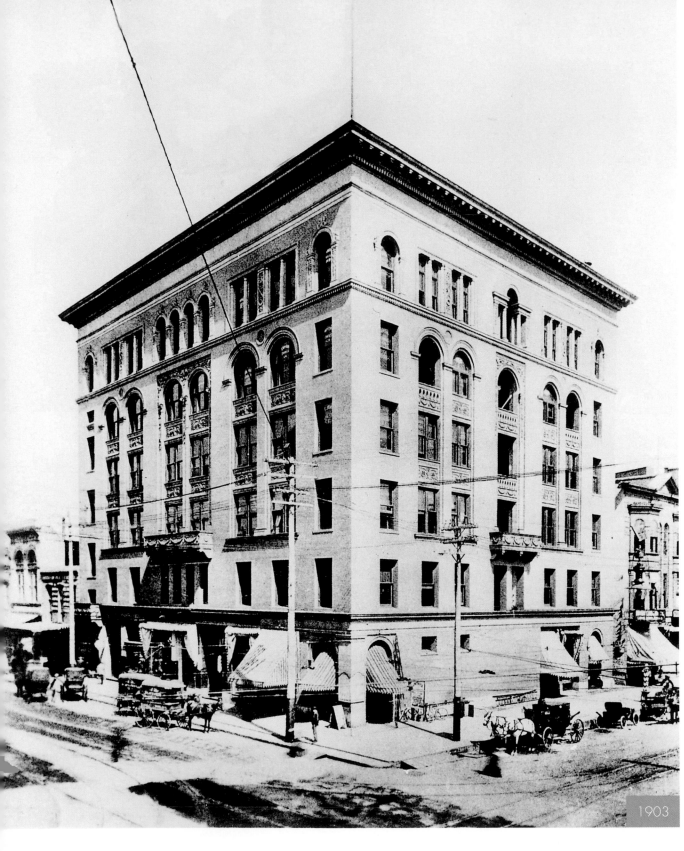

1903

BELOW: The building was taken on by Jacob Binz's son, Arthur Jacob Binz (1875-1955) a Houston realtor.

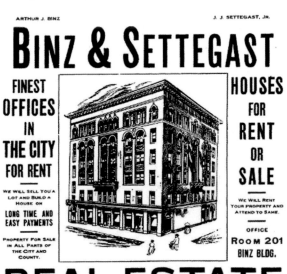

RIGHT: In its day, the old Binz Building's presence gave concrete (and steel) evidence of Houston's ambition. But the definition of "skyscraper" has changed over the years. The bar, and the skyline, have been raised. The original 1895 Binz Building was demolished in 1950, and a new one erected in its place in 1951. The 1951 building was massively renovated and added to in 1982 to make practically a new building. The old-style post clock out front reads "Main at Texas."

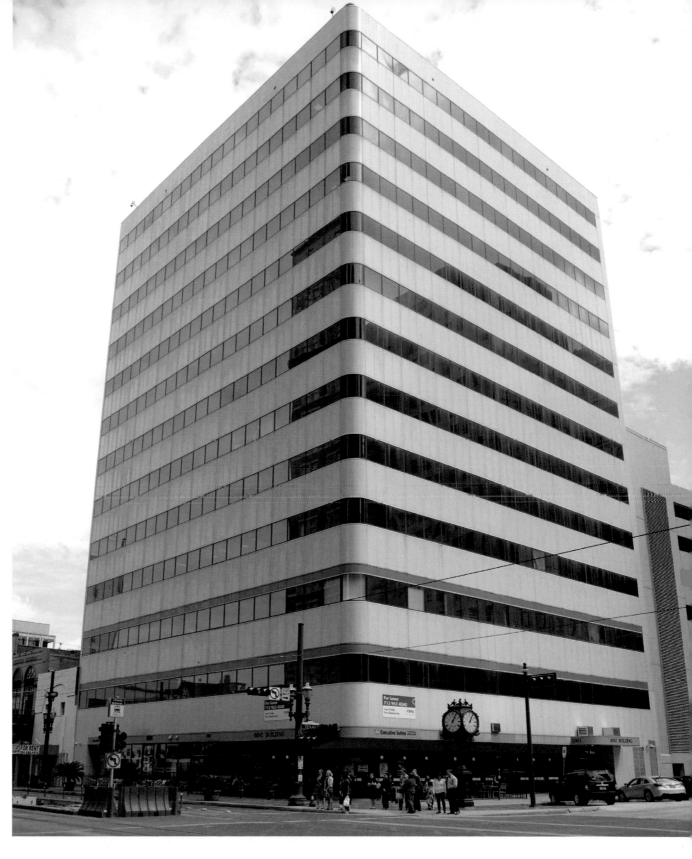

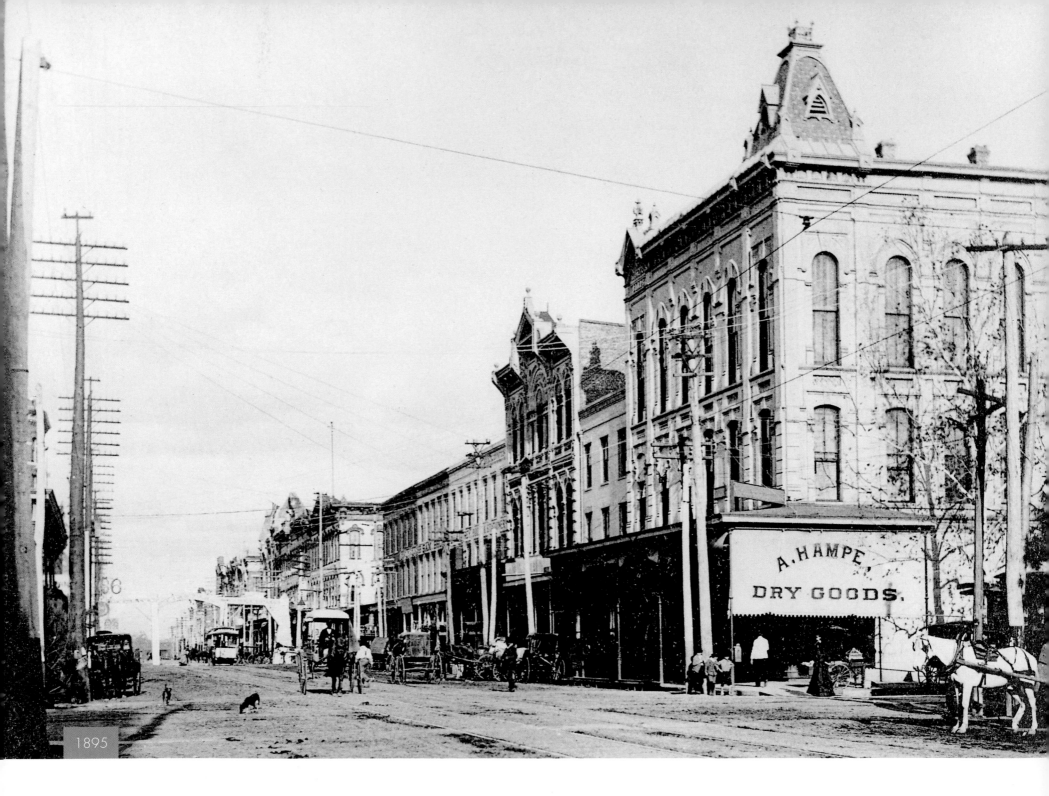

1895

MAIN AND PRAIRIE
Despite being listed on a National Historic register, the 111-year-old Burns Building was demolished

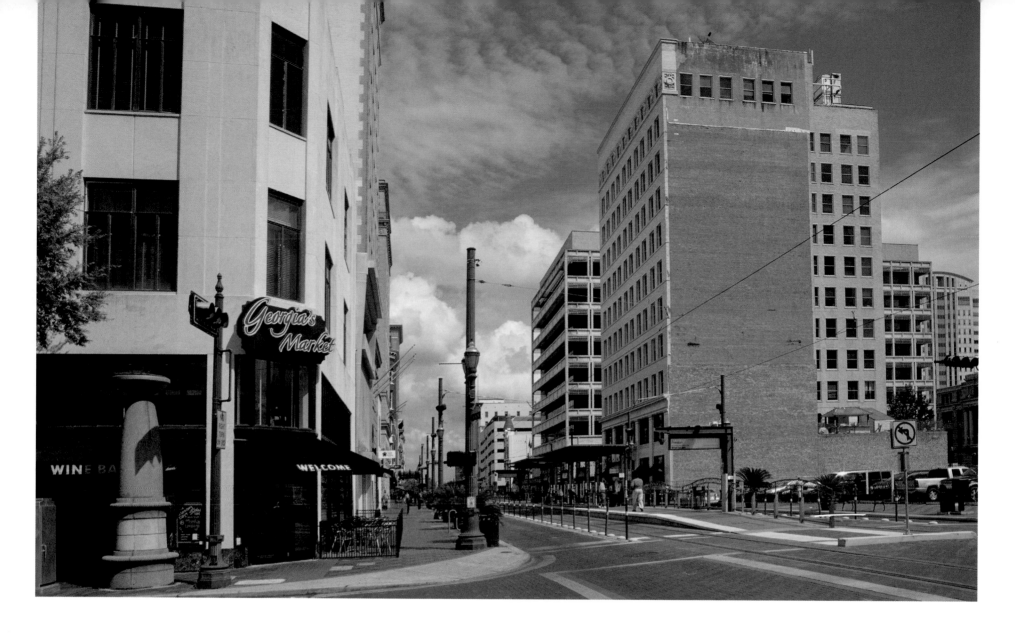

LEFT: Looking north on Main Street at the Prairie Street intersection in the mid-1890s, both telegraph wires and trolley cars gave passersby a glimpse of the next century—even as horses still plodded through the mud. Houston wouldn't see its first automobile until 1901, when a group that called itself the Left Hand Fishing Club bought one. It was an Olds Motor Works from Detroit which topped out at 40mph. The A. Hampe Dry Goods store was one of the city's first true department stores; very popular with the ladies in its day. The Burns Building, front right, was built in 1883 by Hugh Burns. Born in County Roscommon, Ireland, Burns had a hand in much of Texas's railroad development at the turn of the century.

ABOVE: The Burns Building was 111 years old—the second-oldest building in Houston—and on the National Register of Historic Places when it was demolished. A noncommittal owner and lax ordinances governing historical buildings permitted its razing. Most of its contemporary neighbors met a similar fate. Onlookers cried as the wrecking ball swung, but the event served to galvanize local historical activism. Several powerful groups now protect Houston's architectural heritage. Hampe's business didn't last, falling to rivals such as Levis Brothers' and the Foley Brothers. The city's light rail has really perked up this part of town. Georgia's Market at 420 Main, on the left, is a small market and café specializing in organic and locally sourced produce and meats.

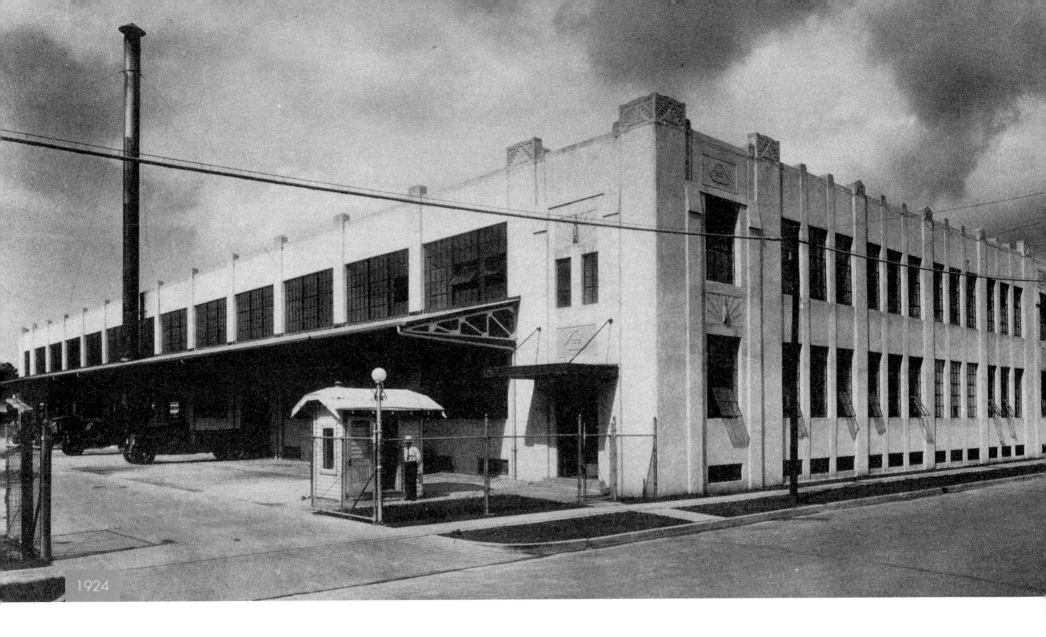

HUGHES TOOL COMPANY
The core business from which Howard Hughes, Jr. built his fortune

ABOVE: This shot shows the outside of the Finished Stock and Shipping Department of the Hughes Tools Company at 5425 Polk Avenue. The building was completed in 1924. Originally established as the Sharp-Hughes Tool Company, the enterprise was a result of Howard R. Hughes, Sr. and his innovative rotary drilling process for use in the oilfield. Much of the company was left to his son, a student at Rice University at the time. Howard Hughes, Jr. bought all controlling interests in the company and turned it into a conglomerate with businesses as diverse as aircraft (just in time for WWII), medicine, and motion pictures—even Las Vegas nightclubs. But while Howard Hughes the younger invested liberally in an eclectic basket of concerns, his one core business that paid the bills, Hughes Tool, was right in this building.

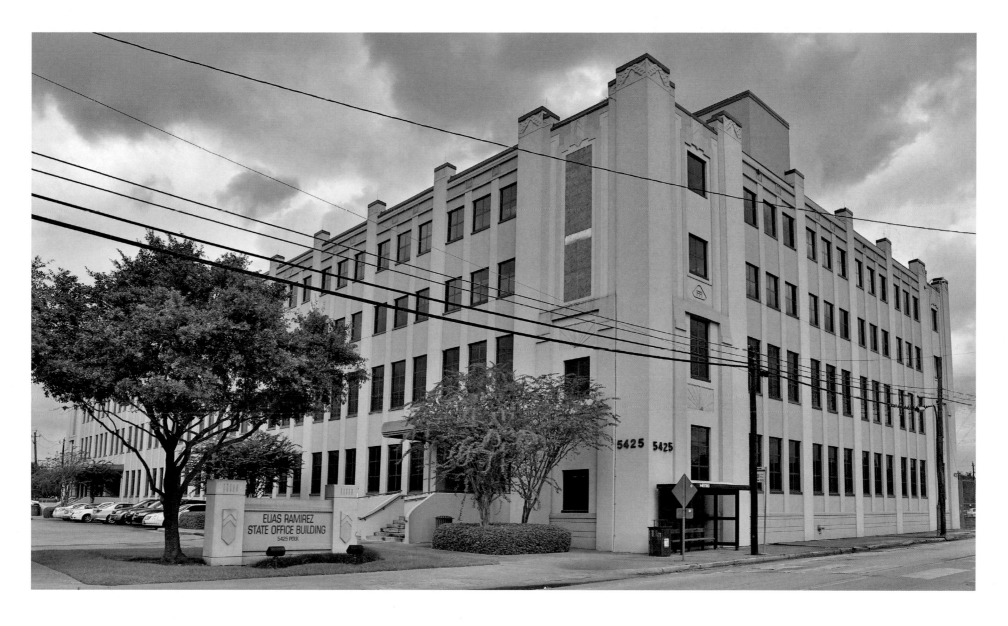

ABOVE: Today, this grand Art Deco building is an administrative office for state-level bureaucrats. Now formally known as the Elias Ramirez State Office Building, its new name celebrates a community leader who helped work to improve the civil rights for Hispanic Houstonians between 1910 and 1960. Where the building once held the products of private engineering, it now serves as host to an alphabet soup of various state government agencies whose function is to dispense a variety of taxpayer-funded social services to the local community. These include the Department of Adult and Child Protective Services, the Texas Commission on Environmental Quality and other such agencies. In 1987, the Hughes Tool Company merged with Baker International to form Baker Hughes, which is also headquartered in Houston. Its consistent financial performance continues; Baker Hughes is 141st in the Fortune 500. Howard Hughes, Jr. led an extraordinary, if somewhat tragic life and is today buried at Houston's Glenwood Cemetery in an ornate family plot (see page 124).

c.1900

CONGRESS AVENUE
Now free from a goading Union flag

LEFT: The quaint turn-of-the-century retail stores lining Congress Avenue around Fannin Street show early Houston's enterprising spirit. Dry goods stores, hoards of book dealers, launderers, furniture stores, druggists, and more lined the street. This was a time of transformation; horse-drawn carriages and bowler hats mixed with the electric railcars rattling down the tracks in the center of the street. The store on the far right specialized in dry goods, books, stationery, and clothes. After the fall of the Confederacy, Federal occupiers draped a huge Union flag over the Congress Avenue sidewalk. Many Houstonians refused to walk under it, preferring to soil their shoes in the mud rather than soil their principles.

ABOVE: The scenery on Congress Avenue has changed a lot. The distinctive old Victorian Sweeney, Coombs, and Fredericks Building at Congress and Main is still around. But on this stretch of Congress, all of the old charming bookstores and five-and-dimes have met the wrecking ball. These days, government agencies representing state, county, local, and federal organizations occupy block upon block of Congress Street. The beautiful 1910 courthouse is seen on the right; it just received a $65 million, five-year restoration. A huge family law center building with a small green space is on the left, just out of the photo. The Harris County Civil Court Building looms in the distance on the left. There's not a lot of free enterprise going on in this particular spot, unless you count taxes or lawyer's fees. But one thing is for sure: not many drivers speed through this part of town.

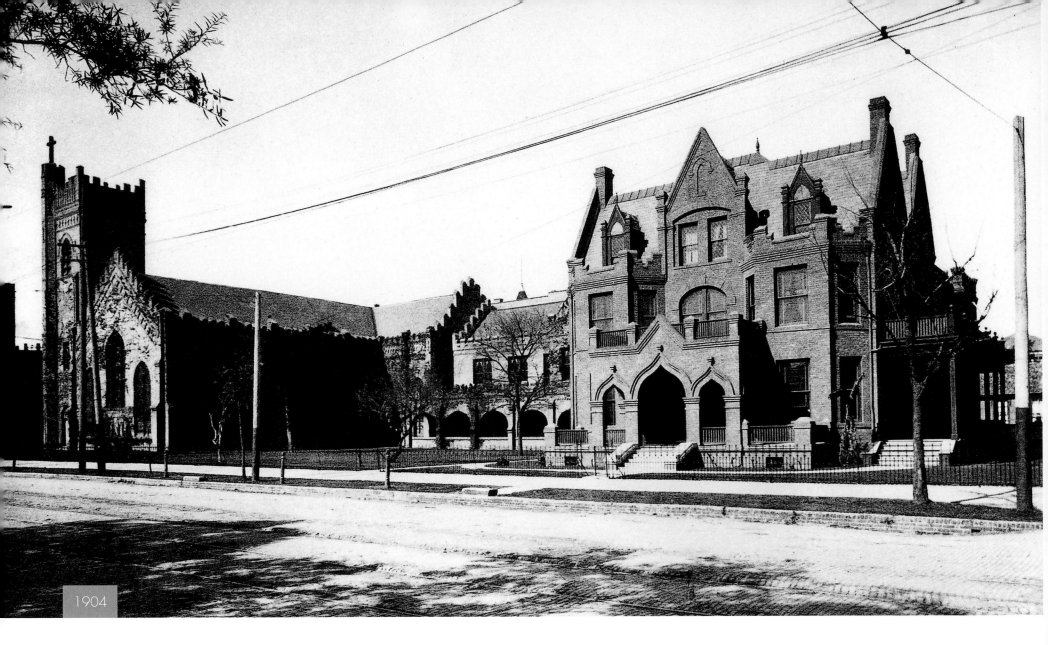

1904

CHRIST CHURCH
The original Houston congregation

ABOVE: Houston was not known for its piety when Christ Church Cathedral was built. In 1837, as Houston was still a nascent city and the capital of the Republic of Texas, it had a theater: it had establishments that sold cold adult beverages: it had horse races and dances and hunting: but no church was to be found. The city's first religious congregation of any Christian faith, Christ Church, built its first church in 1845. The third, and present day, Christ Church building held its first service on Christmas Eve of 1893.

RIGHT: This wonderful old postcard depicts the church and rectory as they were in 1907. The church may be dedicated to Jesus Christ by word and deed, but Houston's early real estate developers would have loved to have the deed to the land on which Christ Church sits. In 1925, the Hogg brothers offered the church $750,000 for the prime Texas Avenue land on which the church sits. But, no sale.

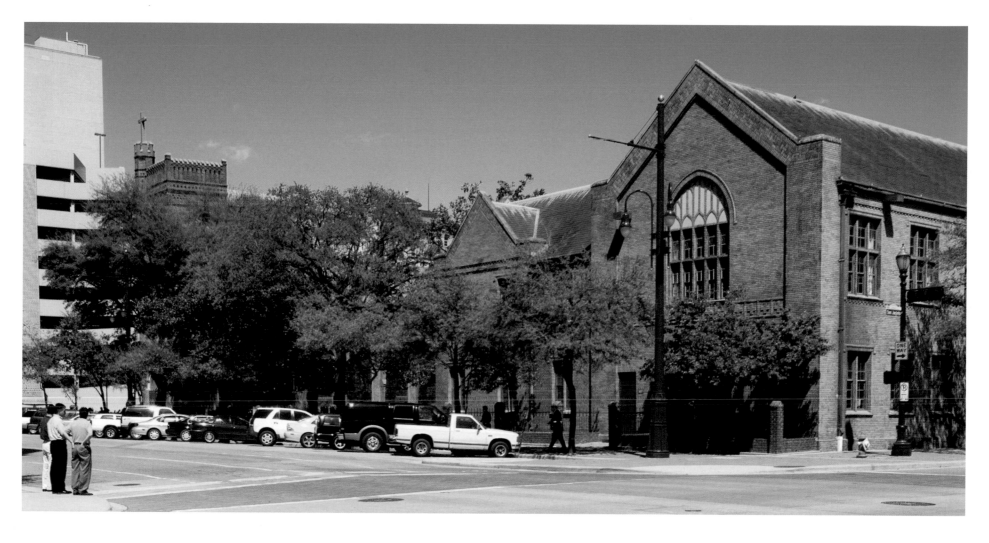

ABOVE: One of the oldest churches still standing downtown, Christ Church is today a thriving center of worship, learning, and leadership. In 1938, a tragic fire started at an adjacent building and ripped through the chancel causing the roof to collapse over the altar. Practically the whole town came together to rebuild the church. A new Aeolian-Skinner organ was installed in 1939, with a grand total of over 4,470 pipes.

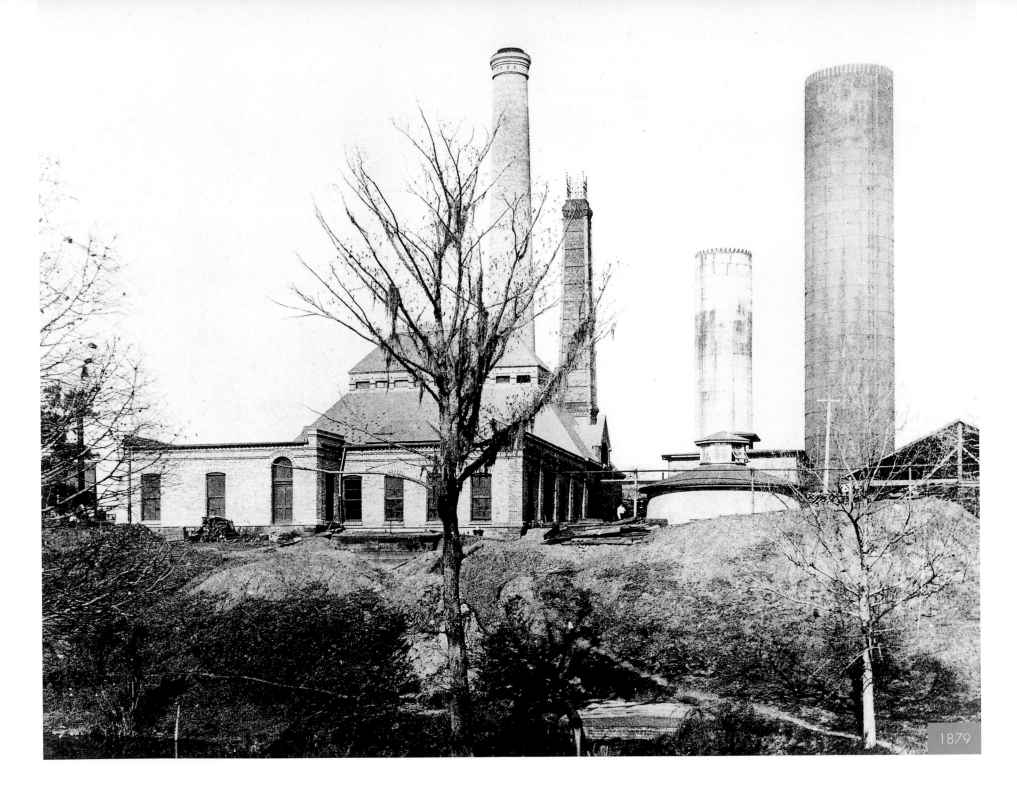

1879

HOUSTON WATER WORKS

Supplying water and fish to Houstonians since 1879

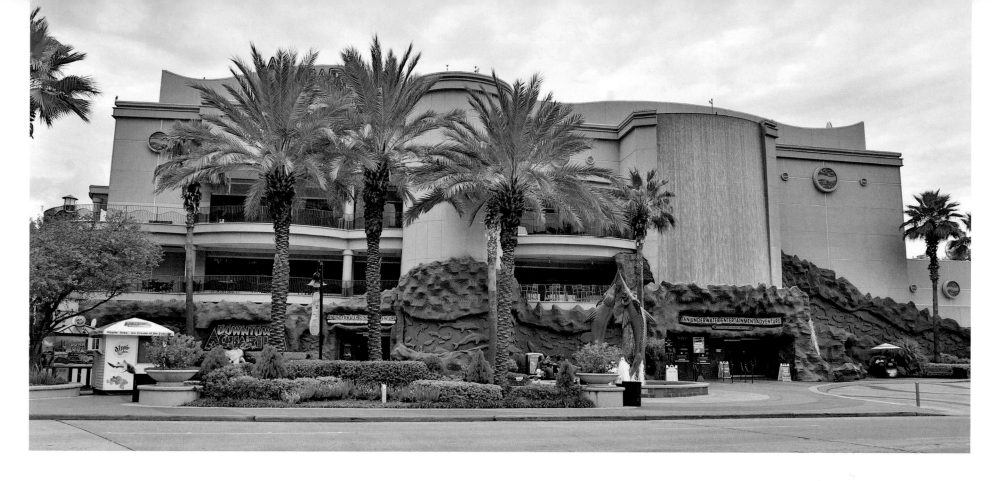

LEFT: The earliest Houstonians got their water from a variety of sources. Some used a cistern to capture rainwater for drinking. Others had water from nearby springs delivered, or dug their own well. Houston's original Water Works, the city's first water facility, was built in 1879 at 27 Artesian Street. New York-owned, it pumped water directly from the bayou into the water main. To do that they dammed the bayou just above the Preston Street Bridge. The enterprise was considered successful, though everyone but the water moccasins lamented the questionable quality of the bayou water. However, a series of deadly and catastrophic fires over the next few decades underscored the system's lack of water pressure. In the late 1880s, the Water Works Company discovered a huge, pure underground water reservoir. It was a dream come true, but there was a problem. Houston was growing—fast. The company drilled another, then another; soon fifteen wells were drilled into the underground reservoir, pumping out water to a thirsty city.

ABOVE: Soon, all that drilling of artesian wells really put the hit on the plant's primary water source, thus causing the dirty bayou water to be used strictly for industrial purposes, such as fire fighting. Houstonians had their suspicions about the Water Works running low on the good stuff and making Buffalo Bayou once again the city's primary watering hole. The issue came to a head when in 1906 a young lady came across a broken water main with some distinctly non-artesian attributes: fish! Showing her findings to city hall in a glass jar, her discovery confirmed suspicions that the water company was cutting costs at the expense of public health. The mayor quickly prompted a city purchase of the facility. Today Houston consumes 382 million gallons of water daily through the use of 7,000 miles of water lines. The 1879 Water Works is on the National Register of Historic Places and today is sporting more fish than ever as a part of the Downtown Aquarium building!

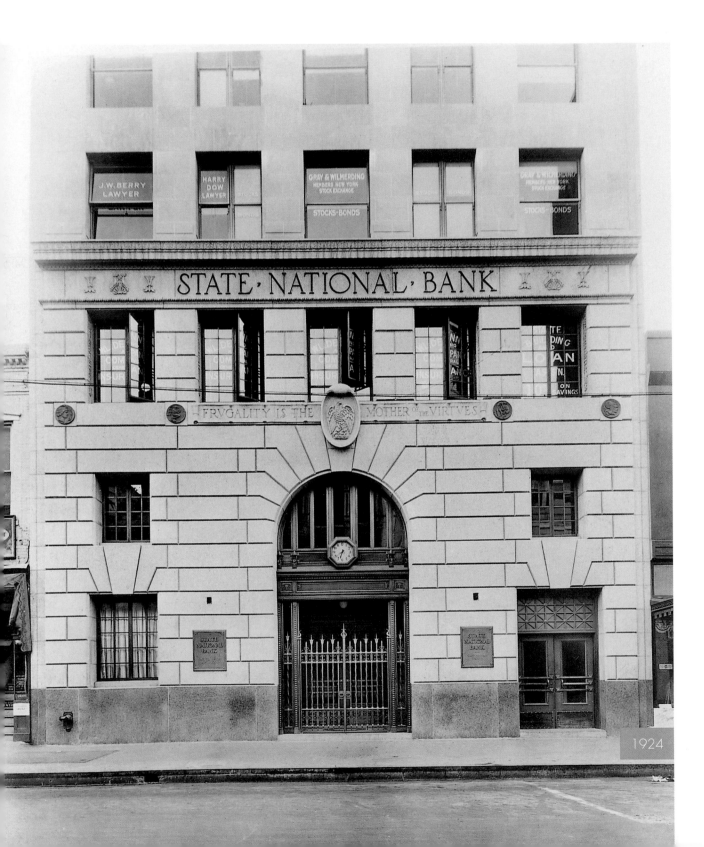

1924

STATE NATIONAL BANK

Reminding its patrons that "frugality is the mother of the virtues"

LEFT: This lanky neoclassical gem was completed in 1924, the product of celebrated Houston architect Alfred C. Finn—who also designed the San Jacinto Monument. When the State Bank and Trust Company started in 1915, it was successful and quite the influential financial institution. Soon renamed State National Bank, it captured a huge share of the local market with its nine-to-five banking hours, enabling them to build this grand commercial structure. Local powerhouse law firm Fulbright & Jaworski got its start by snagging the State National Bank as its first client. The project cost around $800,000. The architecture employed by Finn for this building was pretty standard in its day, though it had some luxurious touches. The base of the building is pink Texas granite, and inside it sported a granite marble staircase and accents. Its rooftop penthouse was designed as a clubhouse, complete with showers. The four circles evocative of coins, that dot the building's façade just above the second floor, each depict a Greek hero.

RIGHT: Once wedged between similar neighbors, the building now looks a lot more architecturally distinctive (and a lot taller) than its twelve stories. Its relative isolation for a building that high really makes it stand out. A number of tenants have occupied it, including many lawyers. Today, the inscription above the entrance still states "Frugality is the Mother of the Virtues," ironic considering that it has housed a series of trendy nightclubs on the first floor. The neighborhood around it is looking good, with restorations and renovations surrounding the area, the new light rail system (you can see the green overhang as part of the stop) and a resurgence of residential and lifestyle developments. Nearby Market Square has seen new development and even bigger future plans, creating a hot market for space in the area. In 2013, rumor had it that Hines was considering a 33-story residential tower right next to the old building—which would help its current vacancy status. It was entered into the National Register of Historic Places in 1982.

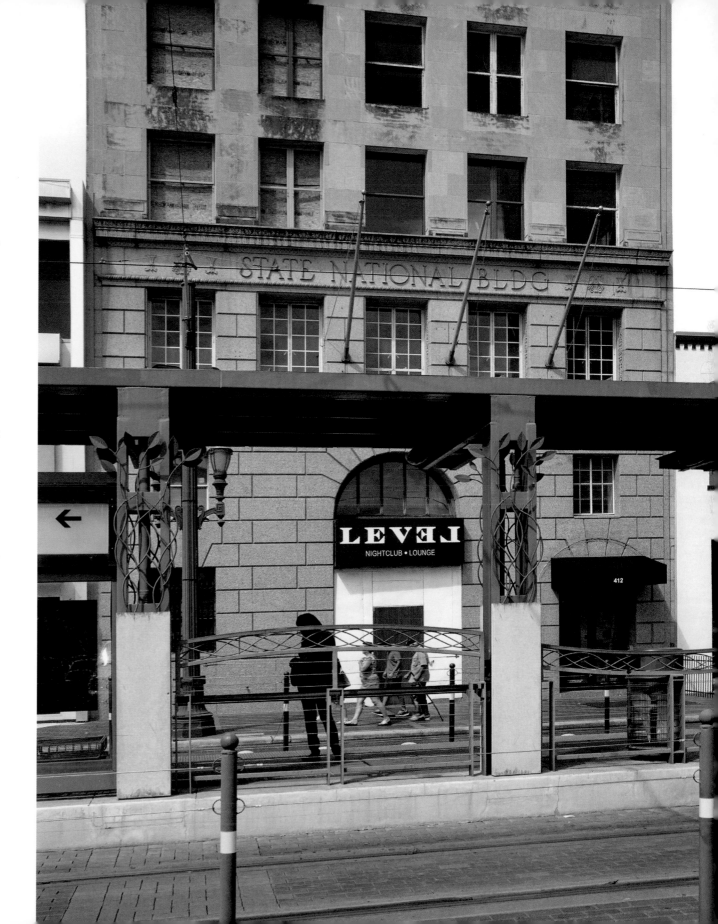

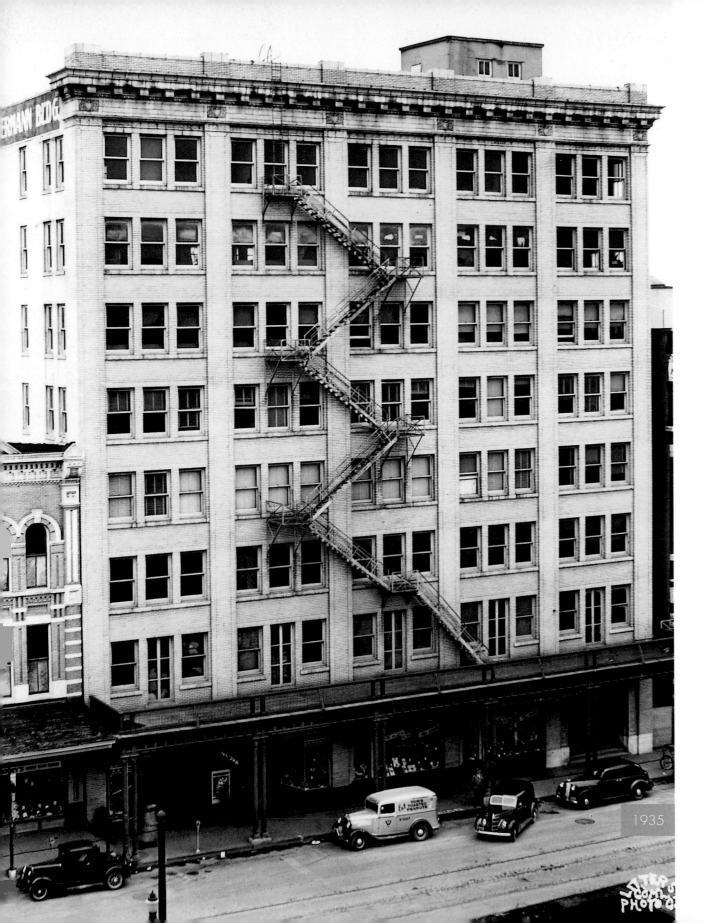

1935

HERMANN BUILDING

Providing office space for the Cotton Exchange next door

LEFT: George Hermann fought the urge to spend a nickel as hard as he fought Yankees when he was in the Texas Cavalry during the War Between the States. As a result, he became a self-made millionaire. It was no surprise when his keen capitalist eye noticed the cramped quarters and fat pockets of the bustling Cotton Exchange on Travis Street. He quickly built this eight-story office in 1917, right next door to the Cotton Exchange building to help the cotton merchants spread out—and spread their wealth. Designed by F. S. Glover & Sons, who also designed the Houston Public Library's Julia Ideson Building, the Hermann Building was 60,000 square feet total and was the largest building completed that year. It cost $100,000. The iron sidewalk canopy jutting out over the walkway at 204 Travis Street is something you just don't see any more. In 1924, the old Cotton Exchange was abandoned for its roomier, more modern successor. The building's biggest cash cow had left the neighborhood.

RIGHT: The Hermann Building's occupants exited post-Cotton Exchange, leaving hardly enough tenants to keep the building profitable. For several decades, the maintenance and profitability of the old building were hot and cold. In World War II, the government rented several floors. Its popularity surged and waned with professionals and the building eventually fell into disrepair. Later, the Salvation Army used it for a shelter and soup kitchen. Its salvation came in 1997, when the building was completely renovated into urban loft space. Now, it is known as the Hermann Lofts. The building has a fabulous rooftop terrace, and twenty-five residential units for sale or rent which sport 10- and 11-foot concrete ceilings, an amazing location and lots of big windows. As soon as they went on the market, they were snapped up. The building also has lots of retail shopping nearby (breakfast at the Macondo Latin Bistro next door is excellent). Many of the lofts in this building have been professionally designed and look astonishing.

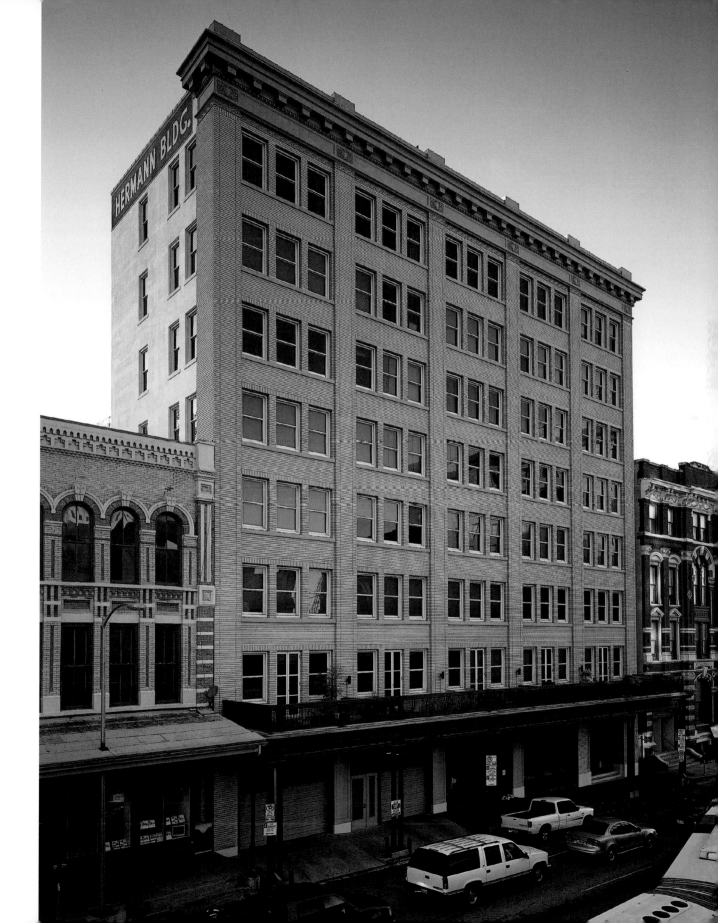

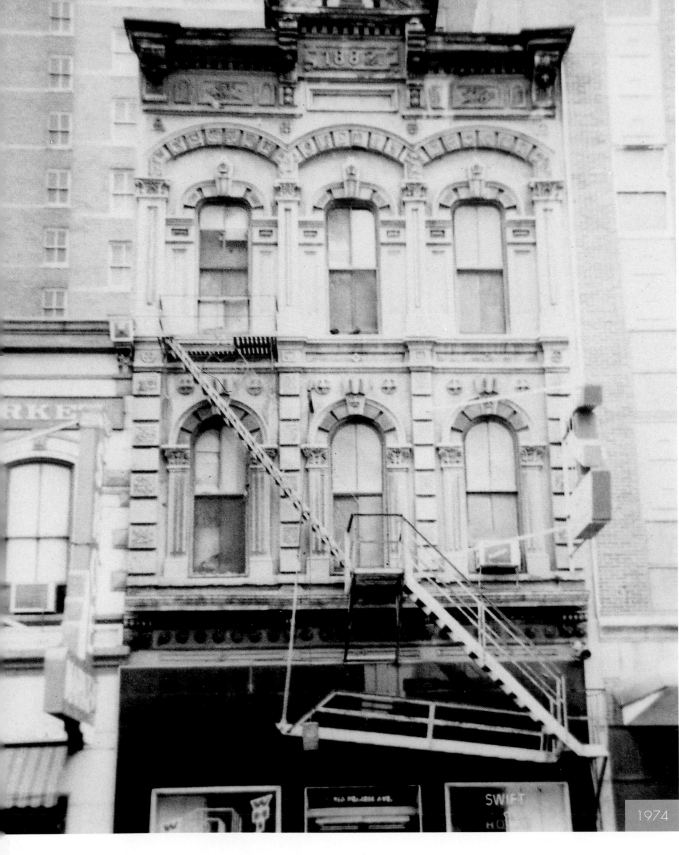

1974

HENRY BRASHEAR BUILDING

A grand old survivor of the Victorian commercial age

LEFT: The Henry Brashear Building was built in 1882 on 910 Prairie Avenue, between Main and Travis Streets. The three-story structure was designed by Eugene Heiner, the same architect who designed the Cotton Exchange building. Its progenitor and namesake, Henry Brashear, was a politician and banker who bought it as an investment. Brashear sold the building to Charles Bente in 1890; Bente sold it to Joseph Meyer in 1905. As was common in its day, the floors above the ground-floor retail space were used for apartments. Its first tenant was likely Erwin Erlenmeyer, a druggist. It was home to Gorman and McAughan jewelers, which specialized in old-fashioned railroad watches, for more than forty years. Along the way it's been the location of the Columbia Dry Goods Company, a children's clothing store, several clubs, a dry cleaners and a deli. Its upstairs was used merely as storage for many tenants.

RIGHT. Today the Brashear Building is one of downtown's most charming, even though it vies for attention with its higher-profile neighbors. Amazingly, it's somehow evaded the wrecking ball over all of these years. When the Carter & Cooley Company deli (now operating in the Heights) leased the space back in 1990, the Henry Brashear Building got a major overhaul and interior renovation. These days it's wedged in between a parking garage, and a few other grand old survivors of the Victorian commercial age—the old 1880 Shoe Market building right next door and the 502 Main and 914 Prairie Building (known as the 1879 F. W. Stegeman Building) at the corner. But the Brashear family left more of their legacy than just this magnificent old building; they were the family who provided the land to the Omaha and South Texas Land Company to develop The Heights, Houston's first suburb. As Mayor of Houston between 1898 and 1900, Sam Brashear also spearheaded the effort to develop Sam Houston Park.

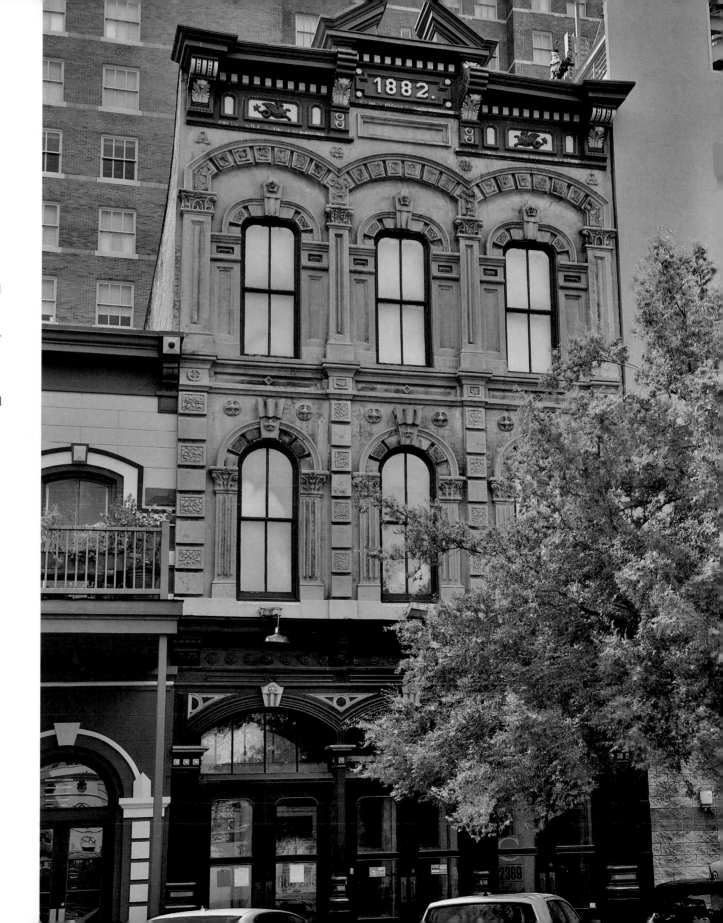

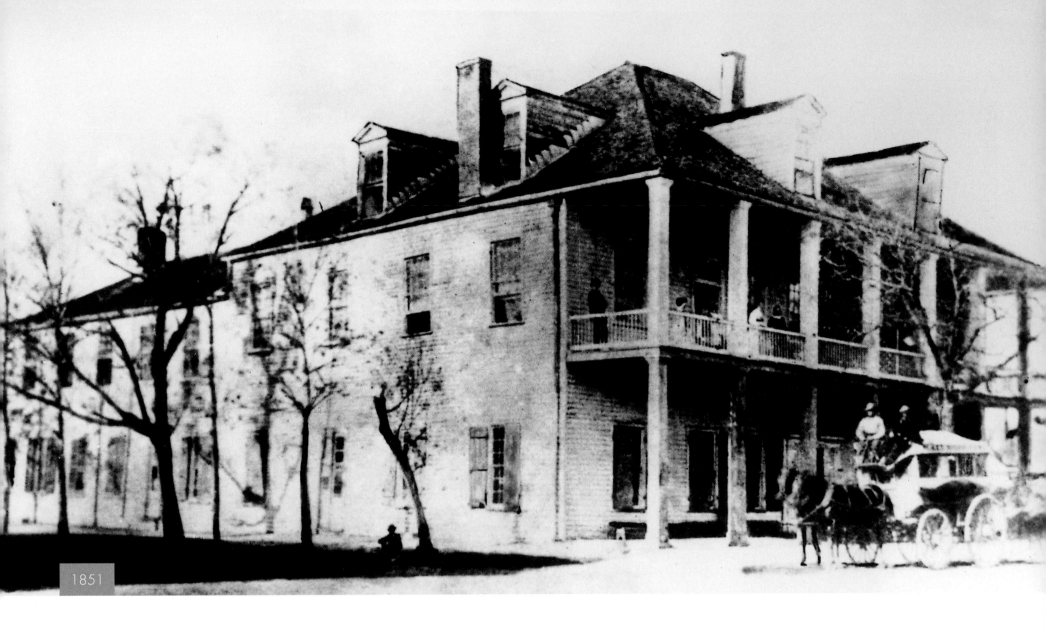

1851

TEXAS CAPITOL BUILDING

Once the seat of government for the new republic

ABOVE: This was home to the Republic of Texas' first Capitol Building from 1837 to 1839 (as well as the General Land Office). After its time as the Capitol, the building served as a series of popular hotels. In 1839, the President of the Republic of Texas, Mirabeau B. Lamar, ordered the nation's capital moved from Houston to Austin. This building was demolished in 1881. It was replaced by the Capitol Hotel. The Capitol Hotel was popular, but was razed to make room for the old five-story Rice Hotel built in 1883 (pictured right). The original hotel was owned by William Marsh Rice. In 1911, Rice's estate sold it to Jesse H. Jones, who demolished the old building and replaced it with the present seventeen-story structure in 1913.

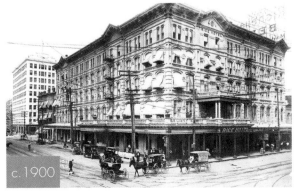

c.1900

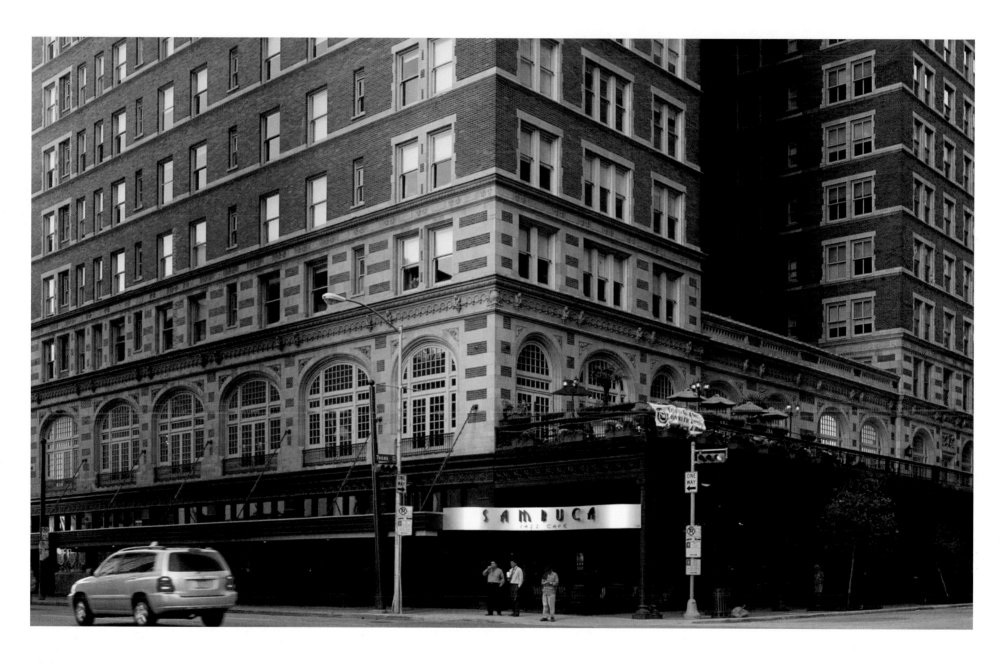

ABOVE: Today, the Rice Hotel occupies the space (actually the second Rice Hotel on the spot). Everyone from John F. Kennedy to Houston's oil business elite ate, slept, and drank at the Rice. In 1998, it was renovated for $27.5 million and converted into the Post Rice Lofts luxury apartments at 909 Texas Avenue. Among countless other amenities, its residents enjoy a sumptuous, 7,000-square-foot dance hall. It also sits on 25,000 square feet of retail space, occupied by businesses such as Minuti Coffee, Azuma, and the Sambuca Jazz Café.

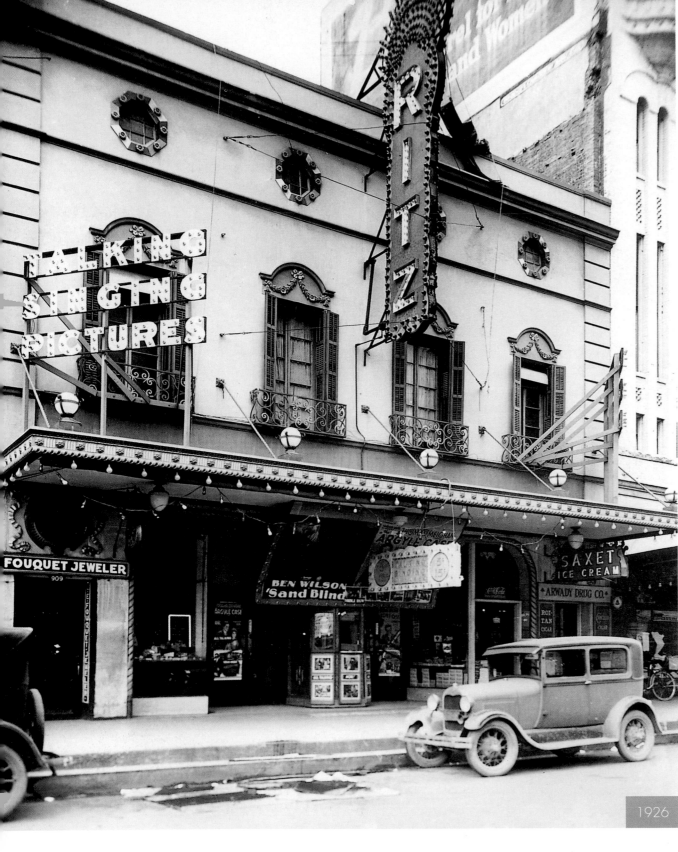

1926

RITZ THEATER
The only vestige of the silent movie era left in town

LEFT: Originally known as the Ritz Theater, this lovely showplace was one of several downtown theaters offering Houstonians a diversion from the daily grind. When it launched, films were still silent and the venue promoted a mixture of silent cinema and live stage performances. Owned by Stella and Lillian Scanlan, the theater held its grand opening on April 15, 1926. The movie feature for the evening was *The Fighting Buckaroo*, starring Buck Jones. Also on-hand to entertain was Miss Le Moyne Veglee, who was promoted as a "Dare Devil Girl Movie Performer." The theater seated 1,260 moviegoers. Admission was 15 cents for one adult. For decades, the Ritz Theater was modestly promoted and provided casual, low-key shows to countless Houstonians. In 1930, the movie house changed management and became part of a larger chain. During the 1940s, the theater actually started running exclusively Spanish language films. It even changed its name to Teatro Ritz, and then Ciné Ritz.

RIGHT: The Theater's name was officially changed to the Majestic Metro in the 1970s. In 1984 it closed its doors. While it wasn't the grandest of Houston's early cinema gems, it is one of the few of its kind to dodge the wrecking ball. In fact, the Majestic Metro is the only extant theater from the silent film age to survive in town. The Metropolitan, Majestic, and Loews theaters, all more famous and upscale in both buildings and billings, were razed by 1970. In the mid-1980s, a local businessman bought the lovely old Majestic Metro and pushed for its restoration to former glory. When the bottom fell out of oil prices the project was put on hold. But on December 15, 1990 the Majestic Metro once again opened its doors to host a corporate party (for Merrill Lynch, actually). Ever since, the Majestic Metro has served as a popular venue for company parties, wedding receptions, and other special events. It's even had a number of classic movie screenings in recent years.

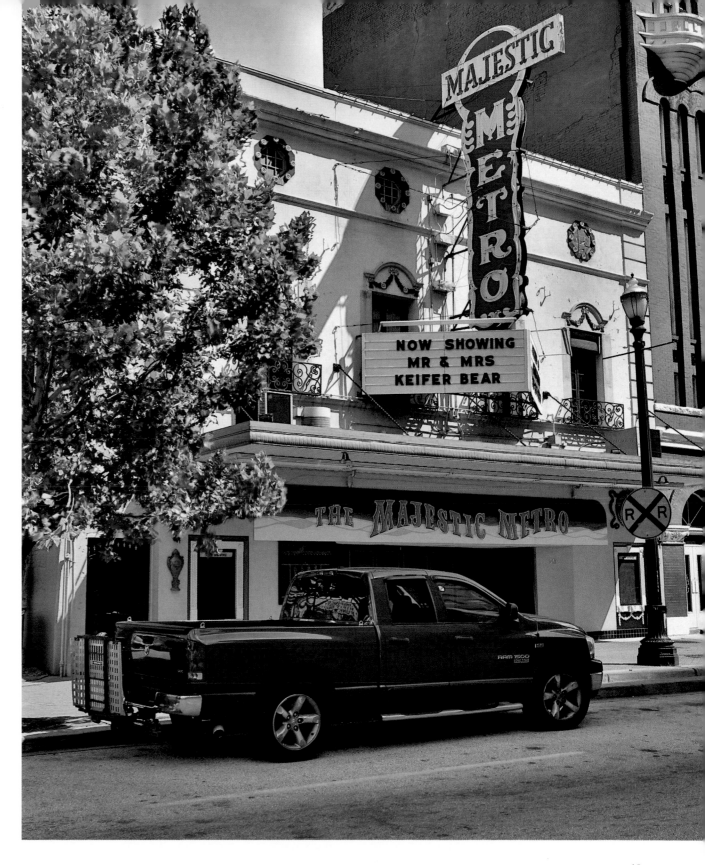

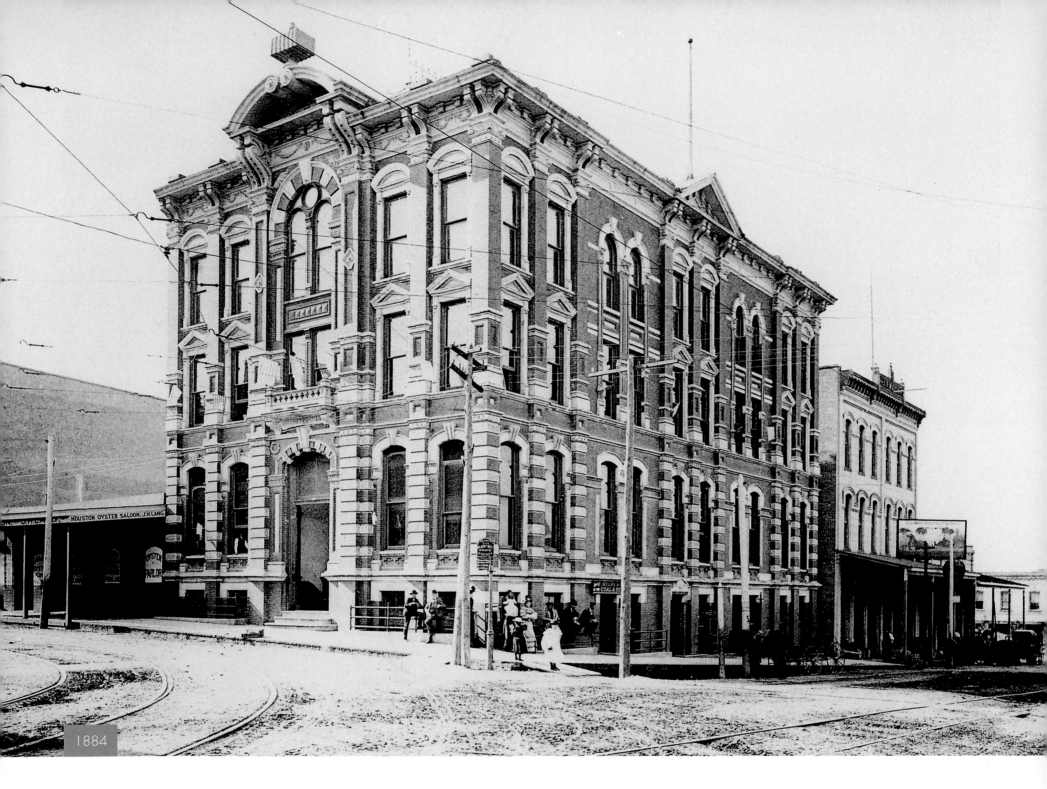

1884

OLD COTTON EXCHANGE

When cotton was king, this is where it held court

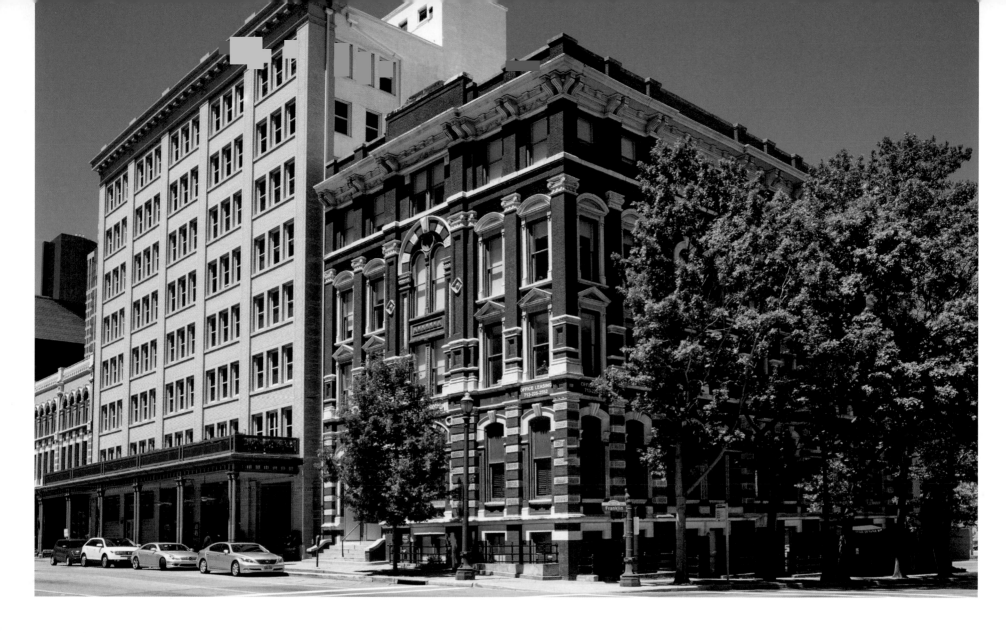

LEFT: Oil put Houston on the map, but cotton was the main source of income for its earliest citizens. Cotton was good business in Texas from the 1820s; by the time the War Between the States came around, Texas exported around 100,000 bales annually to Europe. After the war, it was apparent that Texas needed to make more of an effort to regulate cotton trading. The exchange as a business entity was formed in 1874. Houston was a prime spot for buyers and sellers of this global commodity, and the Houston Cotton Exchange at Travis and Franklin was where its fortunes were harvested. The handsome Victorian Renaissance Revival structure was completed in 1884 and designed by Eugene T. Heiner. Prior to the project's design, Heiner toured cotton exchanges nationwide to research the best examples. The red Philadelphia brick building sported a crowned bale of cotton made of zinc above the entrance—a reminder that cotton was king.

ABOVE: The old Cotton Exchange building has weathered the years well, all things considered. A fourth floor, which wasn't part of the building's original plan, was added in 1907. The building also underwent an extensive remodeling at that time, with the trading floor moved down to the ground floor and outfitted in a style suitable for captains of industry. The building had a good, long run as the center of cotton in Houston but in 1924 the organization moved to a new building; a modern, sixteen-story affair at the corner of Prairie and Caroline. Today, the boll weevil has driven most cotton production away from the Houston area and into places like West Texas. The old cotton exchange building was restored as an office building in the early 1970s. Today it's now chic commercial space for a variety of tenants, from a law firm to a bar.

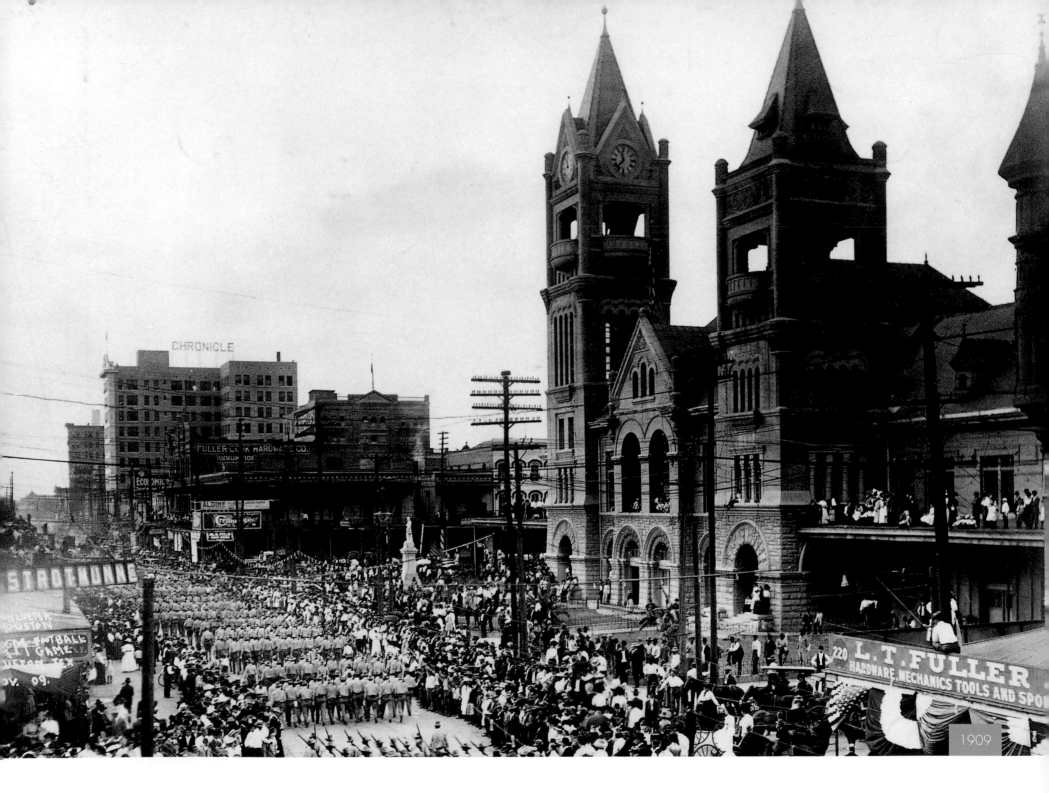

1909

CITY HALL AND MARKET SQUARE
The great clock lives on as a reminder of the old City Hall

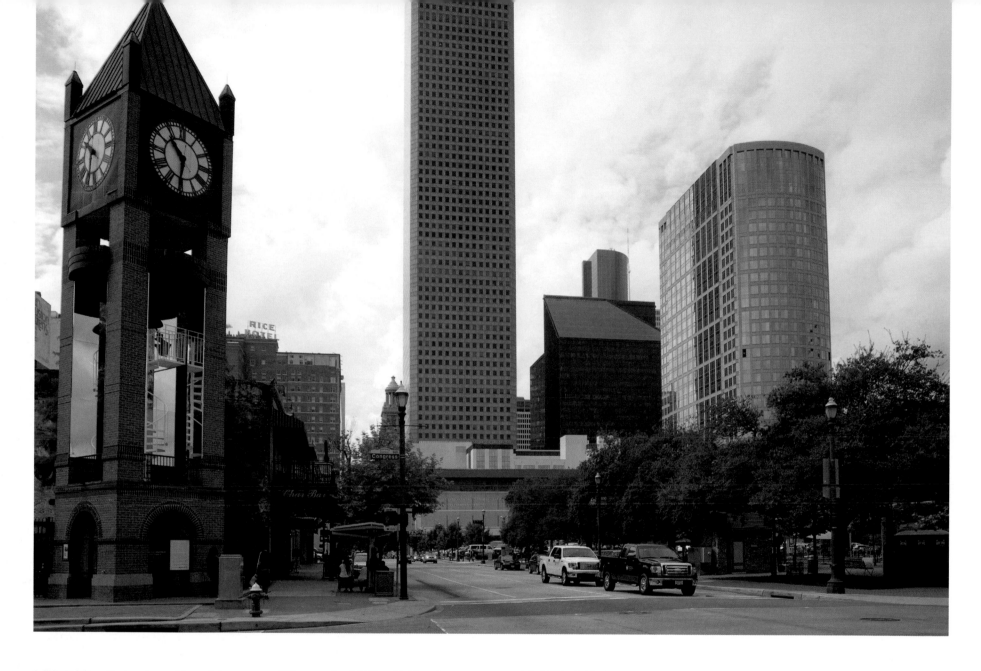

LEFT: The distinctive tall, gothic towers of Houston's old City Hall and Market Square complex were completed in 1904. Located at Travis Street and Prairie Avenue, the complex was surrounded by fish markets, vegetable stands, and butchers. This was actually the third such building that held court in Old Market Square. The first burned down in the 1870s. The second burned down in 1904, replaced by the structure you see here. By the 1920s the City of Houston, and the municipal government bureaucracy that accompanied it, had grown so much that the building had become impractical as an administrative center. The statue in front was of Confederate hero Dick Dowling, and the crowd seen marching in the square consists of Texas A&M cadets in town for a football game against their archrival, the University of Texas.

ABOVE: Official plans for Houston to build a new, modern City Hall got underway in the late 1920s. The new City Hall was completed in 1939 on Hermann Square. With the new facility up and running, the 1904 City Hall was converted into a bus terminal for Market Square shoppers. After yet another fire in 1960, the whole complex was razed. Today Market Square is a park. When the grand old 1904 building was torn down, the huge clock adorning one of its towers was dismantled and placed in storage. Eventually it wound up in a local junkyard, where it was sold without the city's knowledge and installed in a park in a sleepy little East Texas town called Woodville. When Houston city administrators were made aware of the old clock, they asked for it back. Today, a new tower at Market Square has been constructed for it (on the left).

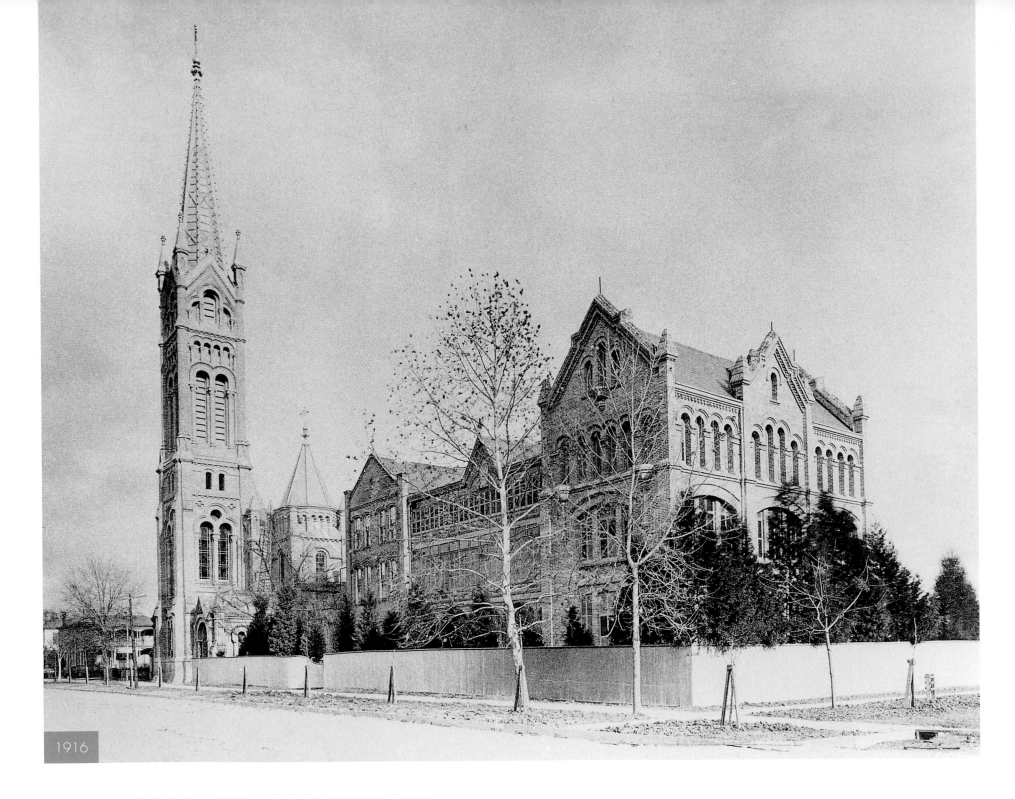

1916

ANNUNCIATION CHURCH
Bricks from the old Harris County Courthouse were used to build this architectural gem

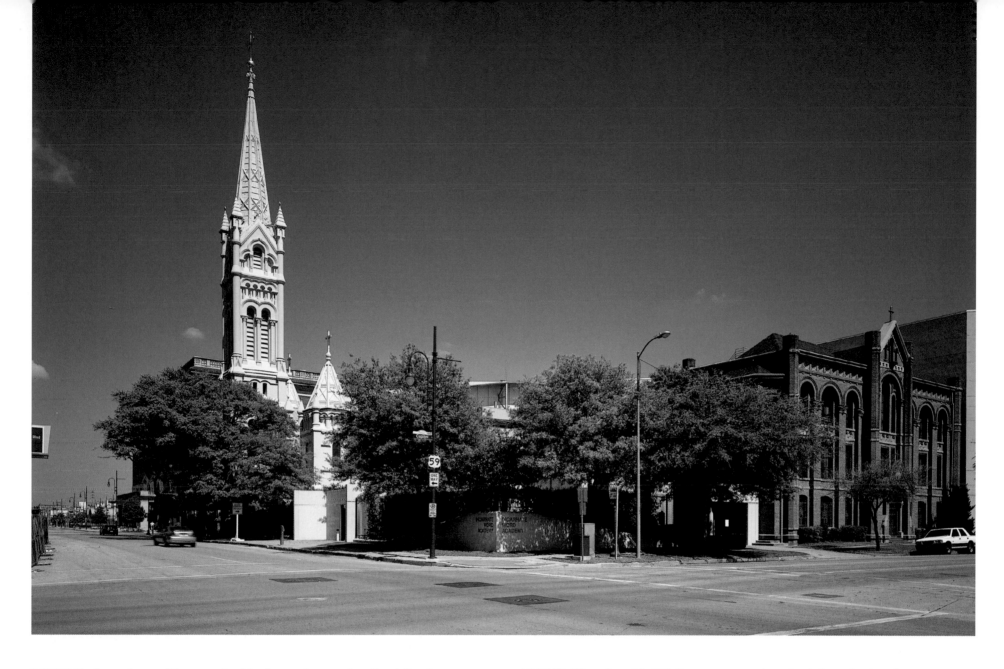

LEFT: Early settlers to Texas under Mexican rule were legally obliged to convert to Catholicism. Originally called St. Vincent de Paul, the Annunciation Parish is Houston's oldest extant Catholic congregation. The European-style Gothic building at Texas and Crawford was designed by Nicholas Clayton, a prominent Irish-born architect from Galveston who also designed the island's famous Bishop's Palace mansion. Annunciation Church was built of bricks salvaged from the old Harris County Courthouse, and officially dedicated September 10, 1871. A bell tower was added later that year, as well as two smaller towers in 1884. As the Parish grew, a number of additions and amenities were made over the years, including an exterior refurbishment in 1916, a Pilcer pipe organ in 1924, and air conditioning in 1937.

ABOVE: The church's 175-foot tower was knocked down in the disastrous hurricane that struck the area in 1900. The storm also completely ravaged St. Joseph's Church in Galveston, which, although restored, transported its original bell to the Annunciation Church following the storm. Annunciation's iconic tower was quickly rebuilt and has been a consistent spiritual symbol for Houstonians. Today Annunciation Church stands as the oldest original church building in town. Minute Maid Park is just visible beyond.

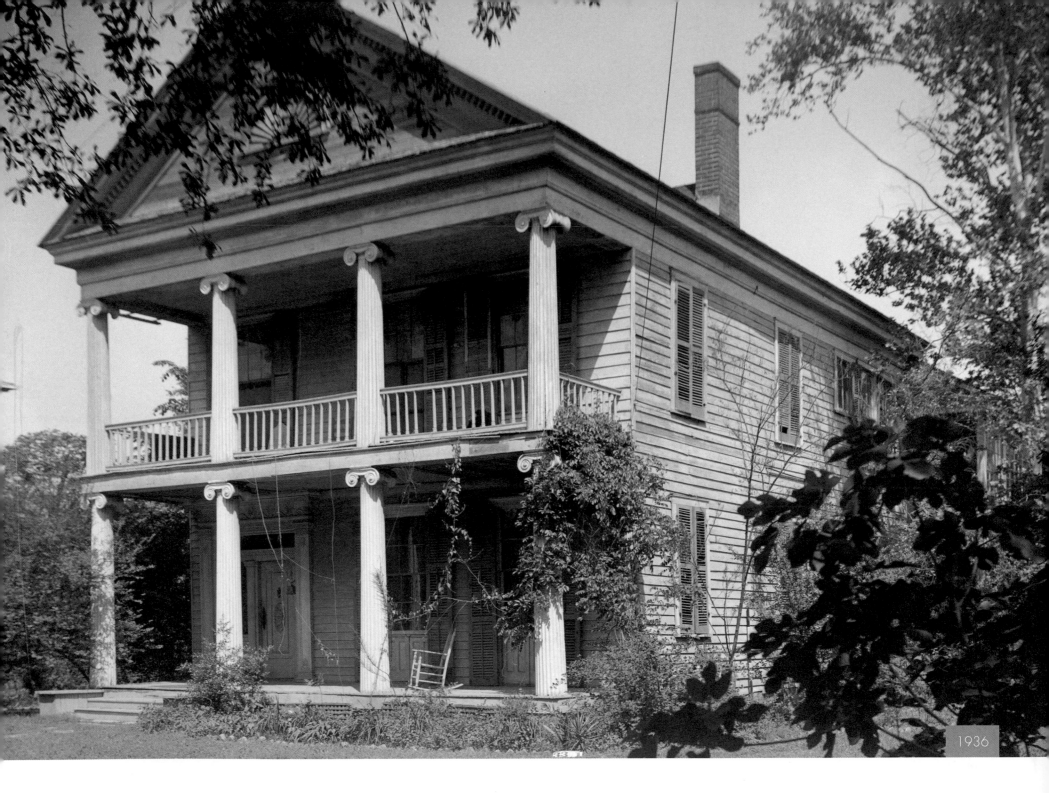
1936

SAM HOUSTON PARK

Helping preserve Houston's architectural heritage

LEFT: The city's first formal, centralized park opened in 1899 when Mayor Sam Brashear bought the property to create what is now Sam Houston Park. Brashear's intention was that it "remind Houstonians of the days when Texas had a president instead of a governor, a congress instead of a legislature." The committee that designed Sam Houston Park laid out the twenty acres like a Victorian-style village, with an old mill complete with a lazy stream. The endeavor was taken seriously and the park was adorned with lavish landscaping, walkways, a rustic bridge, and a fountain. A number of historical homes have been preserved at the park, including the Nichols-Rice-Cherry House (left) which was moved from San Jacinto Street and photographed in 1936. Over the years, progress threatened the park and its charming old buildings. As the city grew and grew, more old homes fell to the wrecking ball.

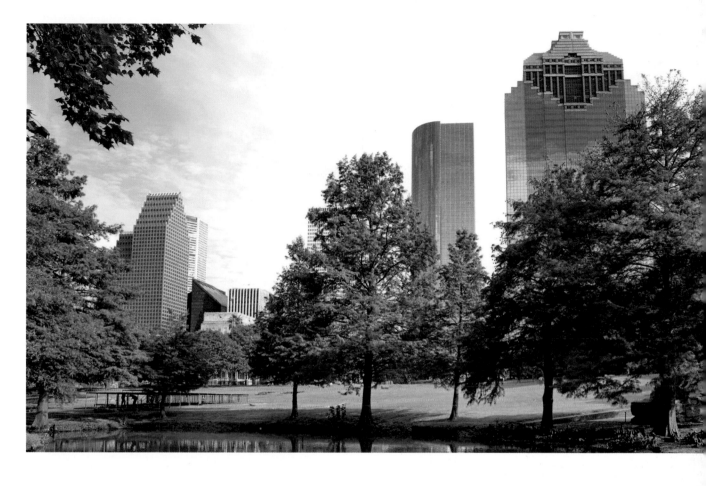

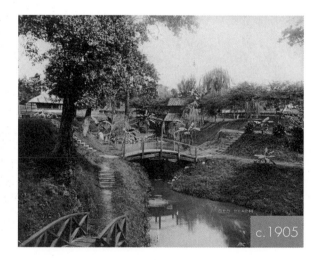

ABOVE This photo shows what was called the Old Park Mill. It provided a needed respite in what was at the time a bustling city of around 40,000 people.

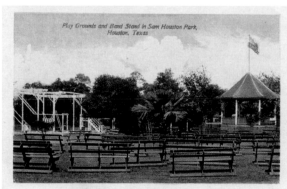

ABOVE A postcard showing the original band stand and the children's playground.

ABOVE: In the mid-1950s a group of prominent Houstonians made an effort to save what they could. The Heritage Society was formed to save the Kellum-Noble House and other historic structures on site. Today the park is more pleasant than ever, showcasing eight historic Houston structures including the Kellum-Noble house and "The Old Place," a rough-hewn cabin made of cedar planks that dates back to 1823. The park recently underwent a $2 million renovation. The large skyscraper on the right is the Heritage Plaza. The skyscraper in the middle is the Wells Fargo Plaza, the tallest all-glass building in the Western Hemisphere. The reddish building on the left is the Bank of America Center.

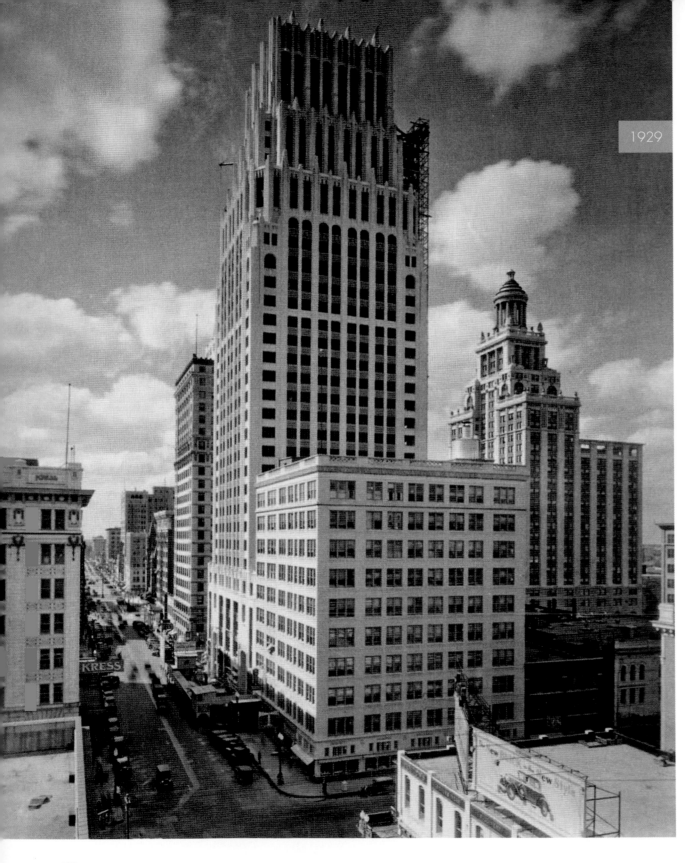

1929

GULF BUILDING
No longer displaying "the lollipop"

LEFT: This amazing structure is one of the Southwest's leading examples of the Art Deco skyscraper. Designed by renowned architect Alfred C. Finn, the Gulf Building at Main and Rusk was the brainchild of Houston industrialist Jesse H. Jones. It was completed in 1929 and stood on record as the tallest building west of the Mississippi River until 1931 (it was Houston's tallest building until 1963). The corporate headquarters of Gulf Oil, it reportedly cost $3.5 million to build. The building sports a steel frame with an exterior built from Indiana limestone. New York artist Vincent Maragliotti adorned the building's Main Street lobby with eight frescoes depicting the history of Houston and Texas. The site upon which the skyscraper was built was once the home of Mrs. Charlotte Allen, the "Mother of Houston," and wife of Houston founder Augustus Chapman Allen.

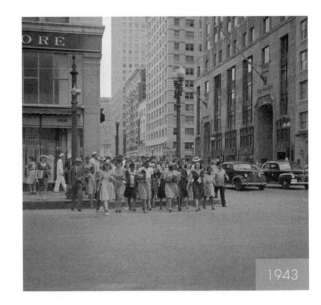

1943

RIGHT: Listed on the National Register of Historic Places, the Gulf Building no longer soars above the skyline, but its grandeur remains. It is still a wonderful example of the neo-modern style of its day. A number of interesting elements have been added over the years, including two annexes, a grand telescope on its observation deck and a heliport for the convenience of downtown oil executives. In 1960, a huge stained-glass window portraying the Battle of San Jacinto was installed. Everyone loved it. In 1966, the company installed a 53-foot orange rotating neon disk replicating the Gulf Oil Corporation's logo, known around town as the "lollipop." When the lollipop came down in 1974 many breathed a sigh of relief. The Gulf Oil Company died in 1985, when the company merged with Standard Oil of California and both rebranded under the Chevron name. Now known as the J. P. Morgan Chase Bank Building, the old Gulf Building is still a brilliant, elegant sight at night (if you're not trying to drive through construction).

LEFT A street view of pedestrians with the entrance to the Gulf Building beyond and the Kress Building to the left. It was taken by O.W.I. (Office of War Information) photographer John Vachon in 1943.

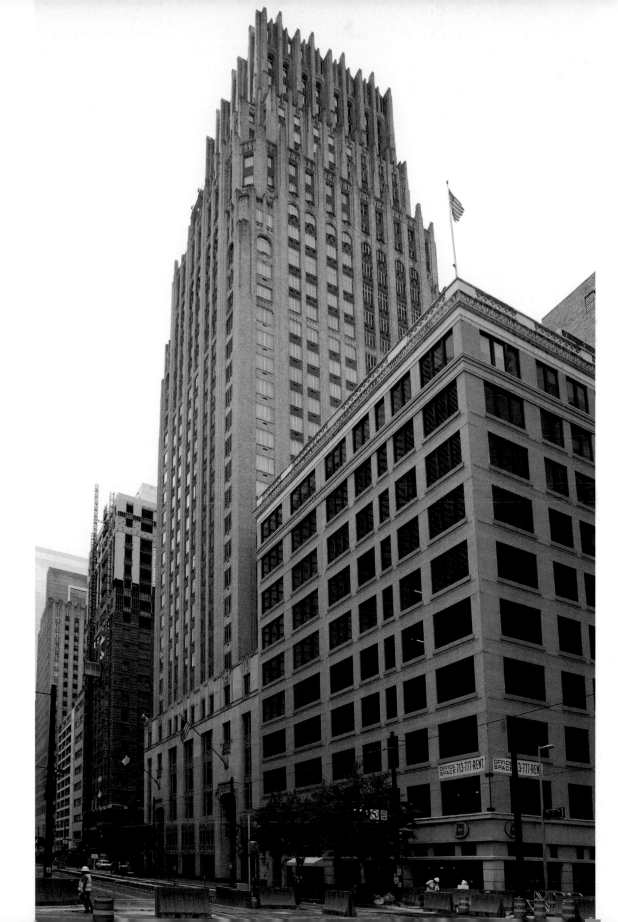

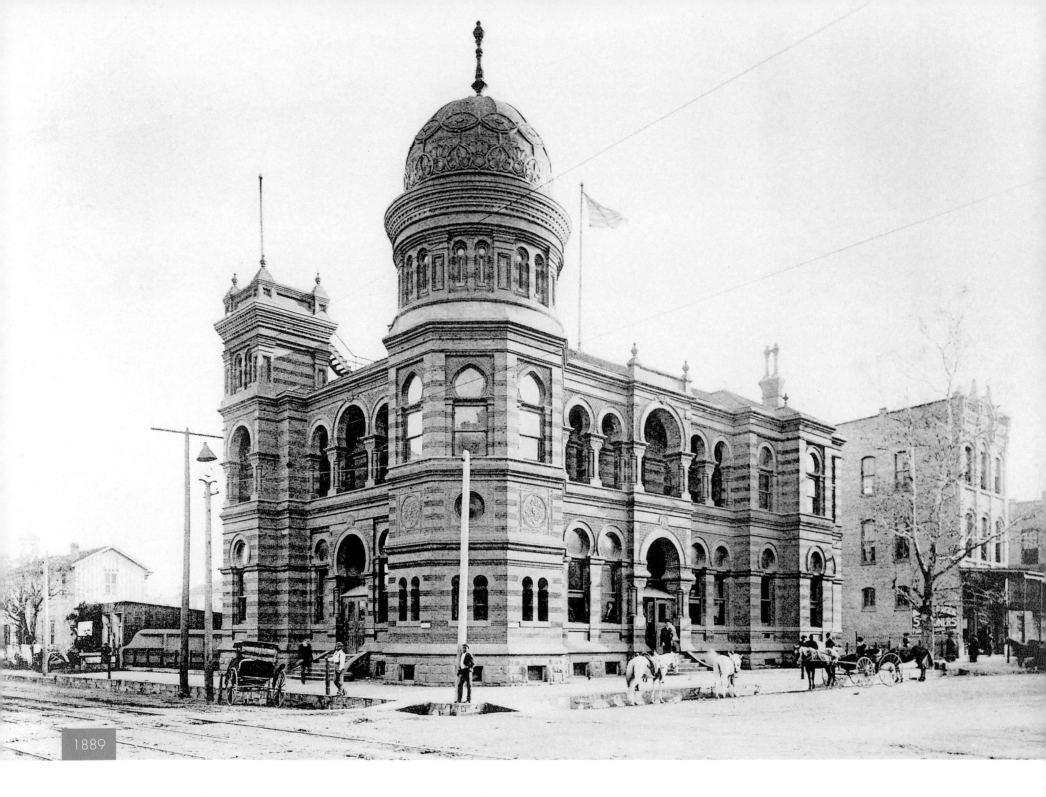

1889

MOORISH FEDERAL BUILDING
This exotic building was dreamt up under the auspices of the U.S. Treasury Department

LEFT: Completed in 1889, U.S. Treasury Department architects designed this Moorish Federal Building, which housed a post office and federal courthouse at Fannin and Franklin. The project's architect was George E. Dickey, who also built the original Capitol Hotel on the site of the provisional capitol of the Republic of Texas. Houstonians didn't really know what to make of the unusual design. Dickey was originally from New Hampshire. His reasoning was that Houston's warm climate seemed to suit such a design, thinking the locals might appreciate this type of architecture reminiscent of the Middle East or North Africa. Many rolled their eyes at the idea, thinking the logic behind the design presumptuous. The building cost $75,000 to build and completion took around two years altogether. Though some found the design attractive and exotic, many felt that it was perhaps a bit too attractive and exotic given its duties as a government administrative center in a city still in economic recovery from the Civil War.

RIGHT: While yesterday's architects may have overstated the association between warm climates and the citizens' proclivity toward Moorish architecture, today's Houstonians would have probably cherished that old distinctive structure. When the new 1911 Post Office and Customs Houston was completed in 1911 at 701 San Jacinto Street (still standing), the old, exotic-looking Moorish building was demolished, not even having seen 30 years of service. The old Moorish Federal Building's site is today occupied by the low-key headquarters of the Harris County District Attorney's Office.

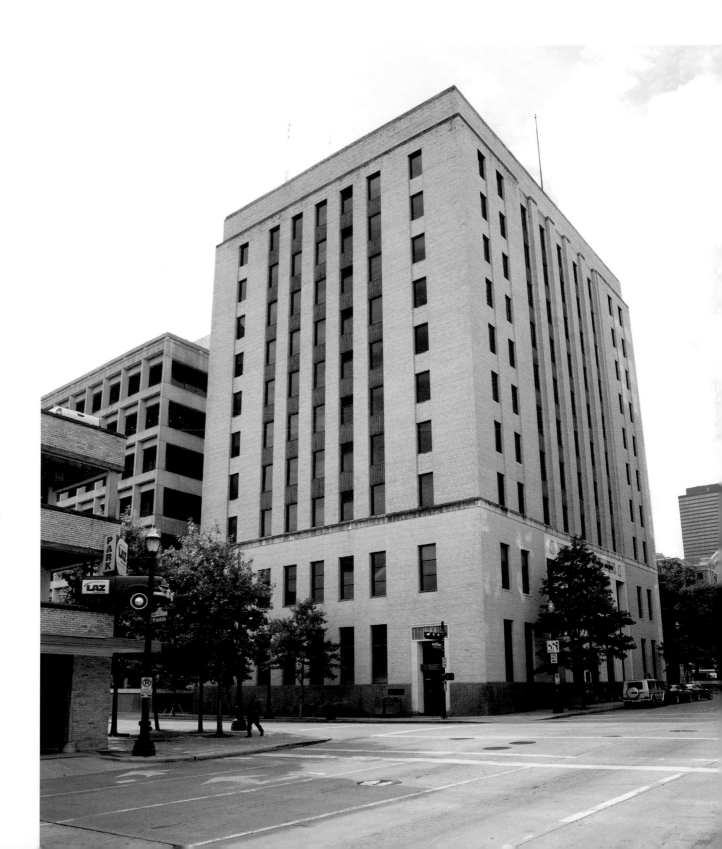

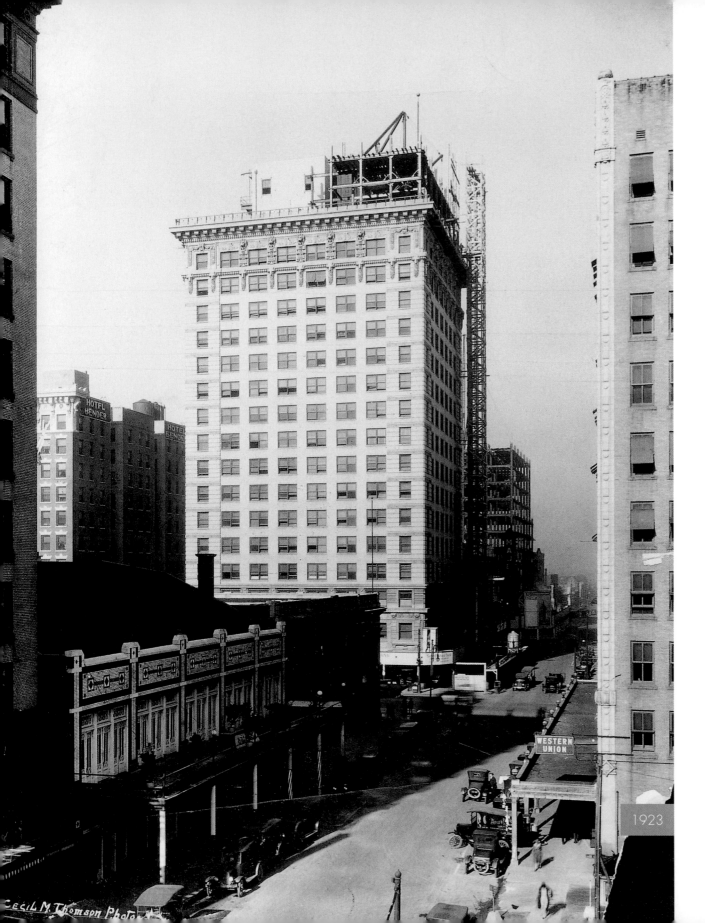

1923

CECIL M. Thomson Photo

CARTER'S FOLLY
Sixteen stories proved not enough for
Samuel Carter who wouldn't be trumped

LEFT: Alabama-born Samuel Fain Carter
was a self-made lumber king from East Texas
who worked hard and dreamed big. His vast
lumber interests led him to shift his focus from
lumber to banking, organizing what would become
Houston's Second National Bank. People mocked
him when he announced plans for a sixteen-story
building to house the bank. Carter hired a popular
architecture firm out of Fort Worth, Sanguiney &
Staats to design the building. The tallest building
in town at the time was the eleven-story Scanlan
Building at 405 Main. His undertaking came to be
known as "Carter's Folly," because in 1910 the
consensus was that bricks could not be stacked
that high. At 806 Main Street, "Carter's Folly"
was completed in 1910—officially the tallest
building in town. The party didn't last long,
however, as Carter's uncle, Jesse H. Jones, built
the seventeen-story Rice Hotel that same year
on the site of the first Texas capitol at Main and
Texas.

RIGHT: Carter felt the need to top his uncle by adding six more floors to the building in the 1920s. But while the focus was on the "space race" for the tallest building at the time, perspective lets us appreciate what a fine building the Samuel F. Carter Building truly was and is. Every floor was adorned with handsome marble and every conceivable modern convenience, from electric fans to cold water fountains. As the years went by, the building's exterior was encased in steel and concrete to make it more "modern." In 2013, a deal was struck to restore the old twenty-two-story building, which had been largely vacant. The plan for the property was to redevelop it into a luxury hotel, removing the "modern" panels and reverting to the building's original historical look and feel. You can see the stripped down façade in progress. A public-private partnership is currently hard at work on the $80+ million project to convert the 102-year-old property into a J. W. Marriott. The hotel is slated to open in 2014.

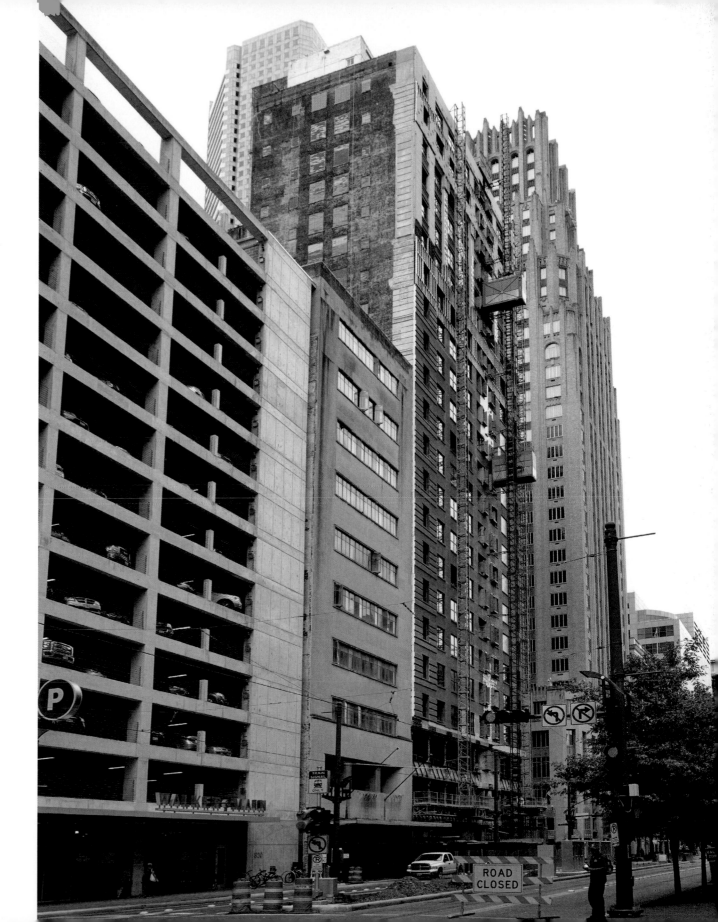

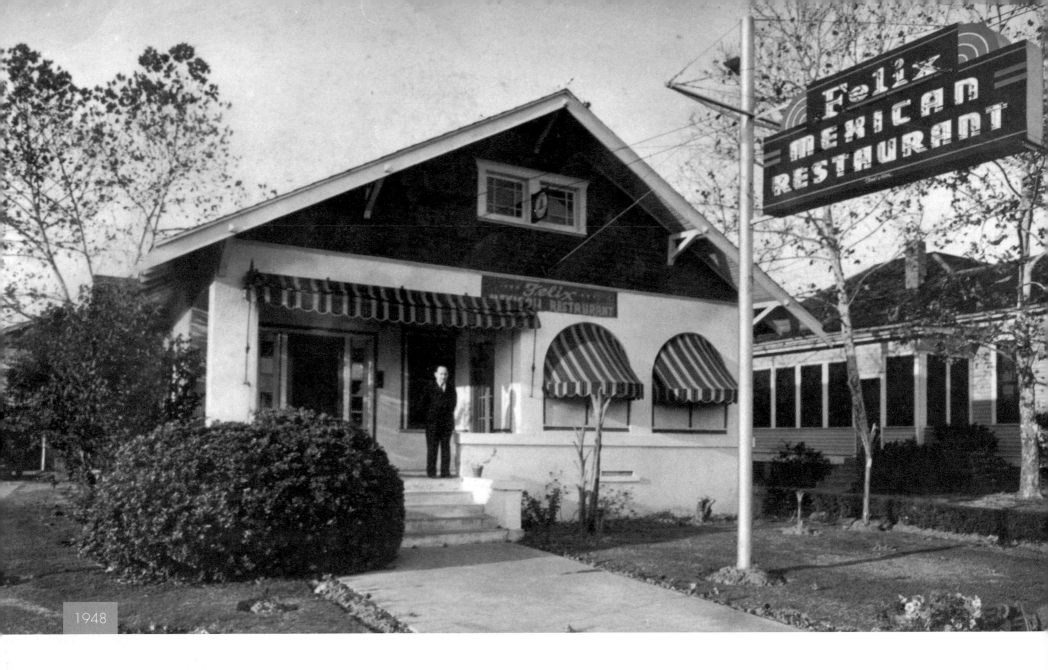

1948

FELIX MEXICAN RESTAURANT

A generation of Houstonians grew up on Felix's Tex-Mex food

ABOVE: Having once been a part of Mexico, it stands to reason that Texans eat a lot of Mexican food—and put their own Tex-Mex spin on it. The restaurant's namesake was Felix Tijerina, a Mexican immigrant who came to Houston with both a dream and a sizzling-hot work ethic. Tijerina spent a little time working at a restaurant, getting the hang of it. Like many "overnight successes," he spent a decade learning his trade. He opened Felix Mexican

Restaurant's original location in Montrose in 1937. At its peak in the early 1970s, Felix had six locations in Houston and one in Beaumont. Legend has it that Tijerina got the start-up capital he needed when his wife, who liked to gamble, got an unexpected bonus from her boss and put it down on a horse. Dinner at Felix was less than a buck, and included all of your Tex-Mex favorites.

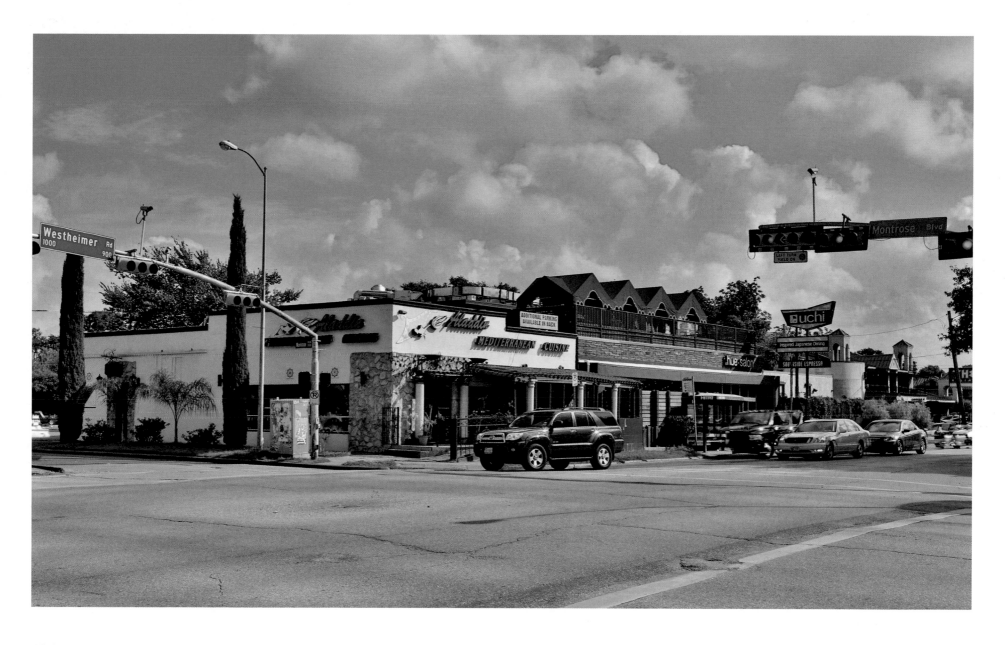

ABOVE: Felix Tijerina passed away in 1965, leaving Janie Tijerina to take over the business. Over the years, the concept of Tex-Mex with community-wide appeal became less novel and competition increased. Despite its role as a Houston institution, other competing family enterprises such as Ninfa's and Molina's, as well as hordes of authentic family restaurants, were on the rise all over town. The business couldn't compete. One by one, Felix locations closed their doors. The Last Felix Mexican Restaurant, located in Montrose and shown here, closed in 2008. The community was shocked. Houstonians grew up on Felix food. The property is now part of a new restaurant, Uchi (you can see the sign on the far right). It's a contemporary Japanese restaurant that's drawn praise from national restaurant critics. As of this writing, the old Felix sign showcasing a man in a sombrero sleeping against a cactus was up for auction. The new owners of the building were selling it and donating the proceeds to the League of United Latin American Citizens (LULAC).

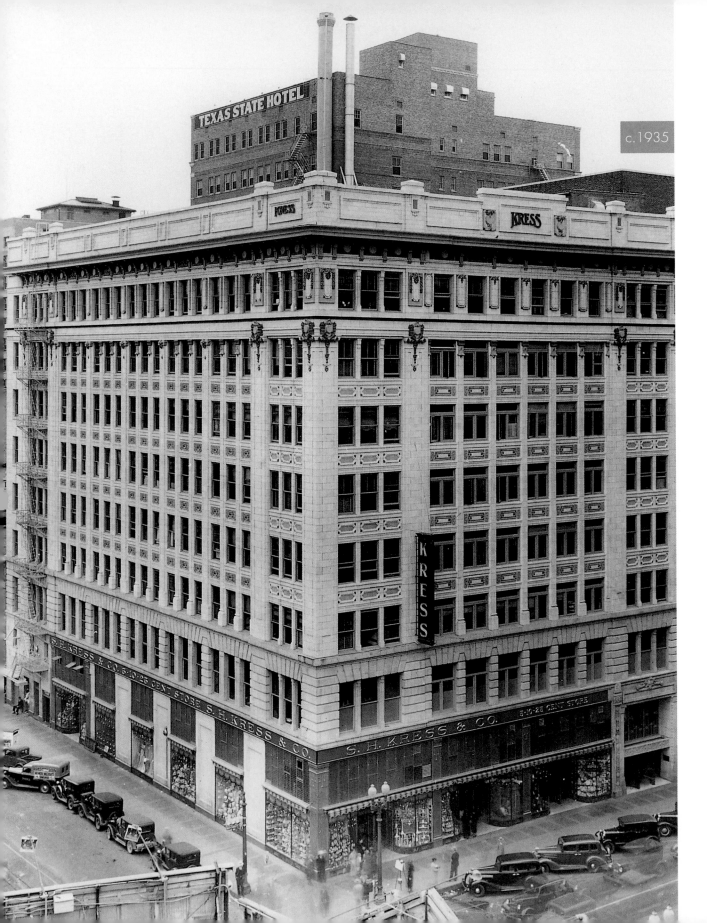

c.1935

KRESS BUILDING
The Kress building was a place to meet friends as well as shop

LEFT: S. H. Kress & Co. was a chain of five-and-dime stores that built standardized, stylish storefronts in downtowns across America. Samuel Kress was a man who really appreciated art. He had a private collection and also insisted that the company have its own in-house architectural staff. They took great pride in designing buildings not just for their function but for their aesthetics and potential as community favorites. More than just places to purchase soap or cigars, they were designed to be social places as well. Their slogan at one time was "Meet Your Friends at Kress." The soda fountain and candy counter were among the store's main attractions. The Houston branch was at Main and Capitol, and was built in 1913. Kress built stores all over the South, but this was the first Texas location. The store itself was in the basement and ground floor. The store's administrators occupied a few other floors, and random tenants rented the rest—including the Gulf Refining Company, which rented the entire eighth-floor penthouse for years.

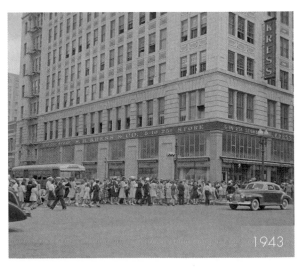

1943

RIGHT: Kress got in early on the downtown department store craze. Today, the whole concept of the dime store as social center—and the department store as a sustainable retail model—has fallen out. Downtown Houston real estate is so prime, you'd have to sell an awful lot of soda and candy to stay afloat. In 1983, the old Kress Building was renovated as the St. Germain Lofts at 705 Main. These beautifully remodeled lofts and flats sport a rooftop deck, billiard parlor, theater room, and other urban luxuries. Downstairs, the Flying Saucer offers a relaxing atmosphere where one can enjoy the finest beer and cigars. The building no longer sports the Kress name but its thoughtful, nostalgic design has made it a Main Street favorite. A philanthropic foundation bearing his name also donated a number of pieces of priceless art to the local Museum of Fine Arts.

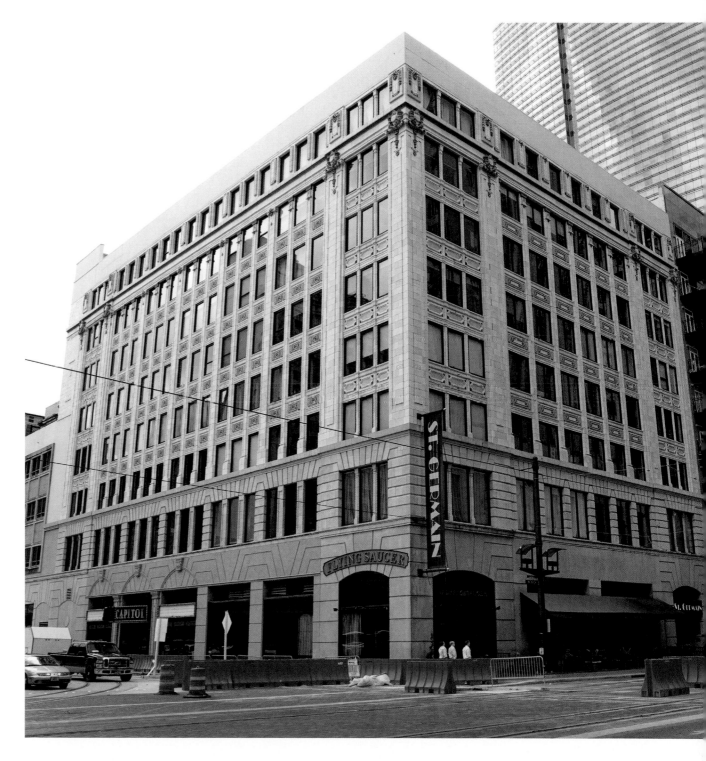

LEFT A street view of the Kress building taken in 1943.

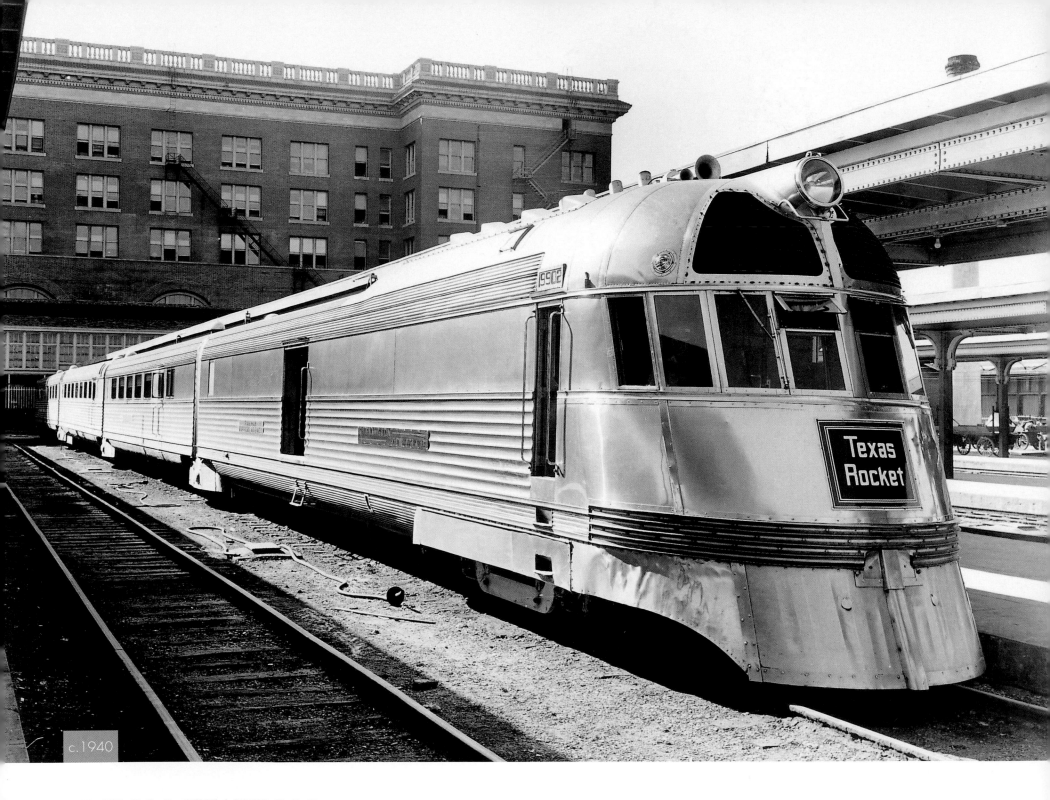

c.1940

UNION STATION

Houston's association with 'space' travel dates back to the late 1930s

LEFT: The original Union Station in Houston was built in 1880 and former president U. S. Grant was in town for the station's opening. The more contemporary iteration of Union Station shown here was completed March 2, 1911. The facility was designed by Warren & Wetmore, who were also the architects behind New York's Grand Central Station. At the corner of Crawford and Texas, the project cost $500,000 dollars and drew a crowd of around 10,000 people on the day it opened. The station had a number of amenities including a "Harvey House" restaurant, which opened in 1911 and closed in 1948. The Harvey House was a welcome sight for weary travelers in the bayou city; it served its meals on fine china and a necktie was required of all gentlemen. The Texas Rocket, owned by the Burlington-Rock Island Railroad, ran between Dallas and Houston in the late 1930s. Its counterpart, the Sam Houston Zephyr, also shuttled passengers between the two cities.

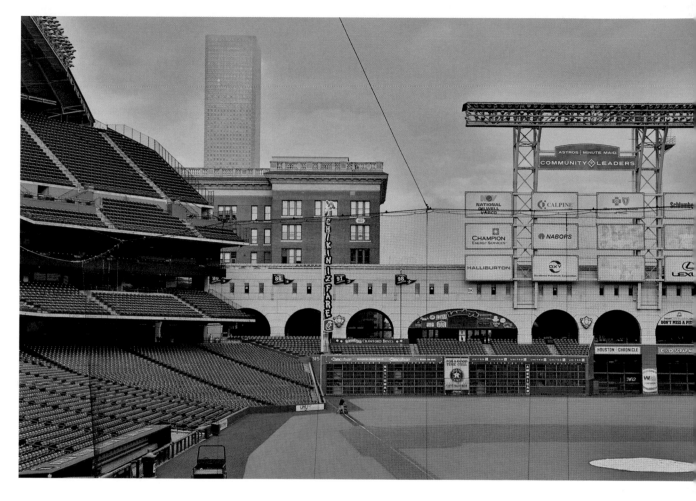

BELOW A commemorative modern plaque marks the site's former use.

ABOVE: Today the only rockets at Union Station come from the pitching mound. In the 1960s, all across America, passenger trains declined in popular use. Cars were becoming more affordable, bus travel was being aggressively promoted and adopted and air travel for both leisure and business travel was becoming more common. By the 1970s, you were hard-pressed to find a passenger train to take you anywhere. The last train left Union Station in 1974, a sad day for a building once so vital to so many Houstonians. In 1999, the facility was renovated into what was at the time a new baseball park called Enron Field— the $100 million, 30-year name sponsorship being an obvious win-win for all parties. Following a corporate glitch at Enron, the stadium came to be known as Minute Maid Park, home of the Houston Astros (you can see some of the new sponsors back in the outfield). The old terminal buildings are used for administration and the team store. Minute Maid Park seats over 40,000 under a retractable roof. Its first game was an exhibition between the Astros and the New York Yankees on March 30, 2000.

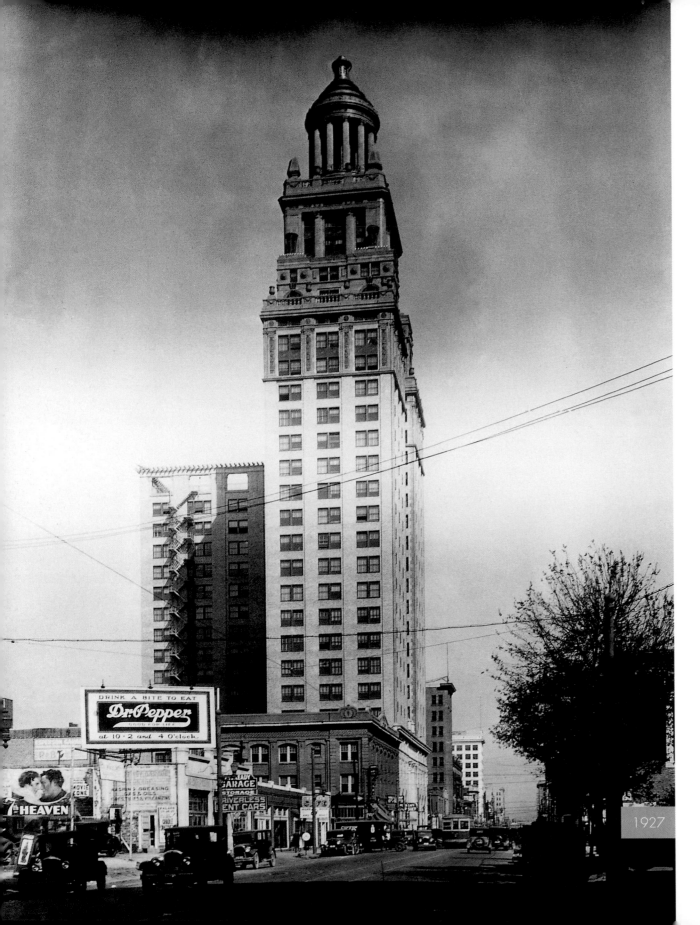

1927

ESPERSON BUILDINGS
The Neils is taller than the Mellie

LEFT: Niels Esperson was born in Denmark, eventually migrating to Houston with hopes of striking "black gold"—and he did. The Humble oil field made him millions, which he quickly diversified into a number of ventures. Esperson dreamed of building a skyscraper at Travis and Rusk, but died in 1922 before he could follow through. His widow, Mellie, built it for him in 1926, naming the beautifully ornamented skyscraper in his honor.

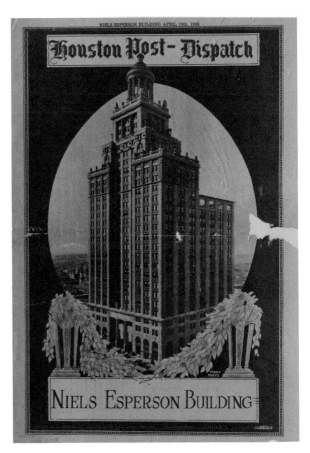

RIGHT: In 1928, Mellie Esperson sold the building with the condition that its name would not change. The buyer eventually defaulted on the mortgage and she bought it back for seventy-five percent of what it had cost her to build. In 1941, she completed the Mellie Esperson Building next to (but shorter than) her husband's. The Niels Esperson Building's detail and six-story Grecian top make it one of Houston's most beloved architectural treasures.

LEFT: The *Houston Post-Dispatch* published this 46-page supplement promoting the grand opening of the Niels Esperson Building on April 10, 1926. It was chock-full of interior photos and also ads for the building's tenants. Page one of the booklet was a brief biography of Esperson, saying that: "He visualized the progress and development of Houston, and proved his faith in the city as a future metropolis." Esperson, like Howard Hughes, Jr. is buried in Glenwood Cemetery.

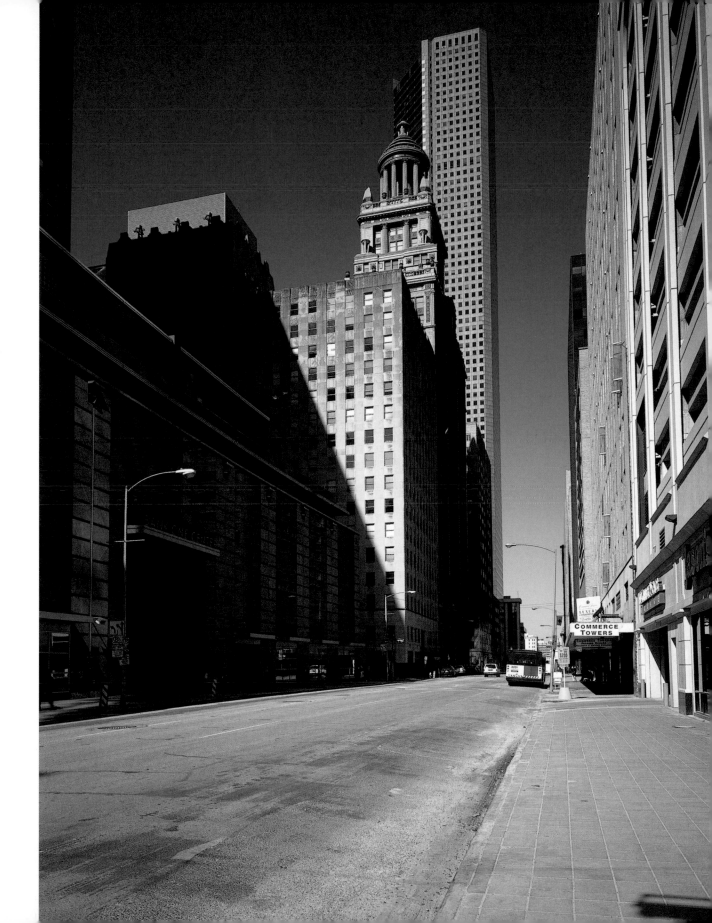

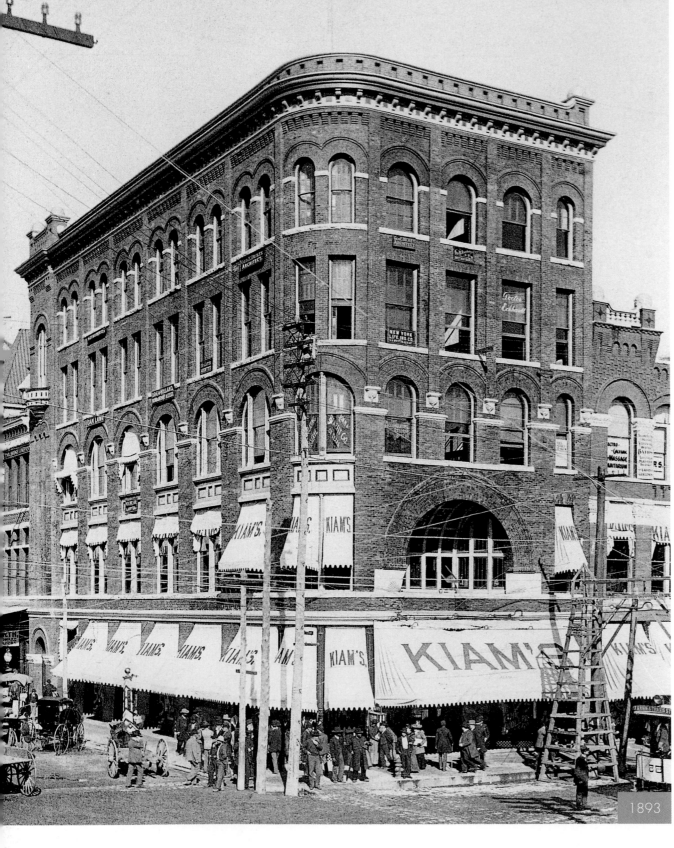

1893

KIAM BUILDING
Originally housing Houston's finest clothes store

LEFT: The Kiam Building at 320 Main, which housed Houston's finest clothier when it opened, is the city's only extant example of Richardsonian Romanesque-influenced architecture. It was completed in 1893 and was used for offices and retail space. Over 15,000 people attended the opening, which featured giveaways and a concert. This was an impressive achievement when you consider Houston only had twenty-something thousand residents at the time. Advertisements boasted, "5,000 square feet of counter space in the best lighted store in America." The building's architect, British-born H. C. Holland, took up an office for a time as an upstairs tenant of the five-story building, which upon the time of its completion was the tallest building in town. It held that title until the Binz Building was completed two years later (which had six floors and a basement). Note the small signs in each upper office tenant's windows. The building's eye-catching red brick and grand entrance alcove made it well suited for bringing in customers.

RIGHT: Alexander Kiam, the last of his family to manage the store, died in 1915 and in two years the once-grand Kiam's was bankrupt. The Sakowitz department store bought the building and occupied it until moving into the Gulf Building in 1928. The block on which the Kiam Building stands is one of downtown's most distinctive—housing the Majestic Metro on one side, and a whole row of old historical retail space including the old Stuart Building (1880) on the other. In 1879, a terrible fire destroyed half of this block. Many of these buildings came out of the resulting rebuild. Today, the Kiam Building houses Mia Bella Trattoria, a popular Italian restaurant. The beautiful building brings in hungry downtown diners all day long. And the patio is a great way to spend a lazy lunch, if you can keep the horses from nibbling your salad. Those are two of HPD's thirty-eight Mounted Patrol horses helping their two-legged partners keep the streets safe.

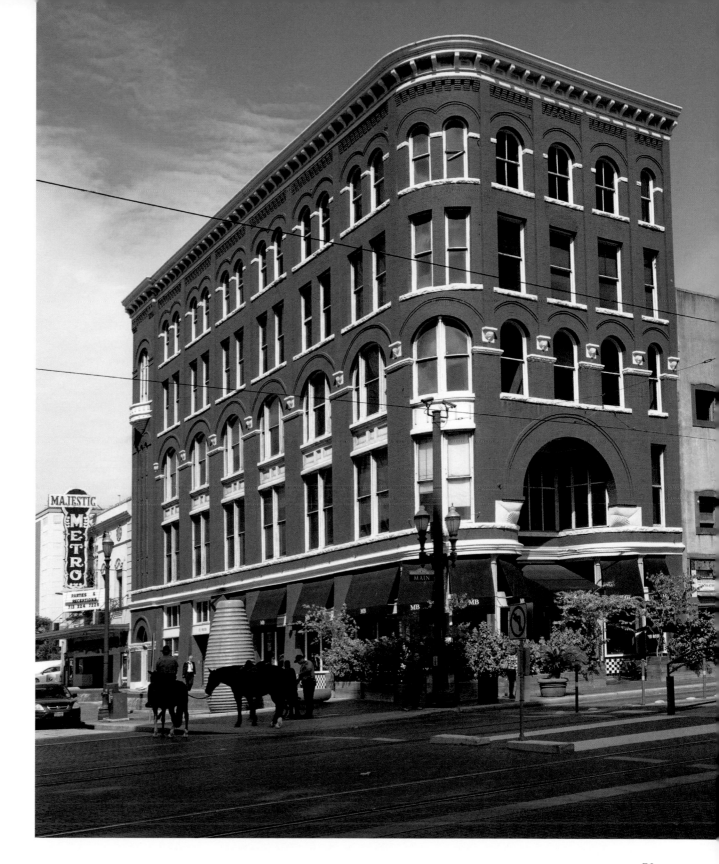

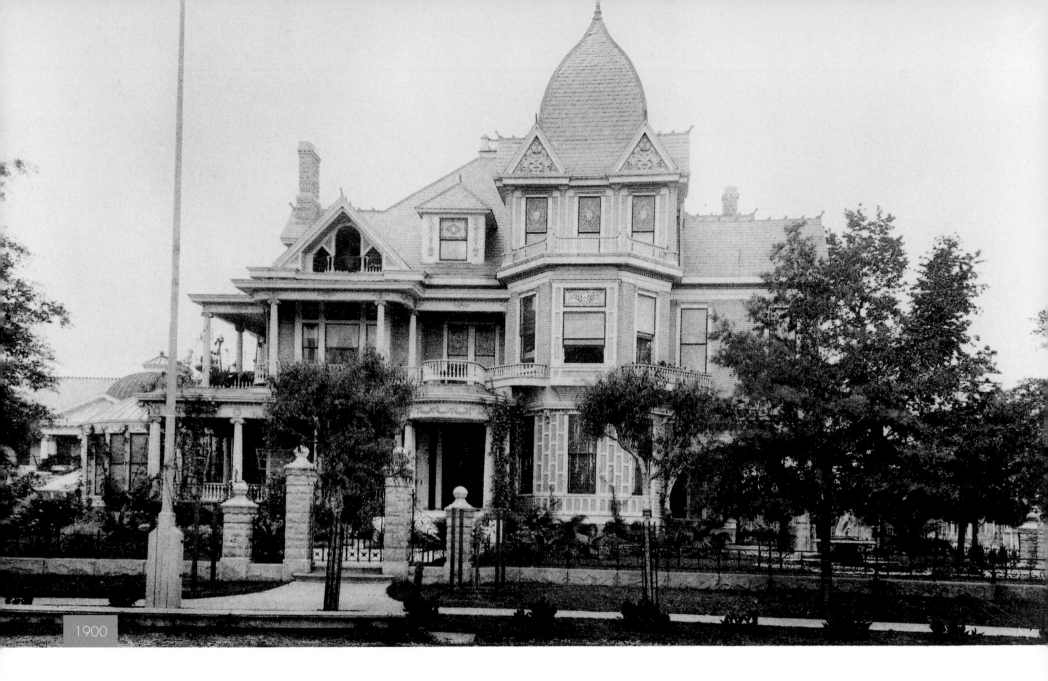

1900

KIRBY MANSION

When John Kirby made a fortune in lumber and oil he revamped his 1896 home

ABOVE: Despite the lack of a formal education, John Henry Kirby was a successful man. Like many businesspeople, both then and now, his fortunes ebbed and flowed. Kirby had a moderately successful law career, but went on to become a very successful lumber magnate. His Kirby Lumber Company at one point operated thirteen mills and 300,000 acres of East Texas pine trees. He also owned the Houston Oil Company. But having earned his money the

hard way, he was weary of spending it too pretentiously. The home Kirby originally built on this spot in 1896 was known as "Inglenook." He didn't want to tear the old place down, so instead they turned their original house at Pierce and Smith Streets into a thirty-six-room mansion. A major renovation—some called it a rebuilding—in 1926 gave the mansion its current Old English look.

74

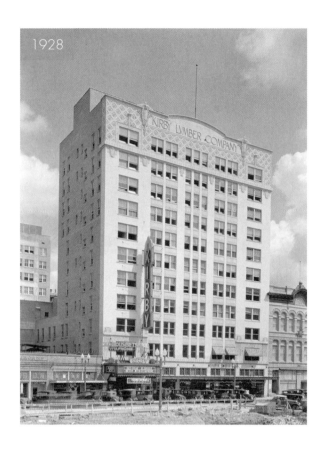

ABOVE: This is the Kirby Lumber Company building in 1928, at the 900 block of Main Street downtown. Not only did it serve as Kirby's lumber empire headquarters at the time, but it also sported its own movie theater, seen on the lower left. The old theater used a full orchestra to accompany its films, and was demolished in 1970.

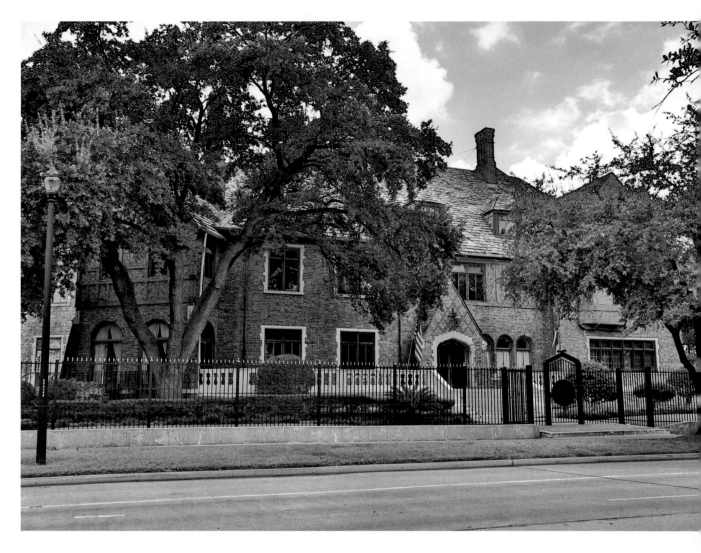

ABOVE: Architect James Ruskin Bailey masterminded the 1926 revamp, which cost Kirby a measly $350,000. Kirby went bankrupt in 1933 during the Great Depression. Kirby's wife, Lelia, sold the home when her husband died in 1940, but fortunately it has avoided demolition. In the late 1940s, it became a mixed-use commercial space. During the 1960s, the Red Cross moved in and used the building as its headquarters for a short time. It was left abandoned throughout much of the 1970s. The old dear saw a fresh renovation again in 1978, and then became home to the Gulf States Oil and Refinery Company (now Chevron) for a brief time. The old Kirby Mansion was also once home to a law office. It's one of the few old downtown mansions still standing, and the current occupants have kept it in fine shape. The Kirby Corporation (formerly Kirby Petroleum) also survives and has now reinvented itself as the nation's largest inland marine barge operator.

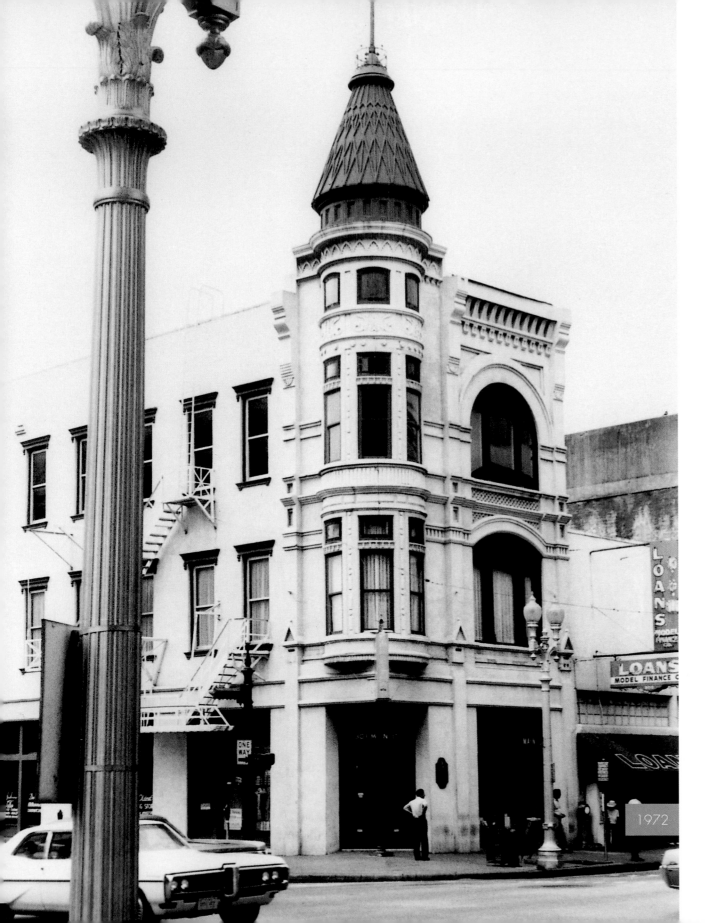

1972

SWEENEY, COOMBS AND FREDERICKS BUILDING

Surviving to the twenty-first century thanks to heritage-minded Houstonians

LEFT: The Sweeney, Coombs and Fredericks Building at 301 Main is one of Houston's few examples of Victorian commercial architecture. It's also one of only two buildings designed by architect George E. Dickey (the other is the B. A. Shepherd Building, 1883). The building is said to have been a massive remodeling of the staid, three-story 1861 Van Alstyne Building. The newly redesigned building at 301 Main—where Main and Commerce Streets come together—was completed in 1889. It was purchased by the Sweeney, Coombs, and Fredericks jewelry company—the building was in a prime spot for such a business at the time. Each of these men was a successful jeweler, and in the venture each threw in so that together they could corner the market rather than compete. Sweeney and Coombs had also gone in together to build the 1890 Sweeney & Coombs Opera House on Fannin Street. With its round turret, pilasters, stained glass, and other elaborate decorative touches, the Sweeney, Coombs, and Fredericks Building is one of the most flavorful historical buildings in Houston.

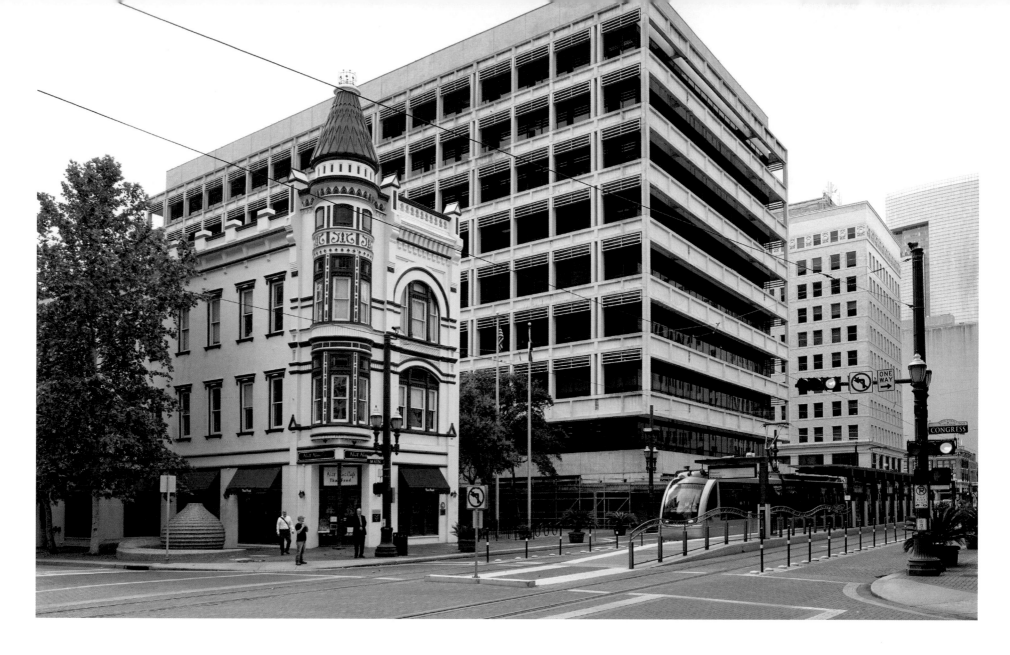

ABOVE: After its run in the jewelry business, the Sweeney, Coombs, and Fredericks Building housed the Burgheim Drug Store. The drugstore enjoyed a long life—one of the longest in Texas—in the building until the Harris County Engineering Department moved in. Today its location and visual appeal hold great potential, most recently as a restaurant. Some say it still retains pieces of the old 1861 Van Alstyne building. In 1974, Harris County made plans to bulldoze the old classic to make additional room to office its growing number of bureaucrats. Houston residents protested. The Harris County planners listened to the will of the taxpayers—modifying their plans to build their Administration Building nearby. In 1974, the Sweeney, Coombs, and Fredericks Building was listed on the National Register of Historic Places. Today, the ground floor houses Nit Noi Thai Restaurant & Cafe, one of Houston's most popular Thai restaurants.

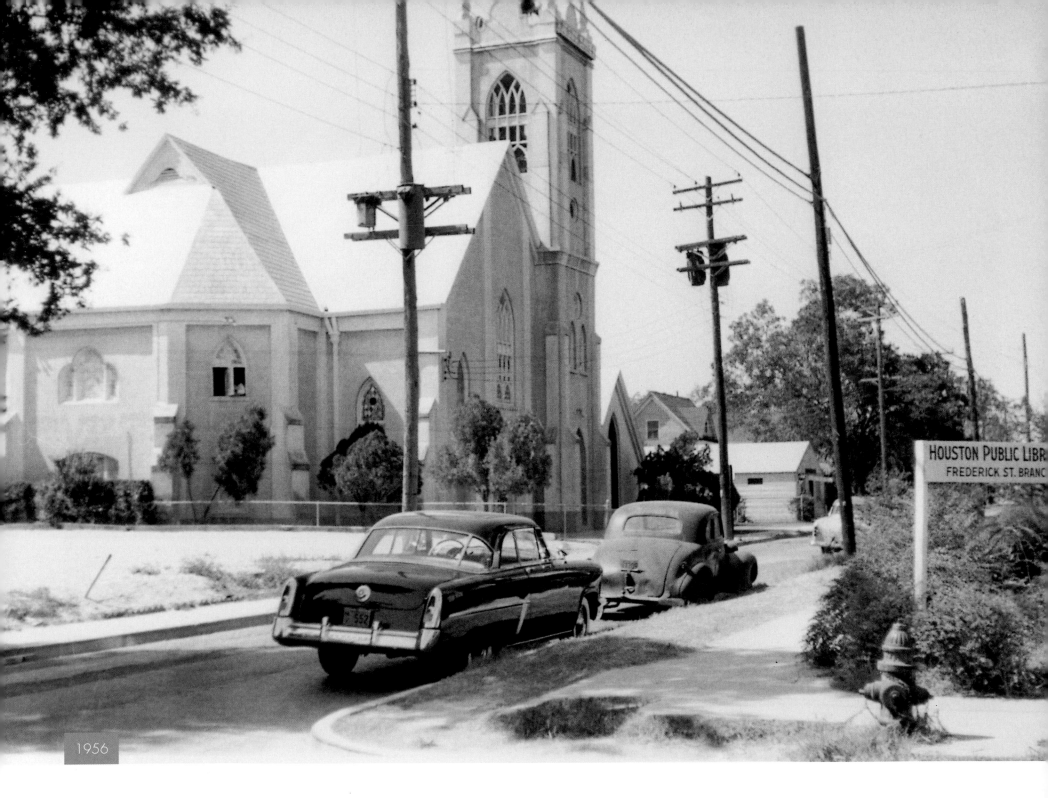

1956

ANTIOCH CHURCH
Reverend Jack Yates built a church that became the spiritual heart of Houston

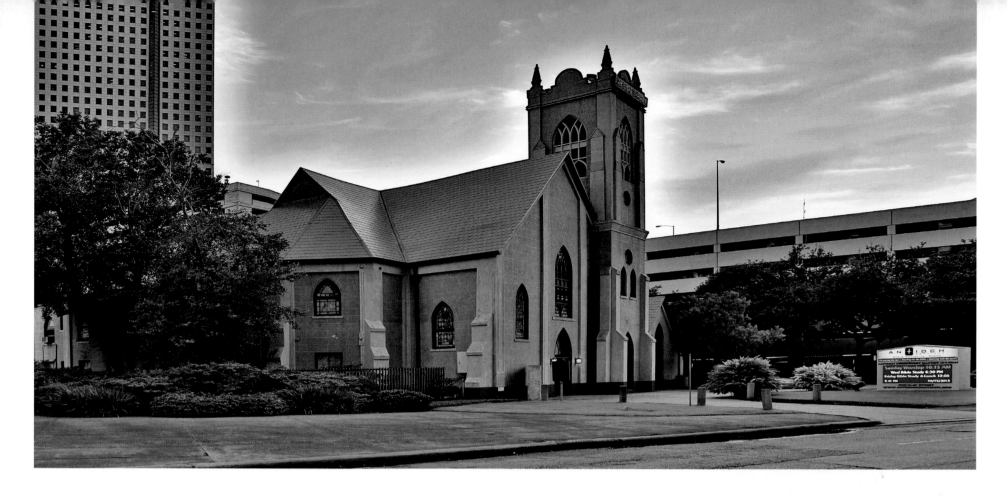

LEFT: Houston's first African-American church, the Antioch Missionary Baptist Church at 313 Robin Street, was started in 1866 just seven months after emancipation on June 19, 1865. A number of people helped to organize the congregation, including members of the local First Baptist Church and various missionaries. The group met in a nearby "brush arbor" off Buffalo Bayou, and then at what was known as "Baptist Hill" at Rush and Bagby. The congregation's first pastor was Reverend Jack Yates, a former slave. The charming red brick church at what is today 500 Clay Street was built for the congregation in 1875 by Richard Allen (completed in 1879). It was the first brick structure owned by an African-American in Houston. The church's second story was added in 1890. Once the heart of Freedman's Town, it not only gave spiritual guidance, but also provided the city's first venue for the education of freed slaves, called "The Baptist Academy."

ABOVE: Today, Antioch is an icon of African-American culture and an integral part of the city's spiritual DNA. The church received a refurbishment and expansion in 1936, which included a neon sign reading "Jesus Saves" which has become a popular landmark for the urban church. The city has grown up around its once modest congregation and community. Local mega-structures such as the rambling, multi-skyscraper Allen Center and Enron Center surround the church and highlight its origins in a bygone era. In 2001, during the Enron scandal, every photojournalist in the world got a shot of the church and its "Jesus Saves" sign with the Enron tower looming in the background. Like a ripple in a pond, Revered Yates' modest Baptist Academy has evolved into what is today Texas Southern University. The church continues to support the community, providing food and shelter to the area's homeless, delivering educational opportunities and promoting bible study.

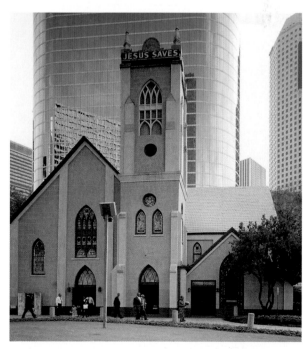

HOUSTON YACHT CLUB

It started life on the bayou but moved out to Galveston Bay

BELOW: This old-time yacht is moored out front of the Houston Yacht Club's original clubhouse. The Houston Yacht Club was founded in 1897. While one doesn't typically think of rough-and-tough Texas Rangers as yachting types, the club's first Commodore was Dan E. Kenney—a former Texas Ranger. Kennedy was elected during a meeting in February of 1898 held at Houston's Binz Building. The club grew, with regattas and group boating trips and waterside parties that helped take the edge off of the brutal Texas summers. In 1905, the group renamed themselves the Yacht and Power Boat Club and then the Launch Club—docking right by Allen's Landing on Buffalo Bayou. In 1910, the Launch Club built the clubhouse you see here in Harrisburg, Texas (now a part of Houston's eastside) about where the turning basin is today. The building was designed by R. D. Steele, and its wide-open second floor breezeways were surely a fine spot to enjoy an iced gin and tonic while discussing the day's sailing.

c.1905

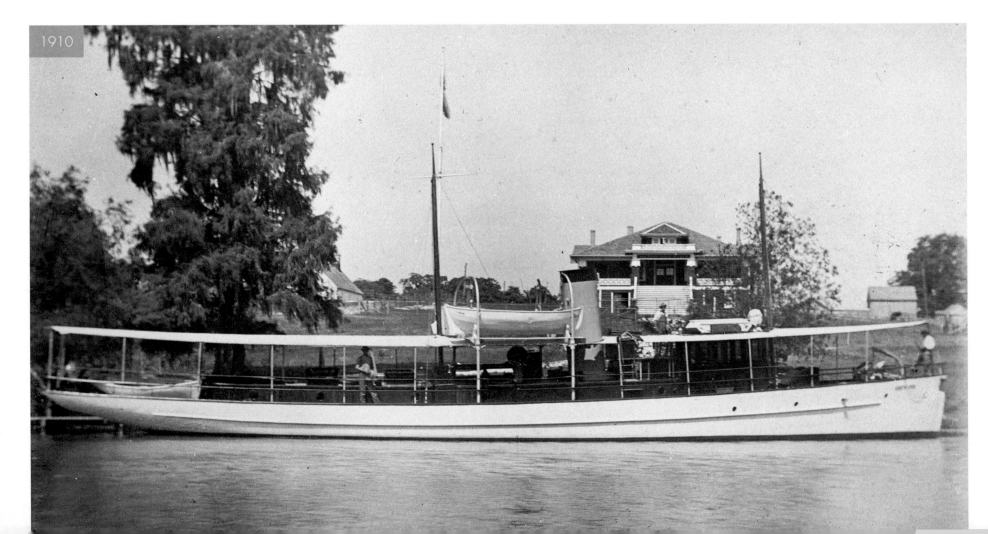

1910

LEFT: This shot shows a new yacht being launched at Morgan Point. The yacht was called the *Ethylwayne*, and belonged to Houston Yacht Club's first Commodore Dan E. Kennedy. Shown in the background is the Kennedy's summer home there on Morgan's Point at 427 Bay Ridge. Built in 1896, this lovely home is still standing and overlooking a new generation of sailors.

BELOW: In July of 1927, the growing Houston Yacht Club completed a new three-story stucco clubhouse—moving the whole operation to Galveston Bay. This festive Spanish Colonial building was designed by Hedrick and Gottleib, and cost around $100,000 to build. The clubhouse was built in a new waterfront development called Shoreacres, just south of La Porte. The grand clubhouse had a porch that ran the length of the building, enclosed to keep out the pesky mosquitos but still let in the breeze. It had huge, fireplaces on each end of the building and even its own airport (that didn't last; this land is now the Bay Colony subdivision). Known affectionately today as the Pink Palace, it underwent remodeling in 1953 and 1961, and a bit of a rebuild following a fire in 1993. Today, the 27,000-square-foot clubhouse is home to a number of venues and facilities—all bringing together the region's sailing community. Sadly, the old Harrisburg Launch Club building burned down sometime in the 1930s.

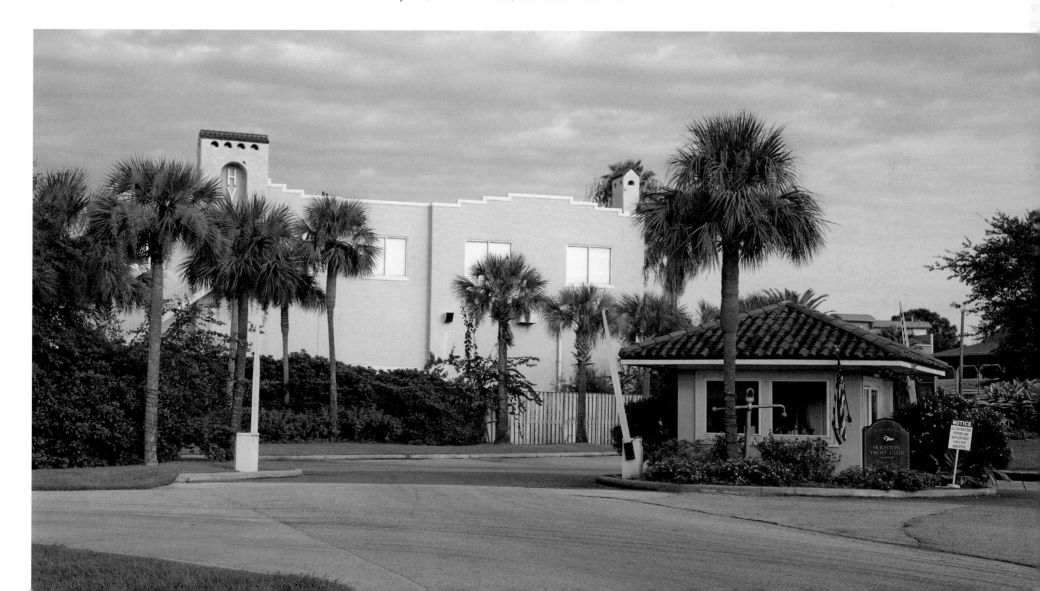

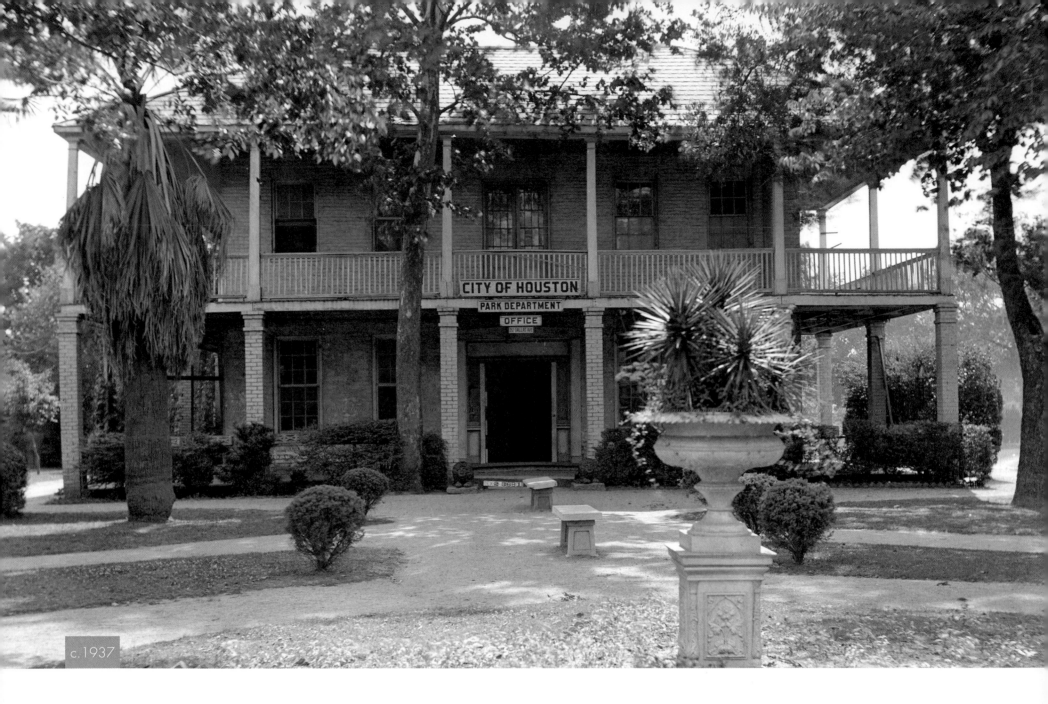

c.1937

KELLUM-NOBLE HOUSE
The house and its grounds were used to create Sam Houston Park

ABOVE: Dating to 1847, the Kellum-Noble House is the oldest brick house in Houston. Virginia-born Nathaniel Kellum built it for his young wife, Elmyra. Its bricks were made in Kellum's own kiln. They would prove much sturdier than his marriage, however, which ended in divorce—and with Kellum shooting his brother-in-law. The house was then sold to Zerviah Noble, who used it to run a private school.

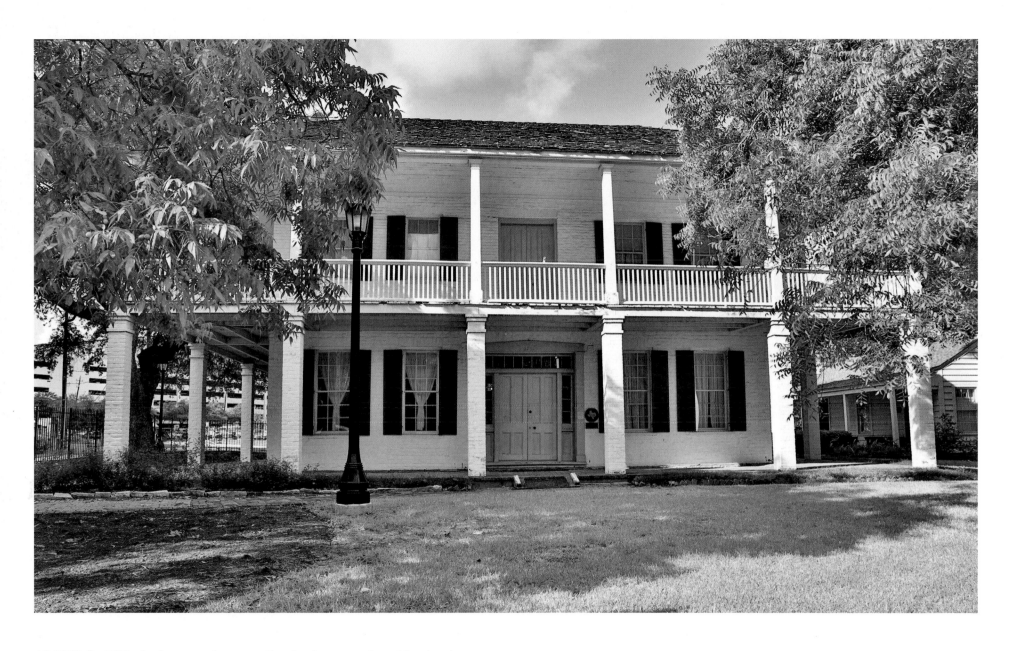

ABOVE: In 1900, the house and surrounding land was purchased by the city to
be used for Sam Houston Park. During the late 1930s and early 1940s it served
as an administrative office for the City of Houston Parks Department. By the
1950s it had become run-down and was destined to become a parking lot.
However, concerned citizens formed the Heritage Society to save it from the
wrecking ball. It's now nestled in with other historical buildings here in Sam
Houston Park downtown.

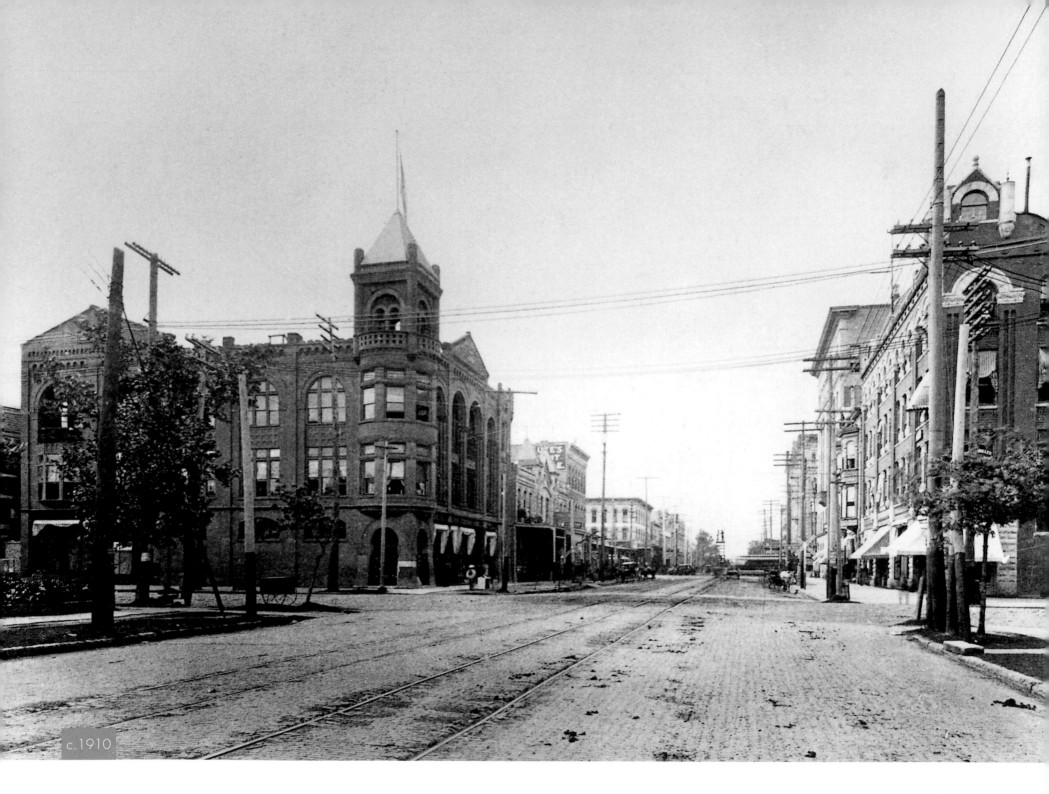

c.1910

HOUSTON LIGHT GUARD ARMORY

A fighting force that accompanied Teddy Roosevelt on his Cuba campaign

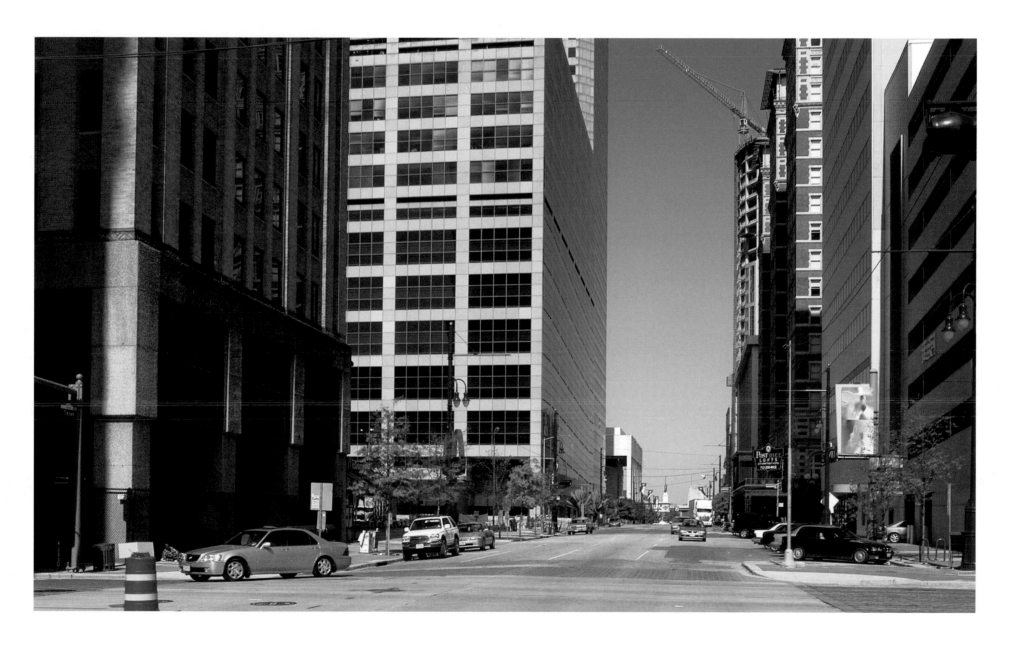

LEFT: Formed in 1873, the Houston Light Guard was a nationally famous military unit. With prize money from drilling competitions, they constructed this armory at Texas and Travis—replete with billiard tables, game rooms, and a reading room. It was a powerful social network of leaders in civic, economic, and social circles. They proved themselves fighting in Havana under Theodore Roosevelt, as well as in a number of civil engagements.

ABOVE: After World War I the old armory was sold and a new one was constructed in 1925 at 3816 Caroline Street, where it's still standing. The original site at Texas and Travis holds giants such as the Texas Tower and J. P. Morgan Chase Tower. Finally known as Company G (Airborne), 143rd Infantry Regiment, one of the Houston Light Guards' last duties before eventual deactivation in 2001 was to help during Tropical Storm Allison.

1955

ALLEN PARKWAY

Buffalo Drive was considered to be a "deathtrap" when it opened

LEFT: This shot shows a view of downtown from Allen Parkway looking west in the 1950s. The road was originally called Buffalo Drive, and connects Interstate-45 (known locally as the Gulf Freeway) to Shepherd Drive, where it turns into Kirby Drive. It roughly follows the south bank of Buffalo Bayou; developers would eventually build a road alongside the northern bank (Memorial Drive). The road is only 2.3 miles long. Buffalo Drive was built in 1925-1926, just before the Great Depression. It immediately saw service as the main road between downtown and a new, experimental community called River Oaks. In its early days, as early as 1929, the road was seen by many as a "death trap" because of its oddly numbered three lanes of traffic and an overhead rail bridge whose supports stood in the median. The road would eventually form the southern border of Buffalo Bayou Park, a 160-acre park that runs from Shepherd to Sabine.

ABOVE: Buffalo Drive was renamed Allen Parkway in 1961. When the name was changed, planners realized that "Buffalo" was still a perfectly fine name for a road and assigned the moniker to "Buffalo Speedway," which runs from Westheimer in River Oaks down to West Belfort—about five-and-a-half miles south. It's certainly not known to most as a death trap these days. Unlike many of Houston's freeways, it doesn't see a ton of traffic congestion and its many gentle curves make it one of the best places in town to take a new sports car (legally and safely, of course). Its proximity to the bayou make it a pretty drive—but also pretty likely that the underpasses will flood during unusually aggressive weather. The whole of the road was underwater during Tropical Storm Allison in 2001. The road is used as part of the course for the Chevron Houston Marathon. Buffalo Bayou Park, which borders the road, is currently on the receiving end of what is eventually planned on being a $30 million development upgrade.

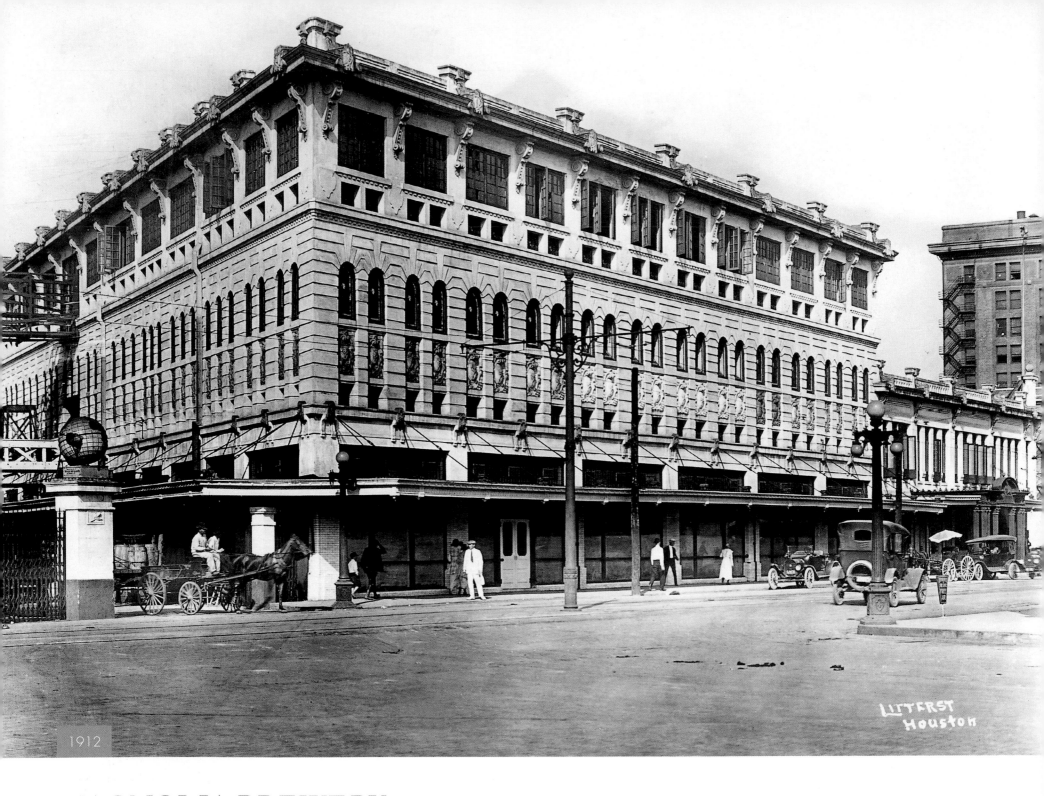

1912

MAGNOLIA BREWERY

The grand brewing enterprise closed its doors in 1950

88

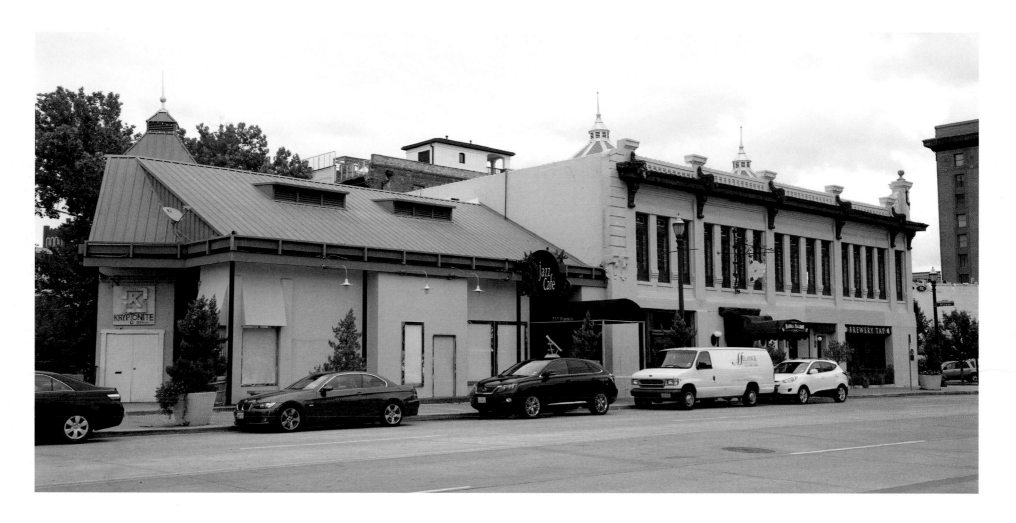

LEFT: At one time, this complex of several buildings engulfed Buffalo Bayou on both sides and comprised a major component of the local economy. The Houston Ice and Brewing Association was founded in 1893, with the Magnolia Brewery operating out of this building as its flagship facility. Architect Eugene Heiner designed this distinctive building at Washington Avenue and Fourth Street. It originally sported one of the city's biggest Artesian water wells, from which the business made its brew. At one time, the factory could make 750 tons of ice and 600 barrels of beer per day. The Irish-born proprietor, Hugh Hamilton, had a German brewmaster under his employ by the name of Frederick P. Kalb who helped the facility craft several different varieties of quality beer that took off in popularity. In 1902, a four-story brick building was added on Washington Street between Fourth and Fifth streets—and in 1912 the small addition on Franklin Street on the far right was completed.

ABOVE: Today, the business surrounding 715 Franklin (at Milam) may have evolved into something a little different—but it's just as popular as it was back in the day. The flood of 1935 hit the Magnolia Brewery facility hard, but it was the waves of Prohibition-era bureaucrats and meddling government enforcers that sent the business down the drain. It finally closed in 1950. On the National Register of Historic Places, the addition at Franklin and Louisiana, seen on the right, is the only portion of the original complex remaining. Under the stewardship of Houston arts patron, architect, and preservationist Bart Truxillo, the building now houses the Magnolia Ballroom—a popular venue for corporate parties, wedding receptions, and other private events. The ballroom also houses a great Brewery Museum showcasing Magnolia artifacts. The smaller space with the red awning next door is the legendary Red Cat Jazz Café.

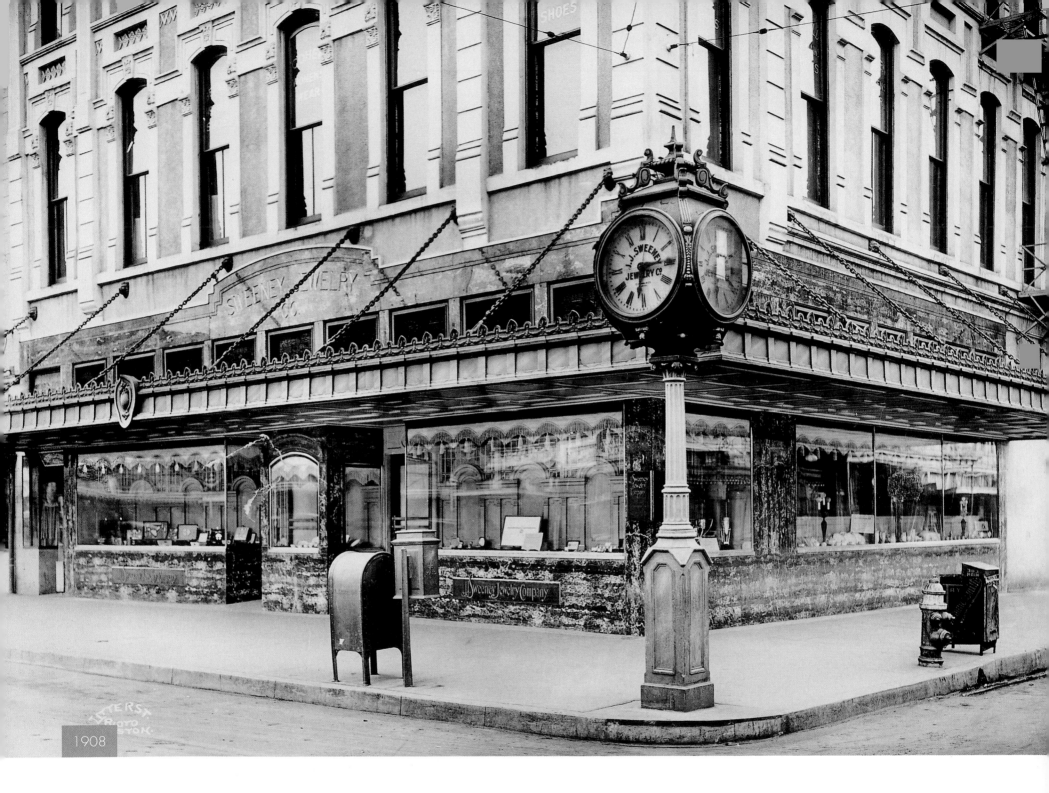

SWEENEY CLOCK
A timely reminder of Houston's heritage

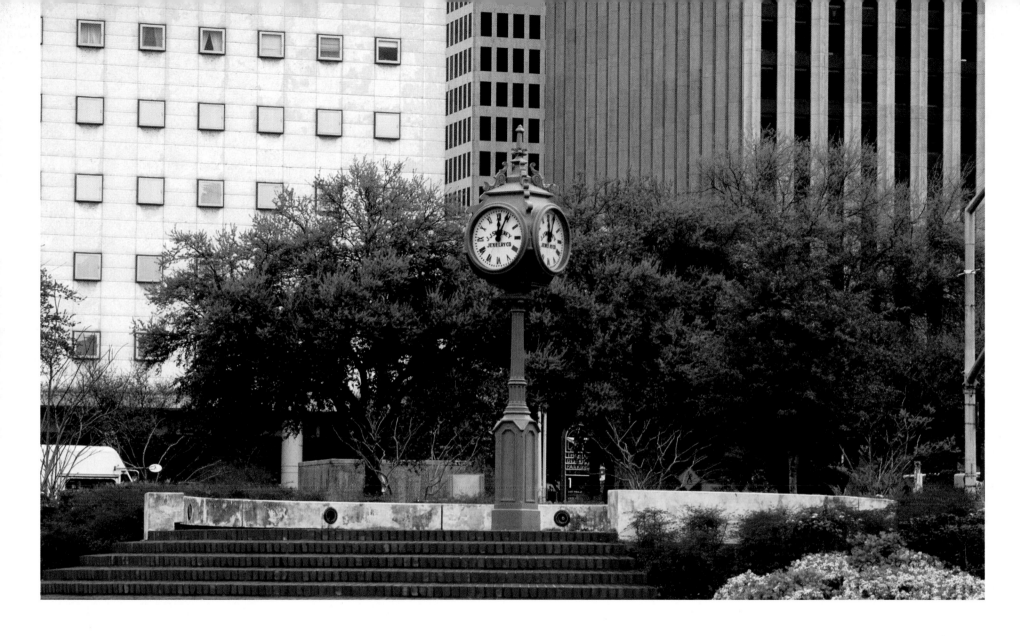

LEFT: The Sweeney Clock was originally built in 1908 in front of Sweeney Jewelry on 409 Main Street. It's been said that Irishman J. J. Sweeney once paid his $10 rent in sweet potatoes. A sound businessman, Sweeney became the proprietor of a pawnshop, which in 1875 became the Sweeney and Coombs jewelry shop. Sweeney bought this charming clock from Boston clock-maker E. A. Howard. Howard was a renowned manufacturer of industrial clocks whose projects included the Clock Tower Building on Broadway in New York. In 1908, the clock was originally placed in front of Sweeney's store on the northeast corner of Main and Prairie. It was a handy thing for people to have, and great advertising for Sweeney. The clock even saw service as a hitching post for horses. But in 1928 Sweeney wanted to move his store. And city bureaucrats kept harassing him about the clock being a traffic hazard.

ABOVE: Sweeney's solution was to donate the clock to the City of Houston. It would shut the traffic people up and be a nice gesture to the community. The clock was moved downtown to the farmer's market, and then to a municipal building near the Jefferson Davis Hospital. It was a quality piece of machinery, but like all things mechanical some maintenance and repair was in order. By the 1960s, the old Sweeney Clock was looking pretty bad. The city was about to auction it off for junk when someone stepped in and suggested it be restored and once again placed in public service. The Colonial Dames of America repaired the clock for $2,000 in 1968, and it was moved to its current location in 1971. The Sweeney Clock now sits in a small, triangular swath of greenery at the intersection of Capitol and Bagby. Maintained by the City of Houston Civic Center Department, it keeps perfect time and is a precious example of Houston's newfound commitment to historical preservation.

GRAND CENTRAL STATION
The tracks remain but a succession of buildings are all gone

BELOW: Cotton and the railroad were still giants when these bales passed through Houston in the early 1900s. This site saw more than one structure, and on the right is the old Grand Central Station building that was built in 1887 to replace an earlier version. It cost $80,000 to build. Hotels sprang up nearby, and it was a good part of town in which to cater to business travelers. Cotton was big business back then. Rail shipments out of Houston peaked around 1917, around the time WWI rolled around. The Old City Hall and Market Square can be seen in the background. Just to the right of the old depot building you can just make out the name "Grand." This was the old Grand Central Hotel that once stood at the corner of Washington Avenue and Seventh Street. Popular with business travelers, it offered a ten-course dinner for just 50 cents! Check out that wonderful old Victorian spire on the building next door.

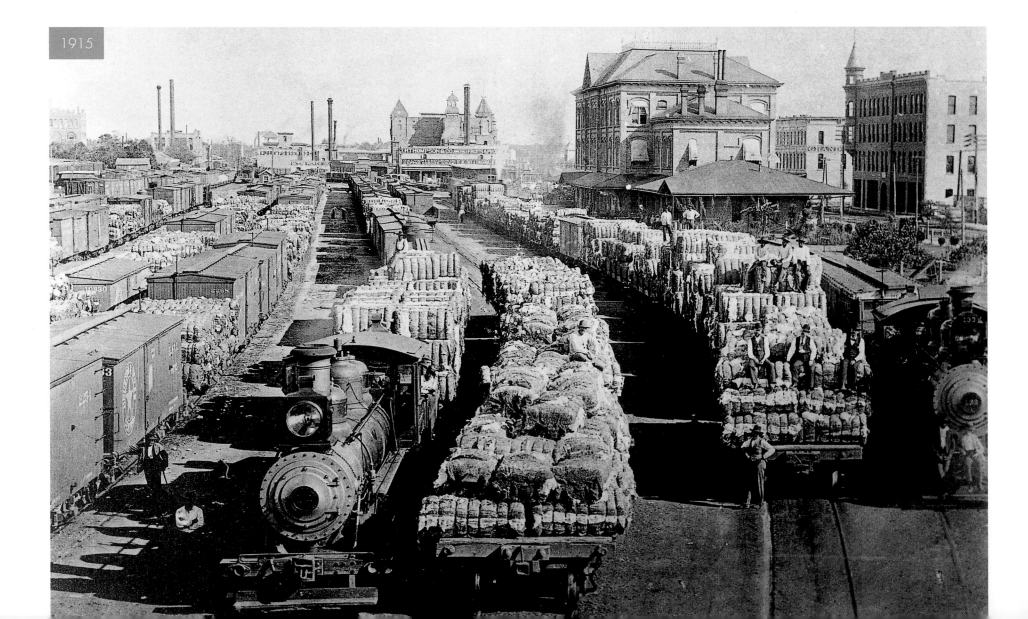

1915

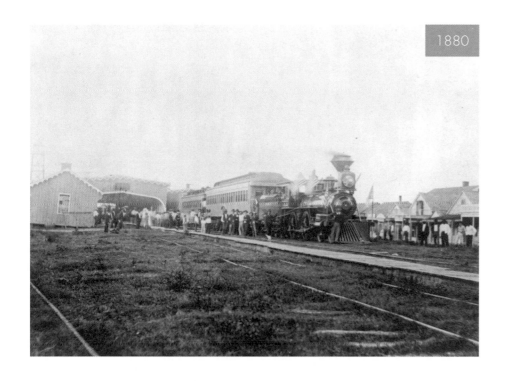

1880

BELOW: The old 1887 Grand Central Station was remodeled in 1906, and then again in 1914. But eventually it was razed and Grand Central's last iteration opened September 1, 1934. It featured black walnut woodwork, intricate interior murals depicting Texas heroes and beautiful marble flooring. The last Grand Central Station building was razed in 1961 and a central post office was built in its place. The tracks still follow the same path as the old rail station and the site now serves as an Amtrak terminal. The Gulf Freeway, Houston's first freeway, opened in 1948 and now passes over the site. In a wonderful flashback to the 1934 station's former glory, one of the station's interior murals—painted by artist John McQuarrie—resurfaced in 2012. It had been given to one of Sam Houston's relatives who, not being a big fan of *The Raven*, kept it in their laundry room (it was recently sold at auction in Dallas).

LEFT: This shot shows the first ever locomotive trip from Houston to New Orleans, Louisiana. The occasion was made possible by the expansion of the Morgan's Louisiana and Texas Railroad, which had been offering service from Beaumont to Houston but was not able to connect Houston with New Orleans for several years due to the War Between the States, flooding, and other challenges. This train set out for New Orleans on August 30, 1880. The trip between the two was known as the "Star and Crescent Route."

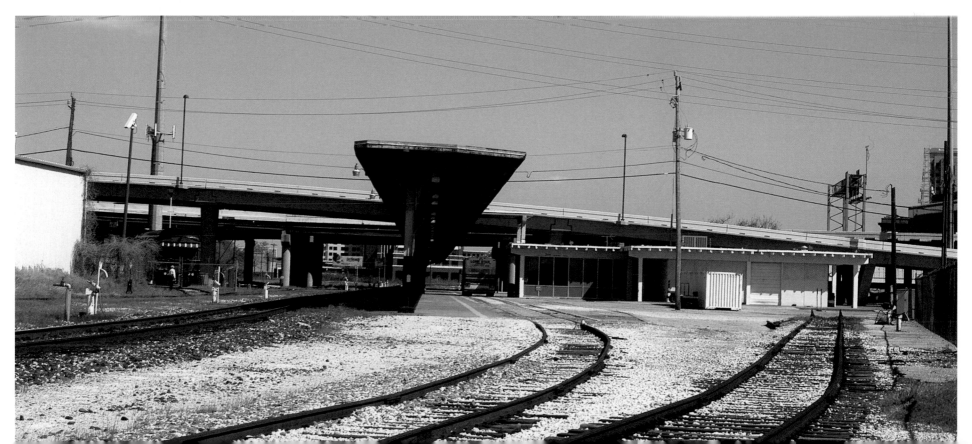

HEIGHTS BOULEVARD

It started with an initial build of just seventeen houses

BELOW: Located near the old Southern Pacific Grand Central Station, Houston Heights was the brainchild of the Omaha and South Texas Land Company. A millionaire by the name of Oscar Carter drove the effort to charter the company and develop the area on land he purchased from the Brashear family. Daniel Denton Cooley served as the team's development supervisor. Beginning in 1892, a team of 300 began building the boulevard that would serve as this neighborhood's centerpiece. Legend has it that Cooley saved a worker's life by shouting at him to "come at once!" as if he were in trouble. He knew the man would snap to, and a tree that had just been felled was about to

fall on him. Houston Heights was officially incorporated in 1896, complete with electric railcars connecting it to downtown. Originally only seventeen homes were built by the Omaha and South Texas Land Company around the boulevard.

RIGHT: A trolley car photographed at the Heights in 1910. Most people don't realize that at one point, Houston was connected by a web of trolley cars out to suburbs like The Heights and Montrose. The network started building up from way back in 1868, but would be completely gone by WWII.

c.1910

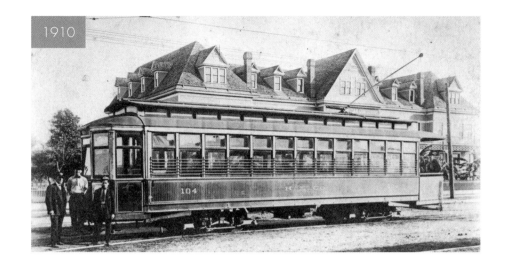

1910

BELOW: Of those original seventeen houses built around the boulevard, only two—1802 Harvard Street and 1102 Heights Boulevard—survived. In 1900, a little more than 800 people lived in the Heights. Favorable land, proximity to downtown and a number of thriving businesses would make it a hot spot for the next century. In 1991, a Texas Historical Commission marker was placed on Heights Boulevard to celebrate its history. Through it all, the town has retained its quiet, small-town suburban feel even as skyscrapers peeked over the oak trees from time to time. The area has undergone intense gentrification over the years. Today, it's the home of not only those who appreciate a prime piece of real estate but also hordes of urban hipsters. Trendy young Houstonians engage in bidding wars to buy in this now posh neighborhood where you're more likely to be run down by a handlebar-mustachioed graphic designer on a Vespa than killed by a falling tree.

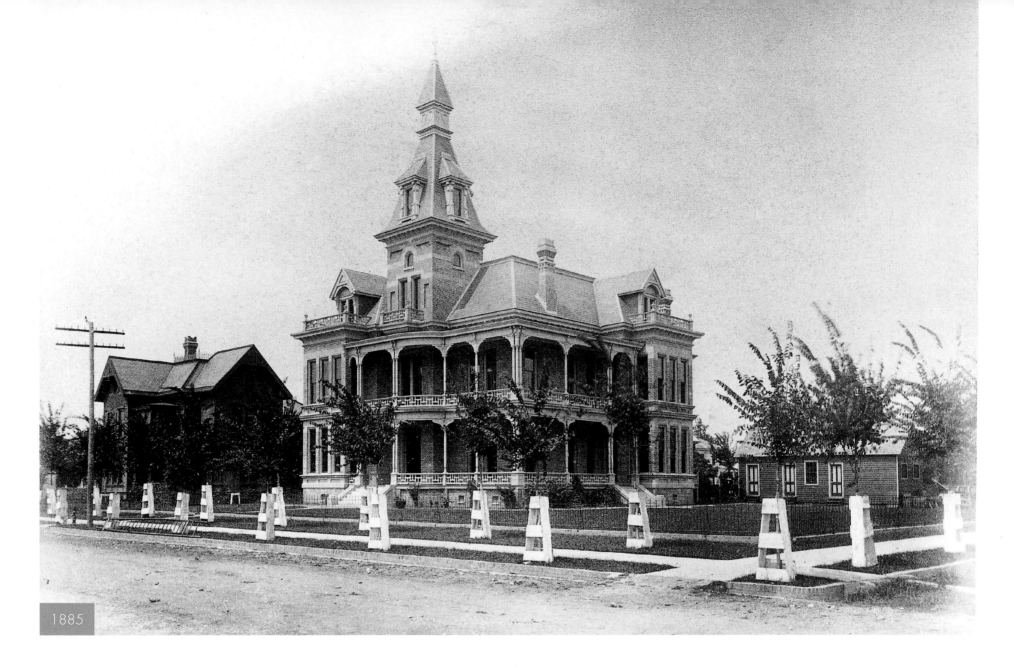

1885

WALDO MANSION

"Jed" Waldo's mansion was moved by his son Wilmer

ABOVE: This beautiful High Victorian mansion was completed in 1885 at the corner of Rusk and Caroline Streets. It was the home of Jedediah Porter Waldo, a successful railroad executive and veteran who fought for the Confederate States of America. The home was stunning, inside and out with an interior sporting ten rooms and nine fireplaces. The interior had intricate millwork detailing, wide verandas on two stories and sported an ornate tower cupola that dominated the block. It made quite an impression in its day. The home was designed by renowned architect George E. Dickey, who designed a number of Houston's Victorian buildings though sadly not a lot of his work has survived over the years (such as the old Capitol Hotel or 1887 Grand Central Station).

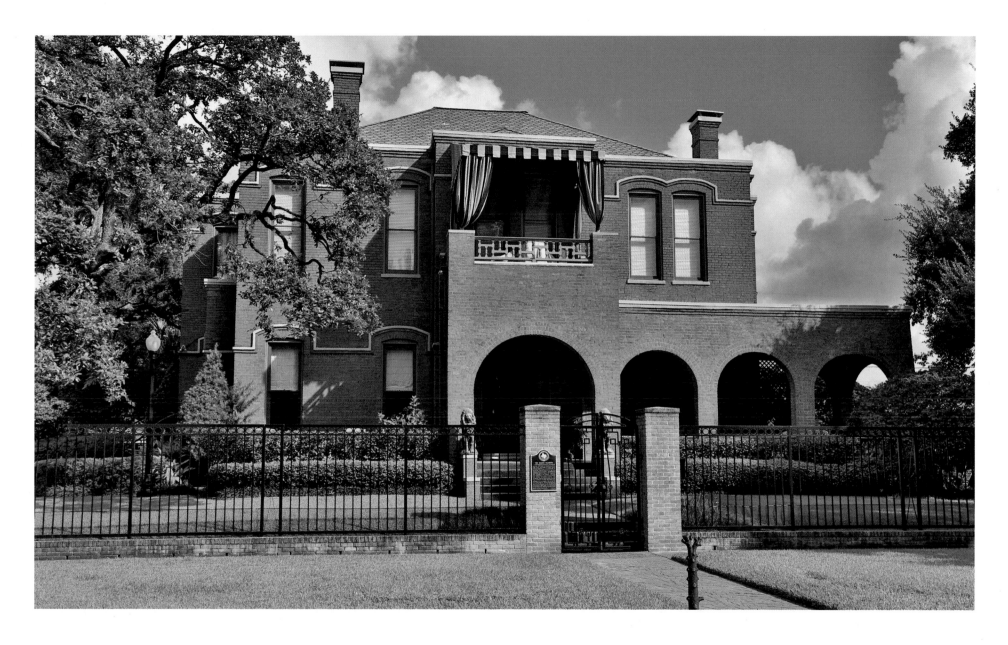

ABOVE: The oldest continuously occupied house in Houston, the Waldo Mansion was meticulously remodeled and relocated to Westmoreland Place in 1905 by Jedediah's son, Wilmer. Wilmer was a Princeton-trained civil engineer who oversaw the home's transport and reconstruction and gave it its current Italianate look. He took a pass on the home's original Victorian look and detailing, however. Now it sports rounded arches and a red brick veneer, with a much smaller, but charming, second-story balcony area. Wilmer had personally developed the Westmoreland Place subdivision. The home stayed in the Waldo family for a very long time—until 1966. In 1978, the home was registered by the Texas Historical Commission. To this day, it remains a beautifully kept private residence. The owners clearly work hard and invest liberally to keep the home and its surrounding grounds in handsome shape. While many of George Dickey's buildings haven't survived in Houston, some other of his charming homes can still be found in Galveston.

RICE UNIVERSITY

The vision of William Marsh Rice was realized only once his poisoners were dealt with

BELOW: Massachusetts-born William Marsh Rice rose from an empty-handed clerk to a Houston multimillionaire by way of hard work and sound investing. At the age of 21, he opened his own business in his native Massachusetts. Eventually he made his way to Houston where for a lifetime he entered into a number of successful business enterprises from shipping to insurance to real estate. Later in life, when his second wife died in 1896, he moved to New York a wealthy man. His fortune was estimated at around $9 million—a king's ransom in turn-of-the-century U.S. dollars. He lived out his final days in a Madison Avenue apartment. In 1891, he incorporated what he called the Institute for the Advancement of Science, Art and Literature of Texas—a high-end university that was his way to help give back to the city that made him. He envisioned it as a Harvard of the South. His will set aside plenty of money for the school upon his death, which occurred on September 23, 1900.

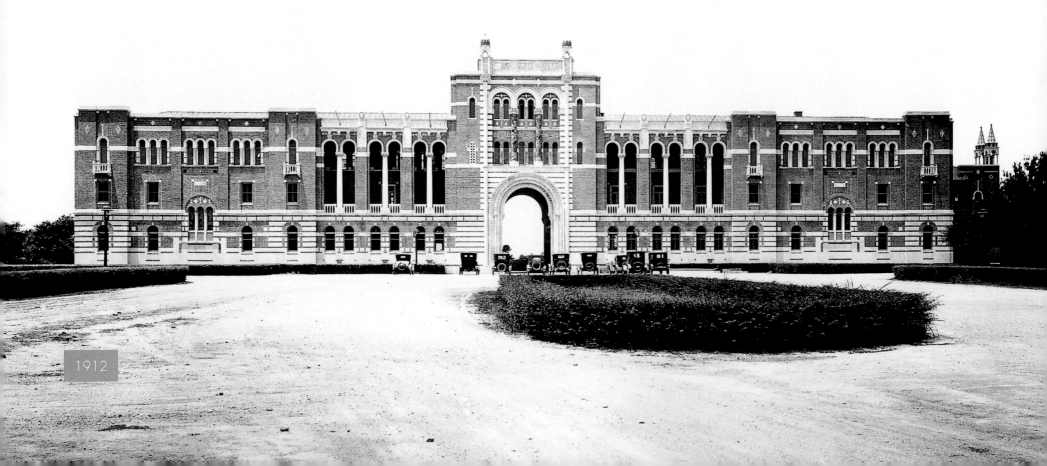

1912

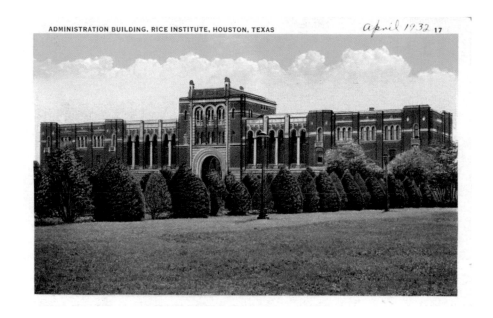

ADMINISTRATION BUILDING. RICE INSTITUTE, HOUSTON, TEXAS *April 1932* 17

BELOW: Rice didn't go gently into that good night; he was poisoned. Specifically, his lawyer and butler colluded to poison Rice with chloroform and forge fake wills that left them, and not the university, the lion's share of the Rice fortune. They were found out, if not justly punished. The upside of their scandalous behavior was that during the ensuing legal battles, Rice's fortune earned tons of interest. By the time the Rice Institute opened in 1912 it had a solid war chest from which to operate. As of 2012, the institution had around 12,000 students and an endowment of $4.4 billion. Rice's vision of a Southern school worthy of the Ivy League was realized; Rice University is today one of the finest universities in the country. The academic elite flock from around the world to attend. Lovett Hall, shown here, is named after its first president, Edgar Odell Lovett—a Princeton man. William Marsh Rice's ashes are buried beneath a statue of his likeness on campus.

LEFT: This postcard of the admin building shows an illustration of lush hedges on campus. The hedges of the university have become a euphemism on campus as a boundary between academic life at Rice University and the world outside. In 2012, the university's 100-year anniversary was branded "Beyond the Hedges," and explored ways that this powerful city and this powerhouse university could better support each other.

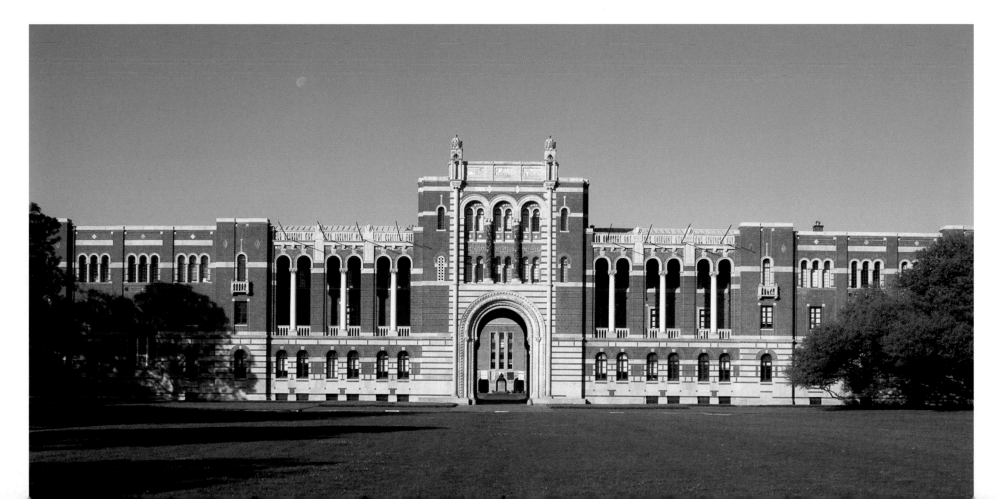

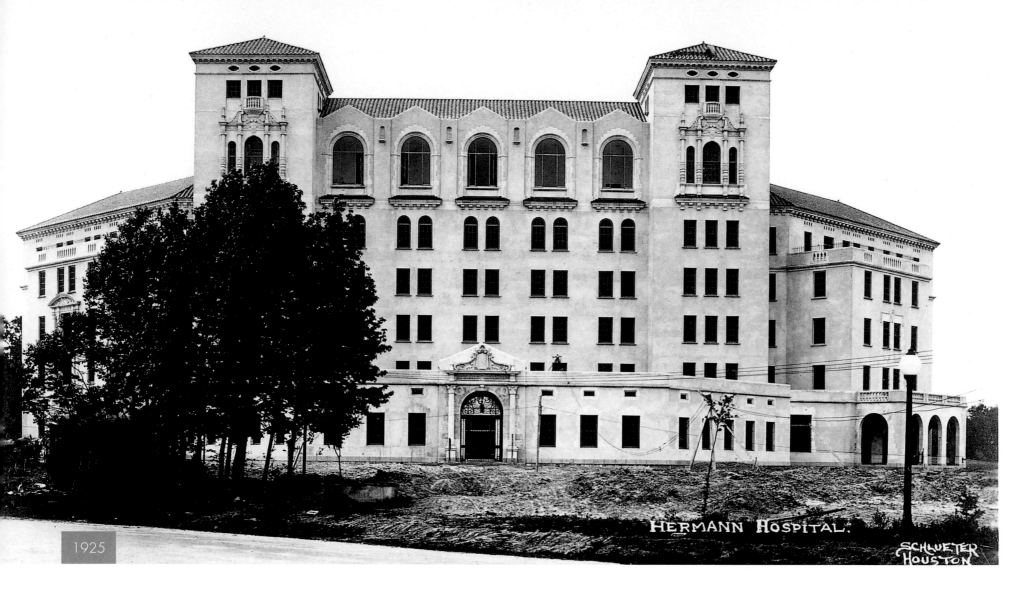

1925

HERMANN HOSPITAL.

SCHLUETER HOUSTON

HERMANN HOSPITAL
An integral part of the Texas Medical Center

ABOVE: George Hermann, the son of Swiss immigrants who left him a substantial inheritance, was a native Houstonian. While visiting New York, Hermann fell ill suddenly, passing out right on the sidewalk. He awoke in a charity hospital, where he was treated horribly. He vowed that such a fate would not befall any Houstonians, and in 1925—eleven years after his death—Hermann Hospital opened to give humane treatment to Houston's poor.

RIGHT: When it originally opened, the facility sported just 100 beds. It had 109 physicians on staff and treated 558 inpatients its first year. Today, the complex is composed of twelve separate hospitals with over 20,000 employees, more than 3,500 beds and 4,178 medical staff members. Around 377,000 people make an emergency visit to Memorial Hermann every year. It's a part of the Texas Medical Center, the world's largest medical center.

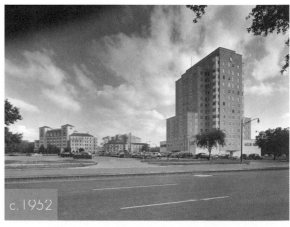

c.1952

100

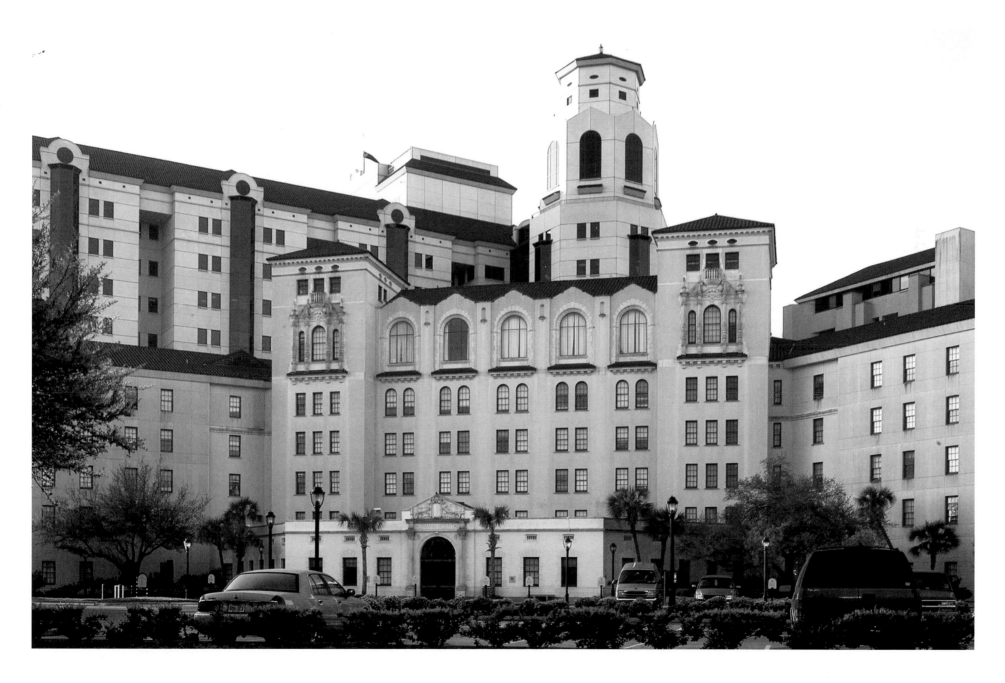

ABOVE: The hospital was designed for Houston's poor, but not poorly designed. Its Spanish Renaissance architecture, complete with a red barrel tile roof, is a tasteful complement to nearby Rice University. Now known as Memorial Hermann Hospital after merging with another early hospital, it comprises multiple facilities and institutions with a huge breadth of specialized healthcare disciplines. It's one of two Level I major trauma centers in town, offering 24-hour trauma care to 40,000 patients per year.

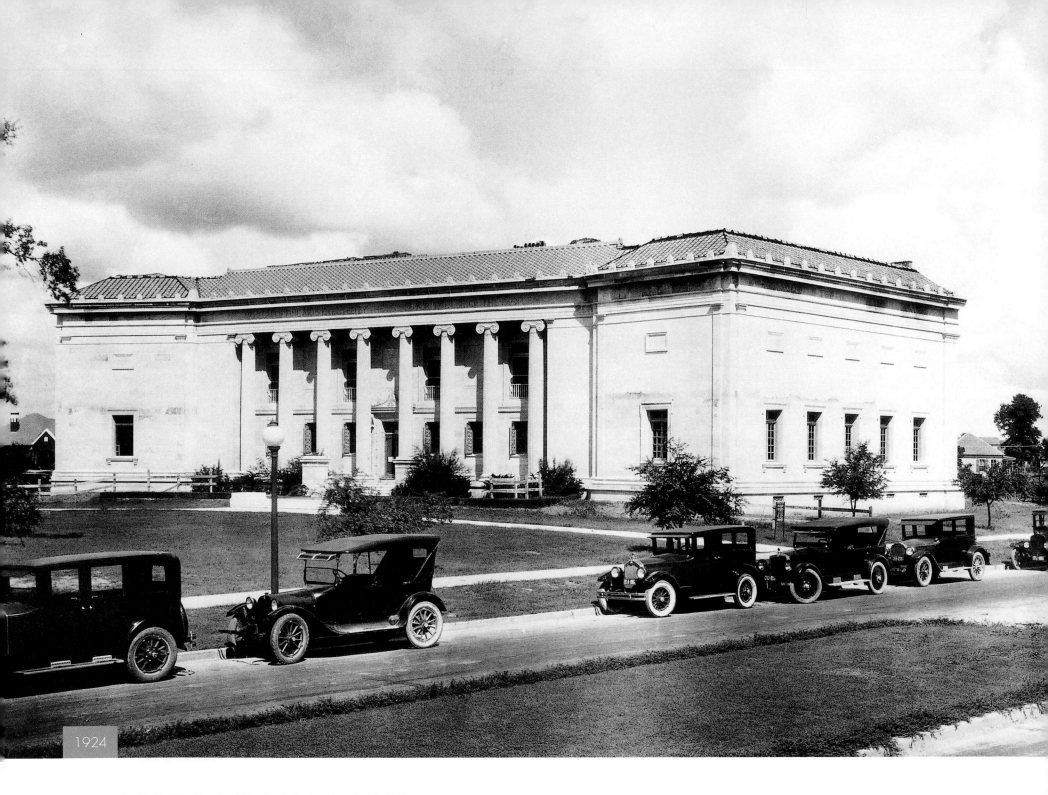

1924

MUSEUM OF FINE ARTS
Founded by the Houston Public School Art League, an organization that put a classic work of art in every Houston school

LEFT: The oldest art museum in Texas, the Museum of Fine Arts, Houston (MFAH) got its start when the Houston Public School Art League donated its current museum site for the purpose of creating a public art museum. The museum was chartered as a step toward bringing more cultural appreciation to the city. It opened for business in 1924. The group went into debt putting a classic work of art in every Houston school. William Ward Watkin designed the original building. The collection started off slow, but grew exponentially, especially after the Great Depression.

BELOW: This shot shows the backstreets behind the grand new Houston Museum of Fine Arts in 1924 when the building opened. Here you're looking west from the triangle where Main Street, Bissonnet, and Montrose come together. At the time, the institution had only its original building, but from 1926 to 2000 the facility underwent numerous additional wings and expansions. The museum's latest addition was the Audrey Jones Beck Building, designed by Rafael Moneo.

1924

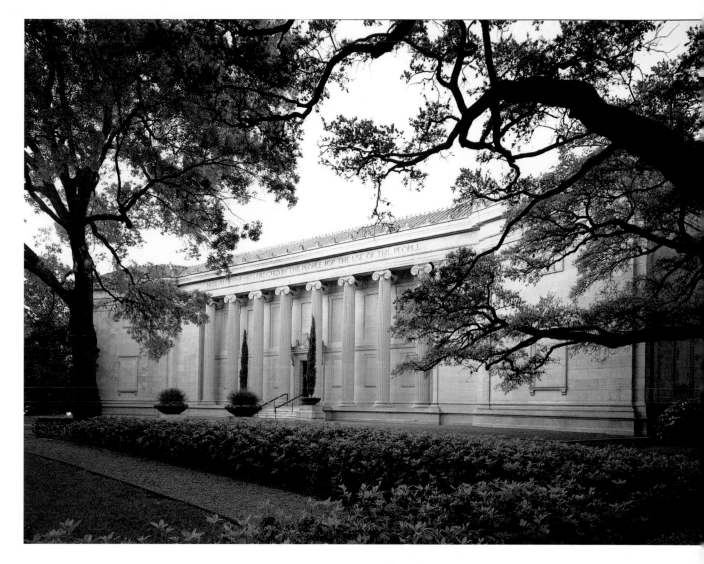

ABOVE: Over the years, a number of prominent Houstonians donated works to the museum. Today, the MFAH is a generous complex of facilities displaying 300,000 square feet of art. It includes art schools, houses for the display of decorative arts, a sculpture garden, eighteen acres of public gardens, and one of the largest art libraries in the Southwest. It houses works from ancient times to the modern day, from all of the world's great civilizations.

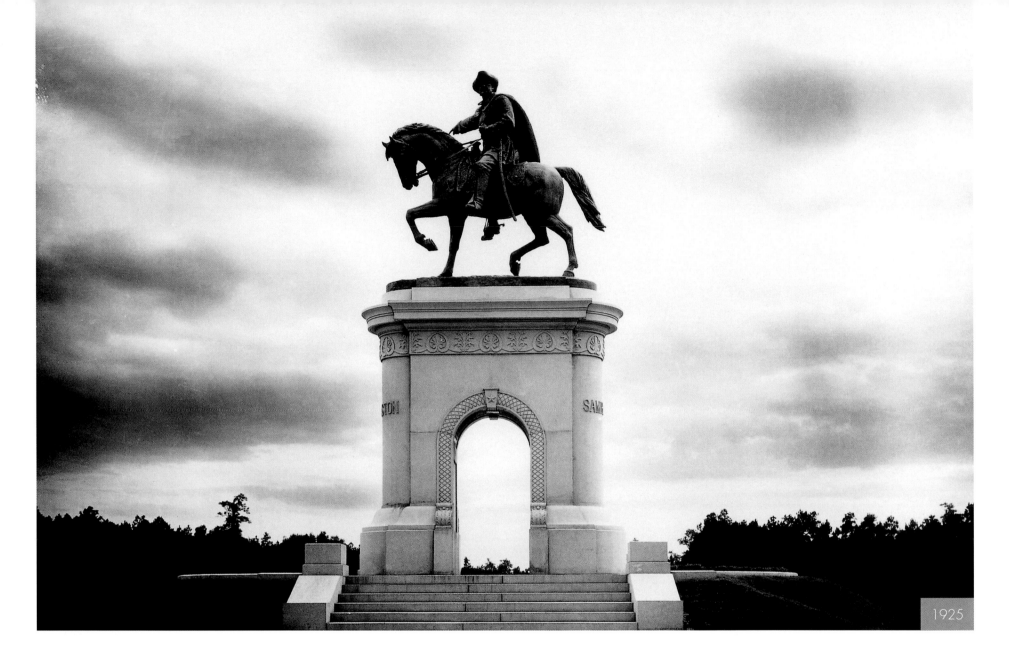

1925

SAM HOUSTON STATUE
Pointing to the scene of his great triumph

ABOVE: An article in the March 1, 1917, *Houston Chronicle* made a public appeal for funds toward this effort to recognize Texas hero Sam Houston. With the Women's City Club spearheading the fundraising, this beautiful bronze sculpture was finally unveiled on August 16, 1925. Depicting Houston's leadership at San Jacinto during the Texas Revolution, the statue's finger is actually pointing toward the battlefield. The Sam Houston Statue was sculpted by the Italian-born Houstonian, Enrico Filiberto Cerracchio, who studied at the Institute Avellino in Italy. It was forged at the Roman Bronze Works in New York, and the statue's high-profile granite arch was made by Frank Teich. The base is around twenty-five feet tall, with the statue itself standing at twenty feet. A plaque on the monument recognizes the Houston Women's City Club as its patron, along with a chronology of Sam Houston's life from Virginia to Texas. Houston was the only man ever to be governor of two separate states: Tennessee and Texas.

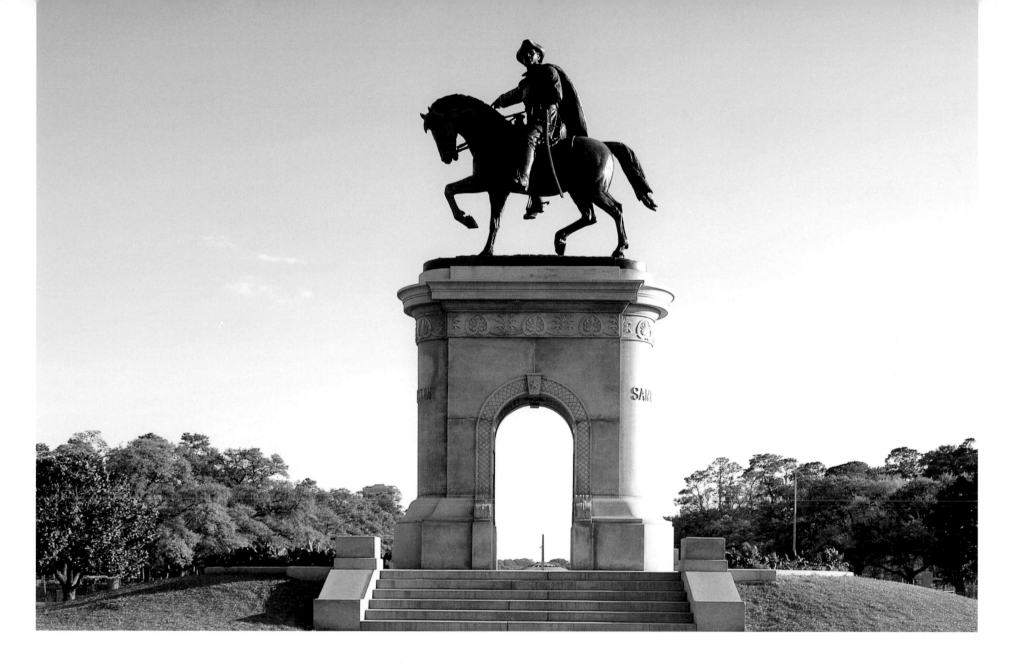

ABOVE: Over the years, the statue has become a landmark in Hermann Park. Of course, decades upon decades of weather will make its mark on the finest craftsmanship. Eventually, the statue's granite arch began to deteriorate, threatening its fitness for public service. As a response, in 1996 the City of Houston's Municipal Art Commission (MAC) started a program by which members of the public and business community could donate money to help preserve, restore, and protect works of public and historical art around town.

The Sam Houston Statue was the MAC's first project. With seventy-one years of service under his hat, old Sam was restored. On September 5th, 1996 the renewed statue was unveiled with great fanfare at a homecoming party attended by the mayor and other supporters. The obelisk appearing beyond the arch is Pioneer Monument, a tribute to the city's founders, and was dedicated in 1936.

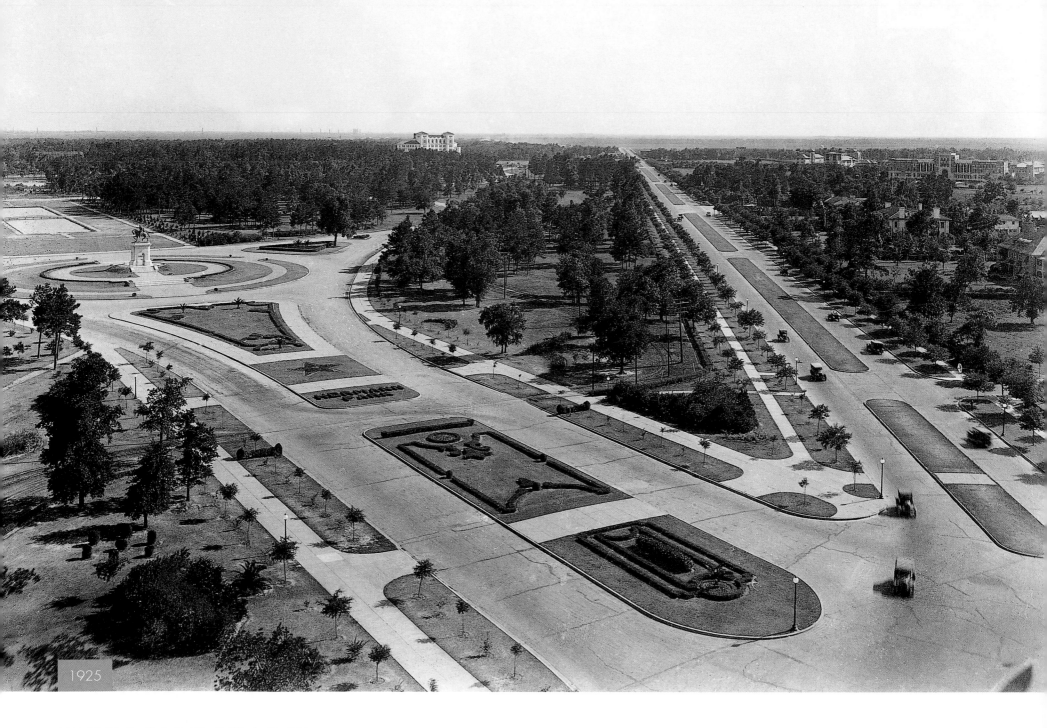

1925

HERMANN PARK

The Texas Medical Center has risen like a city beyond the ever-popular Hermann Park

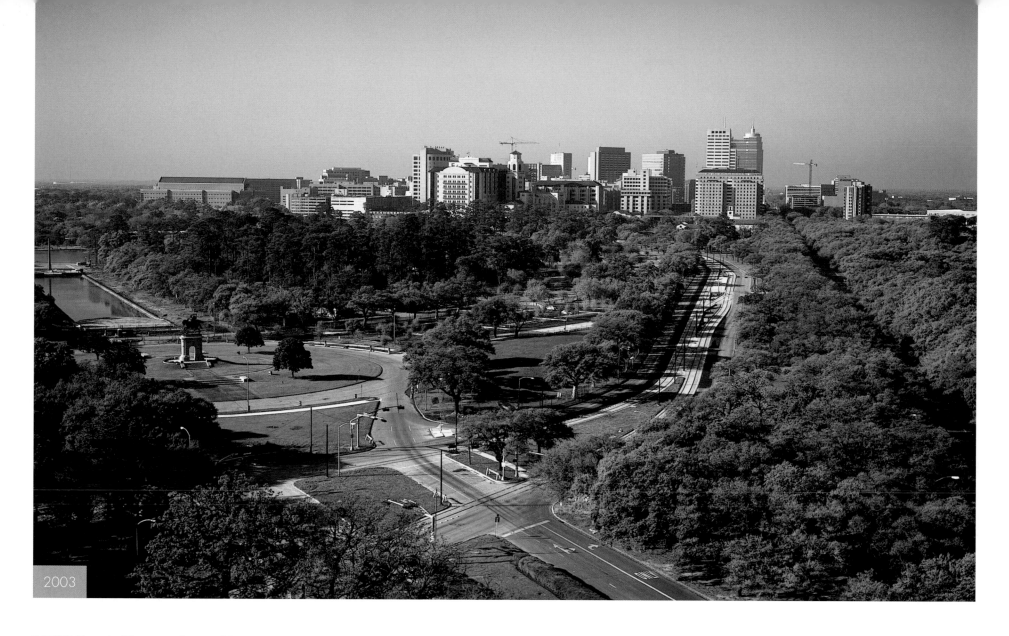

2003

LEFT: Born in Houston, George Hermann fought for the Confederacy in the 26th Texas Cavalry during the War Between the States. Hermann went into the real estate business in the 1880s, and struck it rich during the turn-of-the-century oil boom. Less than six months before his death, Hermann donated 285 acres of land for a city park (this was May of 1914). Several more acres were bequeathed after his death, and the City of Houston later purchased additional acreage from the Hermann estate. Grand and ambitious, Hermann Park was Houston's first truly large-scale public park—and the first big major push for an organized beautification and public space project. When this picture was taken, its fresh esplanade was still lined with young trees and shrubbery—Hermann Hospital can be seen in the distance.

ABOVE: Between Fannin and Cambridge Streets, Hermann Park spans 445 acres and is still one of the most revered public spaces in town. In the heart of the city, it's a great place to park your car and go exploring. The nearby zoo and golf course are both still popular, and the Houston Museum of Natural Science is a major cultural attraction. Over the years, a number of features have been added to key parts of the park, such as the Sam Houston statue and Pioneer Memorial Obelisk with its reflecting pool. By the 1980s, the park was facing the same challenges that face all major urban spaces as time goes by—budget cuts paired with an overwhelming number of visitors. The non-profit groups Friends of Hermann Park, and later the Houston Park Conservancy, were organized to get it back on track. Drawing 5.5 million visitors annually, Hermann Park is today a beautiful space full of energy and always teaming with interesting people and events.

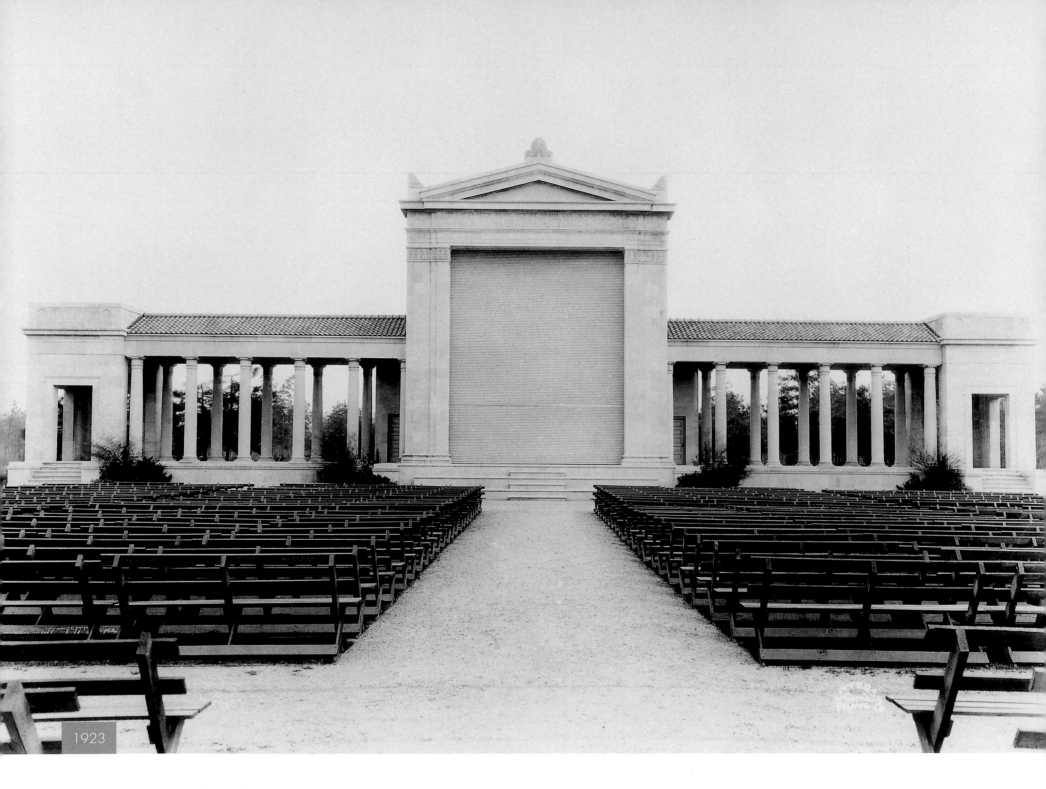

1923

MILLER OUTDOOR THEATER
The grand limestone columns have moved from colonnade to colonnade in Hermann Park

LEFT: The first of its kind in America, the Miller Outdoor Theatre opened in 1923. William Ward Watkin built this beautiful Doric proscenium in Hermann Park at the bequest of Jesse Wright Miller, a successful Houston mining engineer. Employed by the architectural firm Cram, Goodhue and Ferguson, Watkin was on staff at Rice University and designed the nearby Museum of Fine Arts, and many of the buildings at Rice and Texas Tech University in Lubbock.

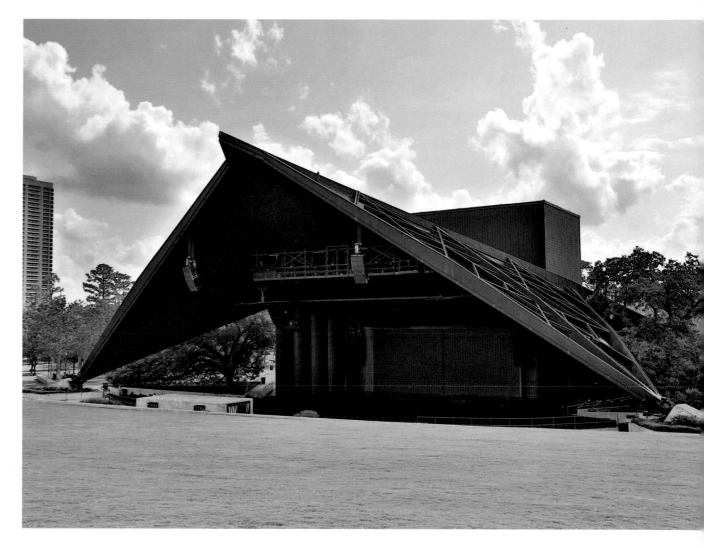

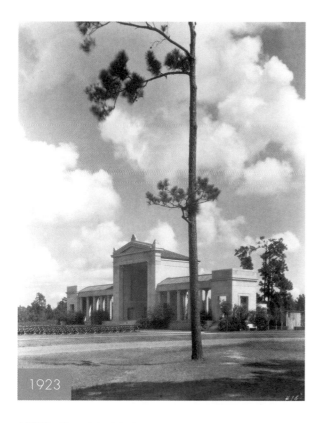

1923

ABOVE: The original Corinthian-style limestone columns for the theater were built by Tom Tellepsen, whose general contracting firm not only built some of Houston's most iconic structures—but is still in business today. The big, grassy hill by the theater is known as "Miller's Hill," and was built from dirt taken from work on Fannin Street in 1948. The first show ever performed there was *Springtimes of Our Nation*, a city pageant that had 2,500 performers.

ABOVE: In 1969, a new Miller Outdoor Theatre was constructed on the site. The pavilion seats almost 1,600, and more can be seated on the beautifully manicured lawn. It's popular for the summer symphony performances—and astonishingly diverse selection of fun, cultural entertainment. And all shows are free. Some of the columns from the 1923 structure were saved and now adorn the Mecom-Rockwell Colonnade at the park's entrance.

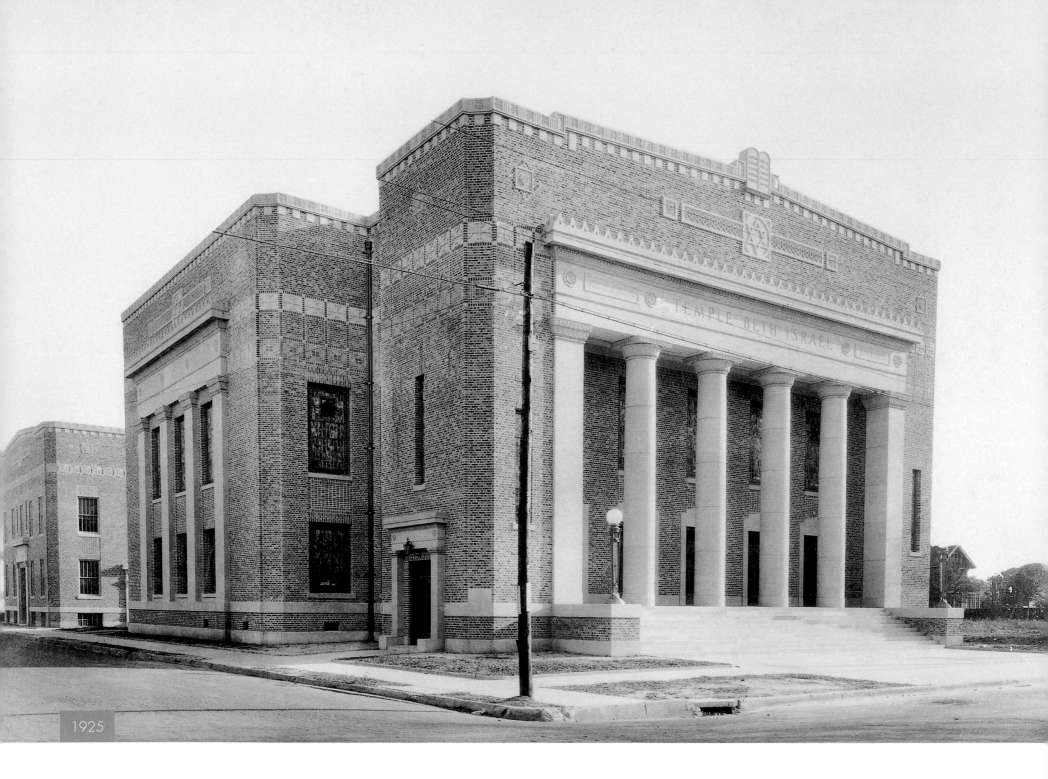

1925

TEMPLE BETH ISRAEL
Originally a synagogue, the building has served as a theater since the late 1960s

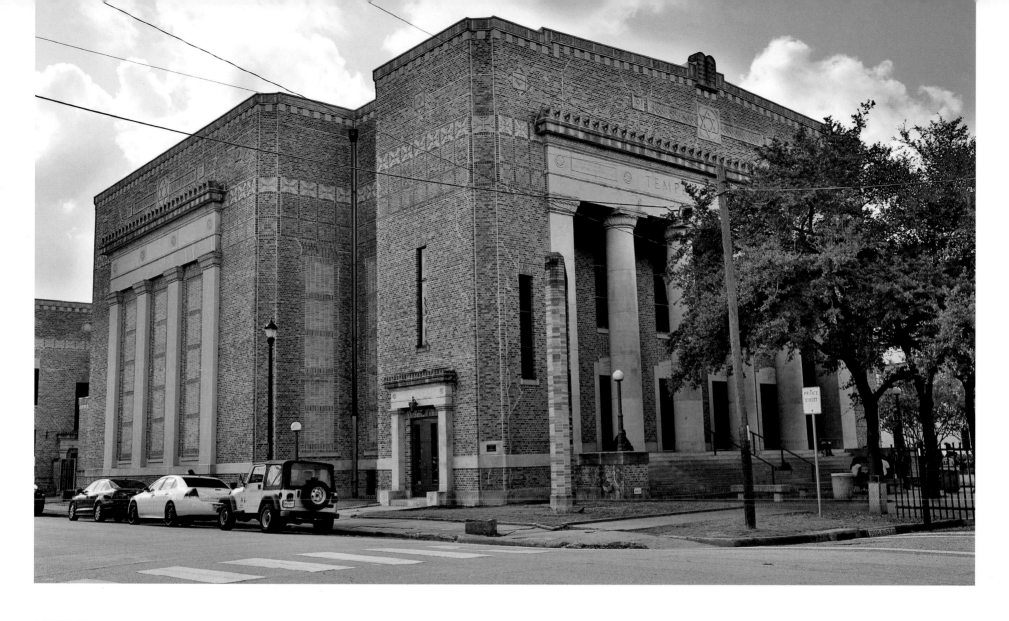

LEFT: This temple, the congregation's third, was designed in the Classic Greek style by renowned architect Joseph Finger. Finger was also a member of the congregation. It was completed in 1925. At the intersection of Austin Street and Holman Avenue, its cost was estimated at $250,000. Houston's Congregation Beth Israel dates back to 1844. By 1854, the orthodox synagogue's twenty-two members were mainly from Western Europe. The group nailed down an official charter on December 28, 1859 as the Hebrew Congregation of the City of Houston. In 1864, as the War Between the States wore on, the congregation started a religious school. Eventually the group incorporated itself as the Hebrew Congregation Beth Israel in 1873, originally adopting the Polish minhag—and later the Union Prayer Book at the turn of the century. Its membership and administration developed itself over the following decades, helping to create a strong Jewish community in Houston. Congregation Beth Israel would occupy this building until 1967.

ABOVE: In the late 1960s, Beth Israel moved out to a new temple at North Braeswood. When the congregation left, the building was occupied by the High School for the Visual and Performance Arts, the first public school in the country to provide gifted young artists the focused, intensive training required for global competition in the arts and integrate this rigorous training with academic study. The school renamed the building Ruth Denney Theatre. Eventually, the school moved out. After the building was renovated in 1984, it began service as the Heinen Theatre, a part of Houston Community College's Fine Arts Department. The theater seats 300 people and supports the school's drama, music, and dance departments. You can see students out front going over their lines. When this building was originally built in the 1920s, it was considered part of Houston's Third Ward. Today, most consider the Heinen Theatre at 3517 Austin Street to be a part of midtown. The building was listed on the National Register of Historic Places in 1984.

WARWICK HOTEL
The hotel's re-launch party was the height of extravagance!

1926

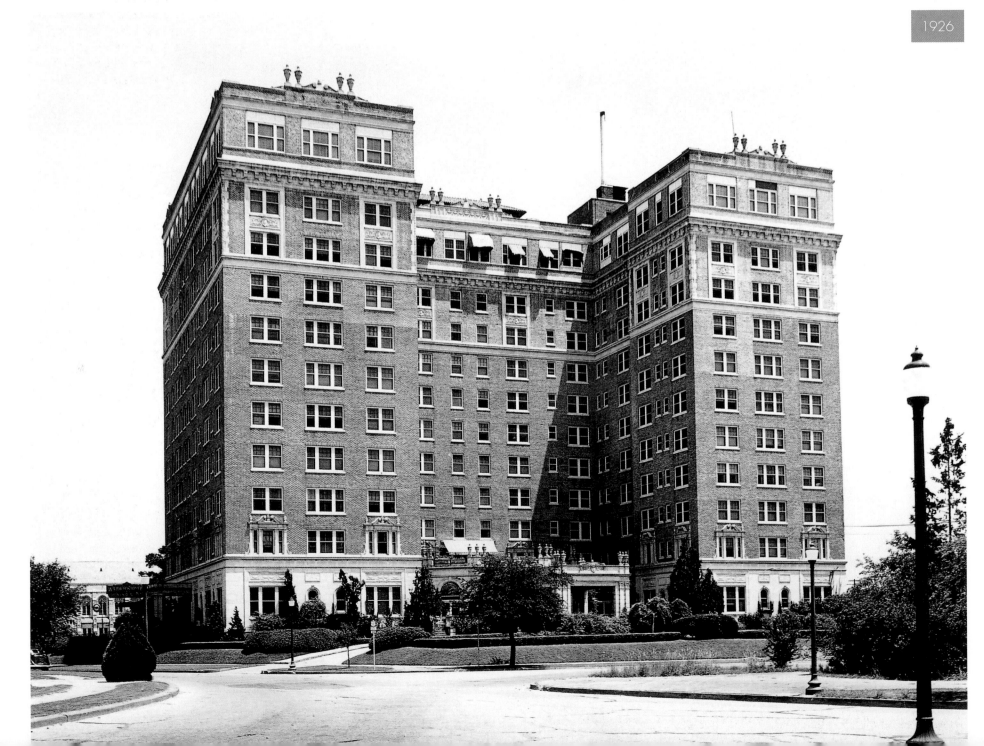

LEFT: The Warwick was completed in 1926 as an upscale apartment building. The eleven-story structure was designed by the ironically named architectural firm of Brickey and Brickey, at a cost of approximately $2.5 million. It was truly beautiful; the *Houston Post-Dispatch* called it "a rare gem." Apartments were $70 per month. You could rent a suite for $5 per night! When the Great Depression hit, the building was foreclosed and sold at auction. It was eventually sold to successful oilman John Mecom in 1962. Mecom spent $13 million fixing it up. He and his wife plundered Europe for its furnishings, including wall panels that were owned by Napoleon's sister and re-launched it as a hotel in 1964. The relaunch party for the Warwick was the height of extravagance. The guests (one of them actor Cary Grant) watched a gold-plated Rolls Royce rise from the ballroom floor, filled with presents for all those attending.

BELOW: Mecom died in 1981 at the age of seventy at his home in River Oaks, and the grand old Hotel Warwick had a series of corporate ownerships after that. In 2005, Dallas-based Hotel ZaZa bought the property; Houston's Hotel ZaZa location opened in 2007. Now a sort of boutique hipster-ish affair, the ZaZa is the kind of hotel for the sort of people who like themed rooms, trendy bars, and a good upscale spa experience. Its themed concept suites include the Casa Blanca, the West Indies Room, Geisha House, and the intriguing "Houston We Have a Problem." It also offers a list of "magnificent seven" suites that include the Black Label and For Your Eyes Only. The flat building in the parking lot is the hotel's Monarch Bistro.

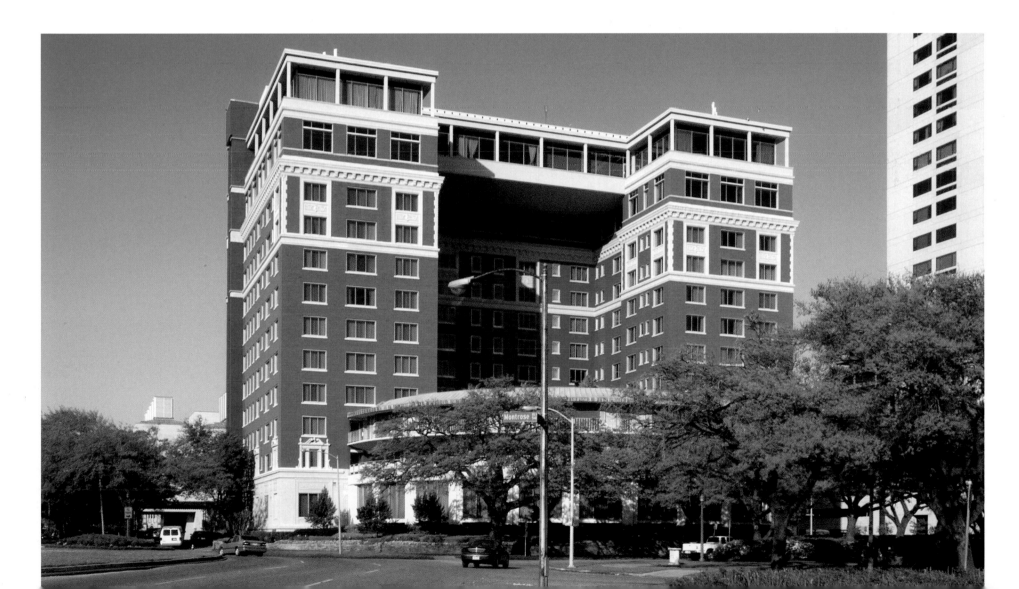

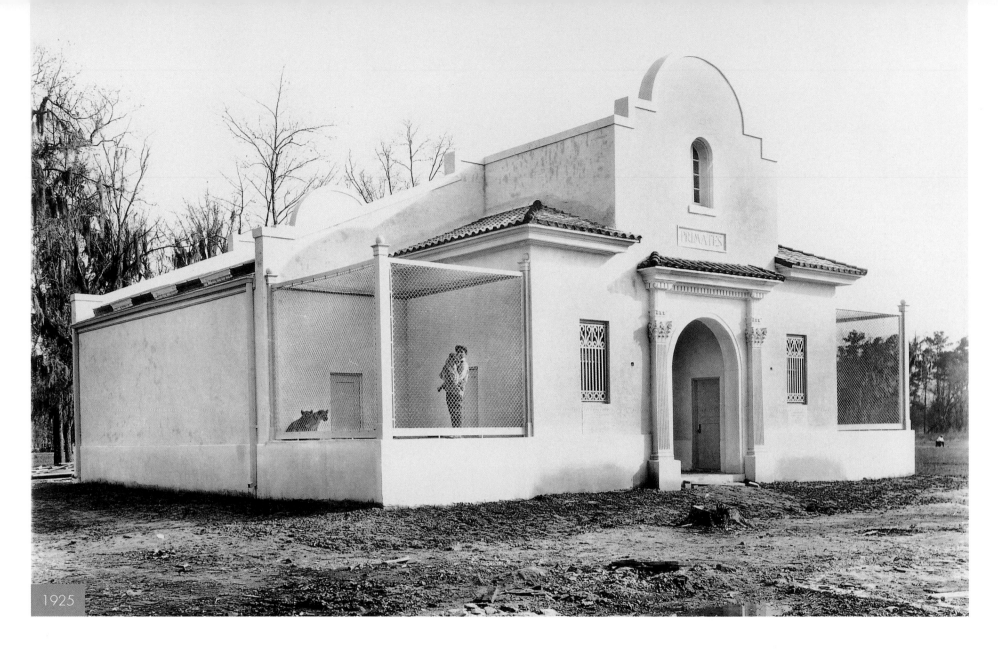

1925

HOUSTON ZOOLOGICAL GARDENS
A bison named Earl started off Houston Zoo

ABOVE: In 1920, the U.S. government set out to reduce the number of bison herds at national parks. One bison was donated to Houston. Earl, as he was affectionately known, was placed in Sam Houston Park. He pretty much had the place to himself at first, and gradually picked up hundreds of neighbors over the years. By 1925, the impressive collection of animals was moved to Hermann Park and became the Houston Zoological Gardens.

1925

LEFT: The zoo actually has two different exhibitions that have survived since the zoo's original layout in the 1920s. The first is The Area, which today holds a pair of Cinereous Vultures. The second is the flamingo pool.

ABOVE: If he were around today Earl would be proud. The Houston Zoo is the most visited zoo in the Southwest, bringing in 1.5 million visitors through this entrance annually. The zoo is home to over 5,000 animals and several elaborately engineered—and spectacularly displayed— habitats. The Wortham World of Primates offers up-close views of threatened and endangered primates, including mandrills, lemurs, agile gibbons, siamangs, patas monkeys, and Sumatran and Bornean orangutans.

1949

SHAMROCK HOTEL
Opened on St. Patrick's Day and demolished on St. Patrick's Day

LEFT: Completed in 1949, the Shamrock Hotel at Main and Holcombe embodied the early imagery of Texas oil extravagance. The eighteen-story building was absolutely mammoth back in its time. It was designed by Fort Worth architect Wyatt C. Hedrick. Commissioned by independent wildcat oilman Glenn McCarthy, the hotel was intended to be the first phase in a bigger mixed-use development. The 1,100-room Shamrock Hotel sported an astonishing 1,000-car parking garage on its north side, and a landscaped garden and terrace. It had a green-tiled roof, sixty-three shades of green within its interior and twenty-three different green employee uniforms. Its opening (on St. Patrick's Day, of course) in 1949 made the national news, the owners flying in almost 200 movie stars including Ginger Rogers. It also helped inspire Edna Ferber's novel, *Giant*. In her book, the hotel was called the "Conquistador." The Shamrock also starred in the film adaptation of *Giant*, starring James Dean, Elizabeth Taylor, Rock Hudson, and Dennis Hopper.

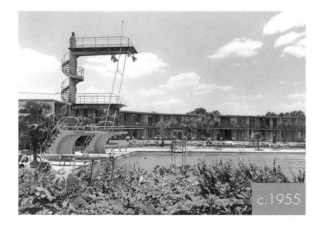

c.1955

ABOVE: This photo shows the high-dive boards of the Shamrock Hotel's swimming pool. It had a pool large enough (165 feet by 142 feet) for water-skiing exhibitions. Even when the financial floodwaters came closing in, the hotel kept right on staging annual water skiing shows in the pool. Many Houstonians remember seeing it live, and it did make a lasting impression.

ABOVE: If the birth of the Shamrock Hotel signified the rise of the Texas oil millionaire, then the decline of it reminded us that everything that goes up must come down. Despite its social value, the Shamrock became a financial burden. McCarthy's hotel was huge for its day, but not in an optimal location to stay filled—south of downtown and a little out of the way at the time. McCarthy was forced to cede the hotel in the 1950s. It eventually became a Hilton. But in the 1980s recession, even Hilton couldn't make it

work. Thousands protested its demolition on St. Patrick's Day, 1986. Today, the parking garage and convention center structures still remain—but the land is now a part of the Texas Medical Center. The Texas A&M Institute of Biosciences and Technology now operates on the property. It's also home to a small park, which has a 650-foot pool, computer-controlled water columns and eighty bald cypress trees. But no water-skiing.

1923

RIVER OAKS COUNTRY CLUB
Formerly a place to shoot rabbits, today it's a place to shoot under par

ABOVE: Westheimer was paved with oyster shells when River Oaks Country Club Estates was born. Its founders purchased 180 acres west of Montrose and on the south bank of the bayou in 1920—far out in the country in a thickly wooded tract of land at the time. People used to shoot rabbits on that land, and one of the prominent Hogg family members had a hunting camp adjacent. But the founders had a vision. The Hogg family invested heavily into the project and served as its heavy-hitting champion. It had a slow start, but by the 1930s some fresh investment started turning heads (and a nice profit). Engineer Herbert Kipp developed the neighborhood around the club. Architect John Staub, who completed dozens of projects in the area, designed the original Spanish Revival clubhouse as his first independent architectural project. Donald Ross created its beautiful golf course.

ABOVE: Over the years, the club became an important part of the community that surrounded it—a place to relax, maybe do some business off the books with colleagues or take the family on a warm summer evening. It also helped put Houston on the sporting map, hosting the Western Open golf tournament in 1940 and the Houston Open in 1946. In 2008, when the Westside Tennis Club lost its hosting of the U.S Men's Clay Court Championship, River Oaks Country Club stepped in to assume the role. Today, River Oaks is almost the geographical center of Houston. While established as a municipality, it's now a part of Houston proper. River Oaks is arguably the most expensive and sought-after real estate in town. The old clubhouse was razed in the late 1960s to make room for a more modern structure. Its members include Houston's most wealthy and powerful citizens, including former U.S. President George H. W. Bush. The River Oaks Country club has a healthy waiting list, and shooting rabbits on its property today will get you promptly arrested.

RIVER OAKS THEATRE
Landmark Theatres have helped keep this Art Deco classic in business

BELOW: River Oaks Shopping Center was completed in 1937 and River Oaks Theatre opened its doors two years later. The theater's original Art Deco design was a fitting accompaniment to the tony suburb for which it was envisioned. The movie house was built by the Interstate Theatre Corporation, which designed many such luxury cinema structures at the time around the country. On opening night it featured Ginger Rogers's *Bachelor Mother*. By the late 1930s, the upscale image of River Oaks already set an expectation of elegance, and businesses such as the River Oaks Theatre catered accordingly. The theater's neighborhood charm calls forth a time before the birth of generic warehouse franchise cinemas, when Houstonians still sought the refreshment of a movie house for its luxurious air conditioning and lack of mosquitoes. It has been operated by Landmark Theatres, owned by Mark Cuban and Todd Wagner, since 1976. Landmark Theatres is the largest American movie theater specializing in art house films.

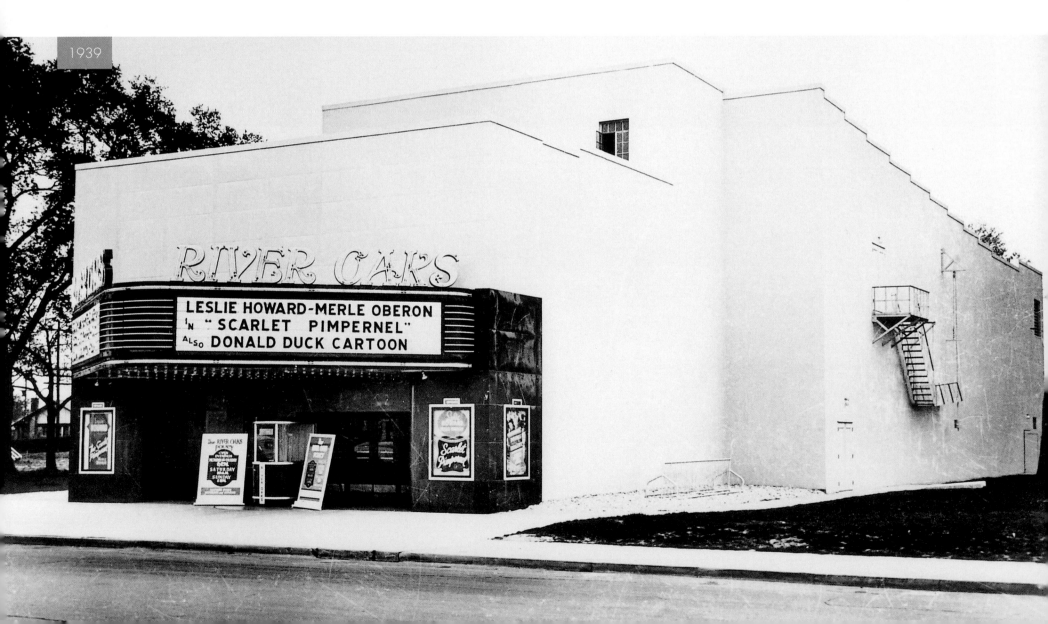

1939

BELOW: Houstonians still flock to the River Oaks Theatre to be refreshed, but not just for its air conditioning. The theater is today an institution, beloved by all Houstonians. Rumor had it in 2006 that the real estate company that owns the River Oaks Shopping Center planned to bulldoze the lot and redevelop. Houstonians freaked out at the prospect of yet another beloved historical institution falling to the wrecking ball. Such freak-outs typically carry little weight among those who simply want the best possible return on their real estate. But the real estate company dismissed these plans as only rumors. The theater shows independent, foreign language, unique, and just plain interesting films. Its diverse offerings and proximity to good food and shopping make it a favorite among Houston filmgoers. In Houston, March 26 is "River Oaks Theatre Day" in Houston. It's won numerous awards over the years, and is one of the few Houston movie houses that carries on the tradition of running *The Rocky Horror Picture Show* at midnight.

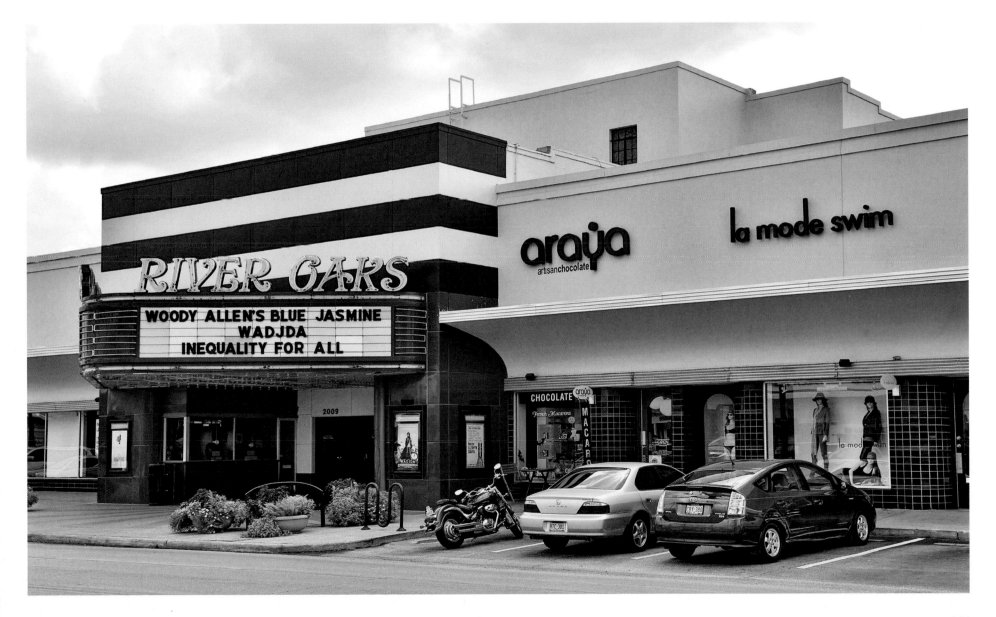

1909

TRAVIS ELEMENTARY SCHOOL
Home to the "Travisaurus"

LEFT: The suburb of Woodland Heights was born near downtown in 1907. At the time, Houstonians still considered public education a frivolous handout. In early Texas, people made their own arrangements for their children's education rather than relying on the government to provide such an apparatus. School-age children attended private schools, either locally or abroad. But the city's leaders saw the importance of providing a public education for its growing population. And this would be a flagship project of its kind. Originally, the school was called the Beauchamp Springs School, with its first building erected here in 1903. The school was named after Thomas Beauchamp, who sold fresh spring water in the area. The school opened in 1907, and was eventually renamed Travis Elementary School. The school was originally three stories with twelve classrooms.

ABOVE: In 1914, six more classrooms were built on to the Travis School. And in 1926, another two-story building—as well as a cafeteria and an auditorium—were added. The building underwent major renovations and maintenance in 1908, 1926, and 1980. Travis Elementary is still one of Houston's most notable public schools. But the original three-story structure became a bit of a dinosaur over the years. Today it still teaches pre-kindergarten through fifth-grade students. It currently has 734 students and thirty-three teachers—as well as some interesting features like an open-air amphitheater-style classroom and its outdoor educational garden. These days, the Houston Independent School District is the seventh-largest school district in the United States, with 282 schools. Its address at 3311 Beauchamp is still a nod to its original name. The "bones" you see in the playground have been nicknamed the "Travisaurus."

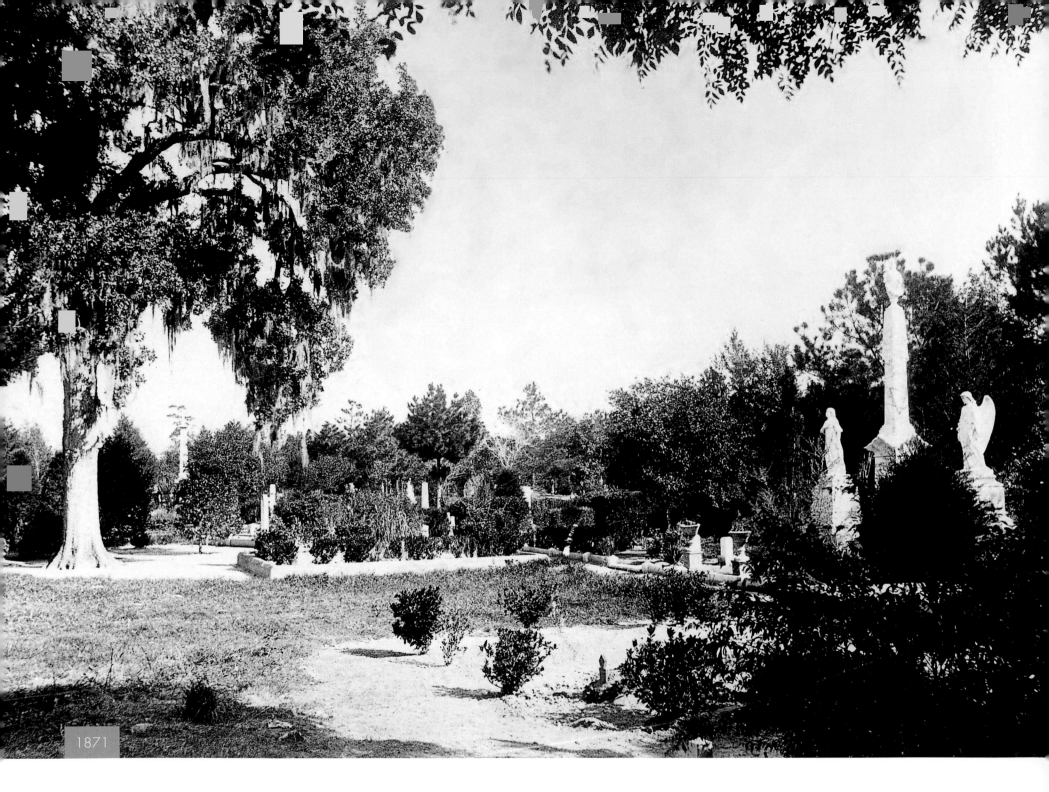

1871

GLENWOOD CEMETERY
Anyone who was anyone in Houston is buried here

LEFT: Glenwood is where the city buried its great and good; many of the names you'll find referenced in this book have found eternal peace in the verdant shade of Glenwood. Houston's first professionally designed cemetery, Glenwood was completed in 1871 at 2525 Washington Avenue, and opened for business in 1872. A renowned landscape architect was brought from England to sculpt the property's lush hills into what would become the most famous and historically significant cemetery in Houston. When it opened, many considered it more of a park than a burial place. Even back in the late nineteenth century people would visit the grounds to enjoy a stroll. A number of enhancements have been made to the property over the years, including water features and drainage improvement, enhanced landscaping, better roads and expansion of the old 1888 cottage that serves as the property's management office.

ABOVE: Today, Glenwood is still a place of peace, reflection, and solace, but fuller. The grounds serve as the burial place of Anson Jones, the last President of the Republic of Texas. Four former Texas governors call Glenwood home, including William P. Hobby. More than twenty Houston mayors and scores of business leaders were interred at Glenwood, including the founders of several major oil companies. The most frequently visited grave is that of billionaire businessman, aviator, and movie producer Howard Hughes (above left). Hughes is buried in an intricate 30-foot by 50-foot family plot alongside his parents. Legend has it that its shape was derived from a key fob that Howard Hughes, Sr. used to carry. Hughes, born in Houston, died on an airplane returning to the Bayou City from Acapulco in 1979. Every week, tourists come into Glenwood wanting to see the final resting place of the eccentric millionaire. On the right is the gravestone of George Austin Quinlan, who was president and general manager of the Houston and Texas Central Railway.

ASTRODOME

The stadium that gave the world AstroTurf

BELOW: Its parking lot wasn't yet paved when this picture of the nearly completed Astrodome was taken in 1965. Widely publicized as the "Eighth Wonder of the World," it was the first domed, air-conditioned, multi-purpose sports stadium in the world. The project was spearheaded by local businessman Roy "The Judge" Hofheinz, who played a big role in bringing Houston a major league baseball team. The total construction of the Astrodome cost over $40 million, most of which was paid from county bonds. The scoreboard alone cost $2 million, a mind-boggling sum at the time (in 1965 dollars). Big enough to house an eighteen-story building, the thermostat was set at a comfy seventy-three degrees with fifty percent humidity. The Astrodome's original operators struggled with keeping grass alive because of the dome's lack of sunlight, prompting the first major installation of a synthetic grass that would become known as AstroTurf. The dome would be the model that cities across America would use to build indoor stadia.

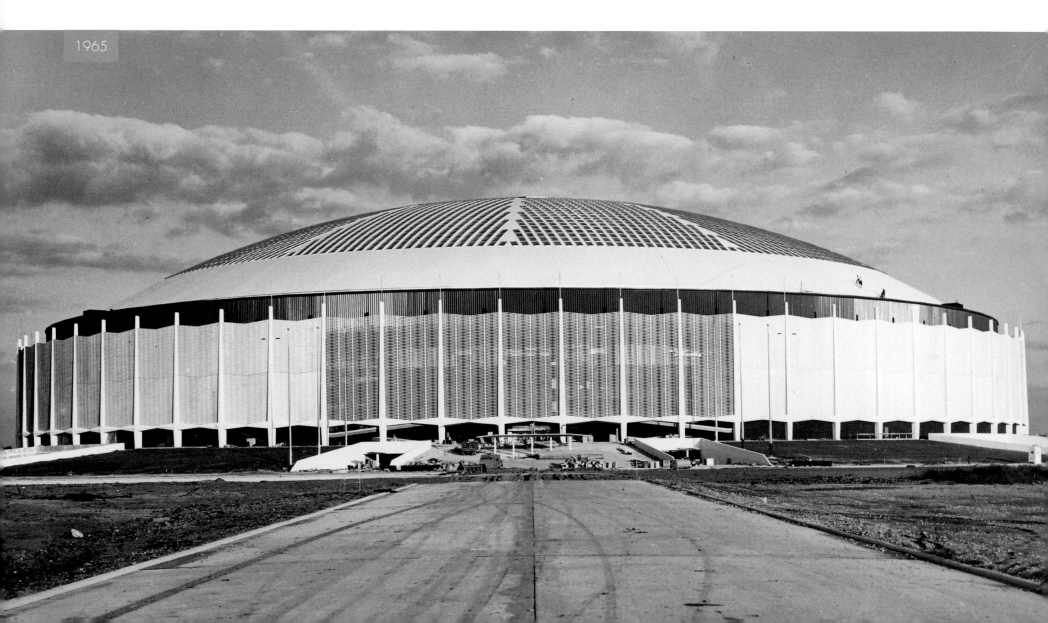

1965

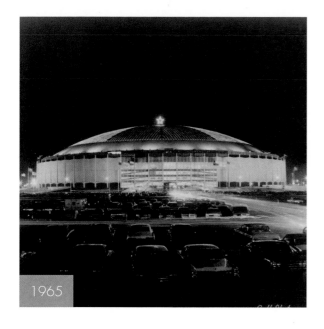

1965

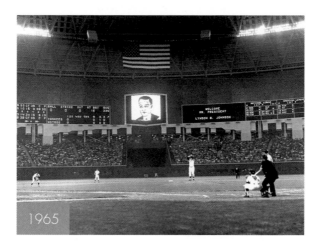

1965

ABOVE: This live action shot was taken at the Astrodome's first event—an exhibition baseball game between the Houston Astros and New York Yankees on April 9, 1965. The stadium held 47,867 fans that night, including President Lyndon B. Johnson and the First Lady. You can see LBJ's likeness on the screen. Roy Hofheinz was a close friend of Johnson's, and supported his various election campaigns in Austin and Washington. Mickey Mantle played that night, and made the game's first hit.

BELOW: The dome underwent a $100 million upgrade in 1987 that expanded seating by 10,000 and added seventy-two luxury boxes from which fans could watch the local football team, the Houston Oilers. For decades, millions came to the Astrodome to see everything from baseball to bullfighting and polo. Elvis played there six times. Mohammed Ali fought there. Evel Knievel jumped thirteen cars on two nights in a row in 1971. The Rolling Stones and Pink Floyd have played there. Musicians U2 filmed a music video at the dome. Also famous for once hosting the Houston Livestock Show and Rodeo, the dome met its match when Reliant Stadium, home of the Houston Texans football team, opened in 2002. The larger, $450 million stadium has left the Astrodome with second-billing events and an uncertain future. The Astros now play at Minute Maid Park. At the time of this writing, the dome was looking pretty quiet—its fate up for public vote.

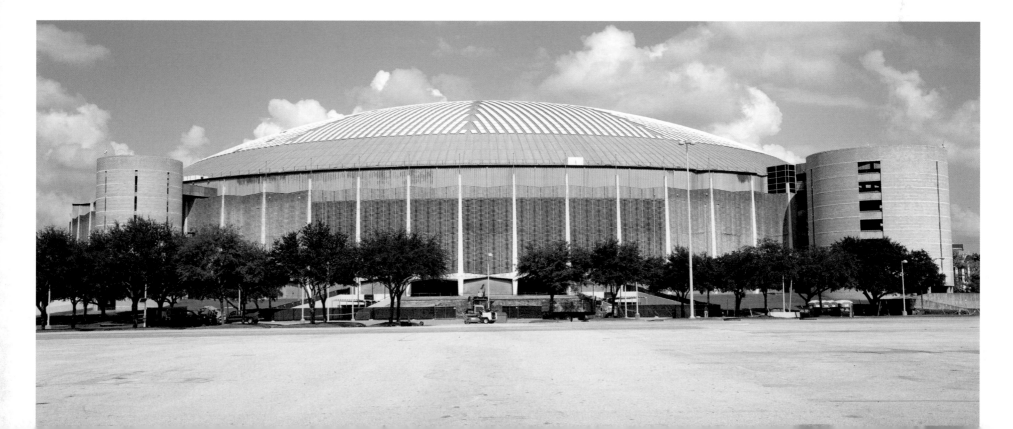

1917

CAMP LOGAN
Now a haven for joggers and serious runners

1924

ABOVE: This charming old shot of local hikers making their way through Camp Logan's land was taken in September of 1924. It documents the first autumn hike of the "Outdoor Nature Club." Founded in 1923, their club is still walking strong. The Outdoor Nature Club these days offers all kinds of programs and field trips promoting the study of nature in general, and disciplines such as ornithology, entomology, and botany in particular.

LEFT: Built in 1917, Camp Logan was an emergency training camp for U.S. soldiers preparing for engagement in World War I. It was built on 2,000 acres of land just west of what was then the Houston city limits. Camp Logan was one of many such facilities that sprung up around the country at the time as the nation anticipated the global impact of events unfolding in Europe. But in August of 1917, it made a name for itself as the home to one of the nation's worst race riots. The incident erupted as the result of an arrest of an African-American soldier from Illinois. When a fellow soldier went to the police station to inquire about his colleague, an incident ensued which escalated into an armed conflict killing four soldiers, four policemen, and a dozen civilians. The camp's reputation also wasn't much improved by its service as a sanatorium for a 1918 Spanish flu outbreak that killed almost fifty soldiers and dozens of Houstonians.

ABOVE: A lot has changed since Camp Logan and the riot of 1917. Today, the site is Memorial Park, the city's largest park. The center of the universe for Houston-area runners, its 1,000-plus acres include a golf course, softball field, picnic area, snack bar, and tennis courts. On any given day you can see Houstonians and visitors doing everything from practicing tai chi to kicking back with a good book. Physical evidence of the park's legacy as an emergency military training facility are still to be found if you know where to look. Many of the park's trails follow old Camp Logan roads, and many of the drainage patterns remain unchanged since its days as a military camp. Random building foundations, chunks of concrete, the remains of an old bridge and other relics in the park have been the formal subject of modern archeological surveys of the area.

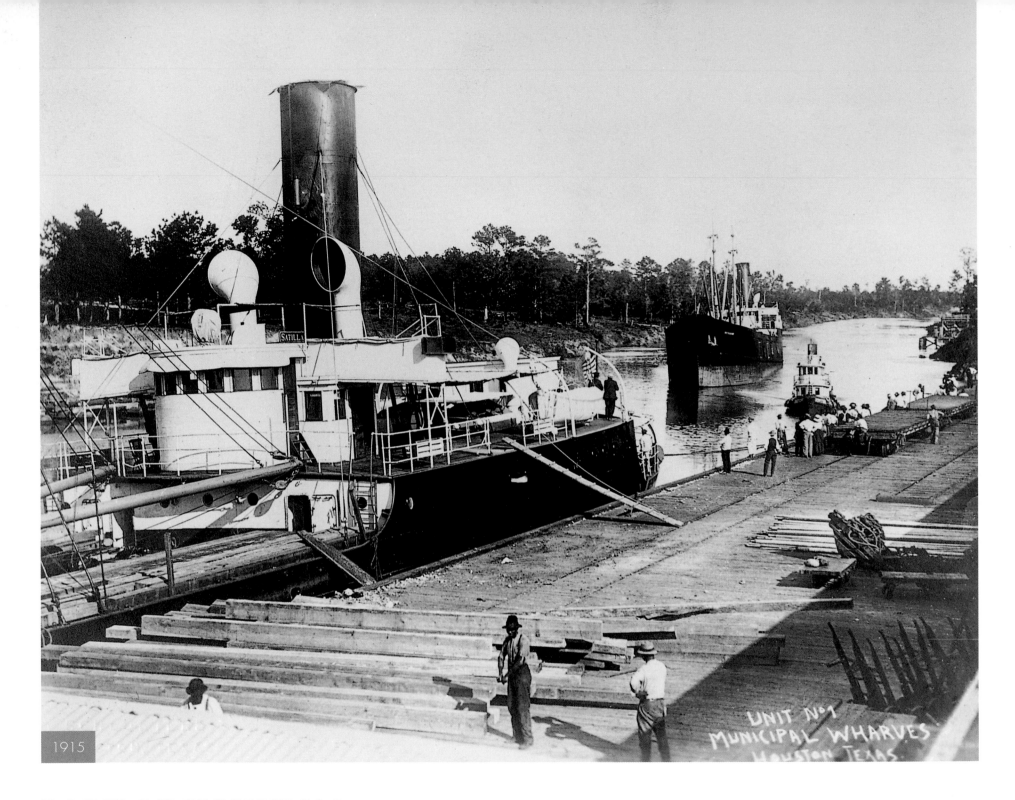

1915

UNIT No 1
MUNICIPAL WHARVES
HOUSTON TEXAS.

PORT OF HOUSTON
The creation of a ship channel allowed Houston's port to develop a large industrial hinterland

LEFT: The Allen Brothers knew that their spot, where the Buffalo and White Oak Bayous came together, would be a business success based on its navigability. Of course, it wasn't super-navigable in the early years. Boats were always getting stuck in fallen trees and running aground. The waterway was an asset, but it was one of limited value. Early merchants shipped cattle, cotton, and other commodities by steamer to Galveston, where they were transferred to more seaworthy vessels. In 1870, the U.S. Congress officially declared Houston a port and began planning Buffalo Bayou's upgrade. In 1896, neighboring Galveston had a 25-foot-deep waterway, and so Houston set aside $1.25 million for their own (split between local and federal money). On November 10, 1914 President Woodrow Wilson fired a cannon remotely from Washington—using a telegraph—to help celebrate the christening of the new and improved port. In 1915, the *Satilla* became the first deep-water ship to land at Houston's recently upgraded docks.

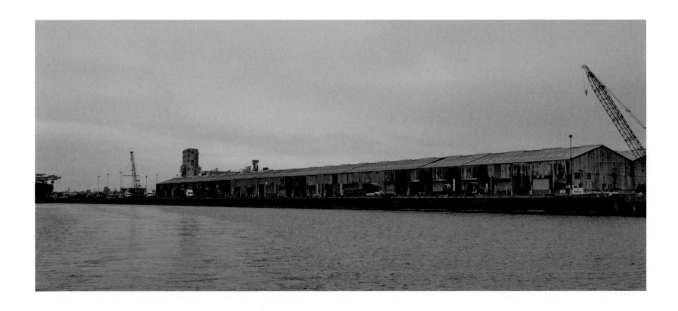

ABOVE AND LEFT: Today, the Port of Houston ranks first in U.S. foreign tonnage, and second in terms of cargo value. It's the largest Texas port, handling forty-six percent of all trade by tonnage. The port handled 220 million tons of domestic and foreign cargo in 2010—from petroleum products to machinery to automobiles. Its original wharves are now used only for mooring, and over one hundred public wharves are in use. Its eight cargo terminals generate billions of dollars annually. The port is home to more than 150 companies, including petrochemical and chemical plants, oil refineries, and other heavy industrial facilities. The port also has the world's second-largest petrochemical complex in the world, second only to the Dow-Aramco facilities in Saudi Arabia.

1913

HOUSTON SHIP CHANNEL
Today it's a 52-mile Madison Avenue of industrial production

LEFT: Back in the day, Galveston was the big port city in Southeast Texas and Houston was merely an ambitious afterthought. Goods would flow from the seven seas into Galveston, and then ship via steamer or other means into the Bayou City. Frustrated at these limitations on trade, an initiative in 1874 was begun to turn Houston into a major port city and cut the legs out from under its economic rival next door. It started out as a project among Houston businessmen, but the government eventually bought the venture and invested in it. Progress was gradual. But in 1914, the twenty-five-foot-deep Houston Ship Channel finally came into being. It opened for business with much pomp and circumstance, the port being christened with white rose petals. Just in time, too, as World War I spiked global demand for petroleum from Texas oilfields.

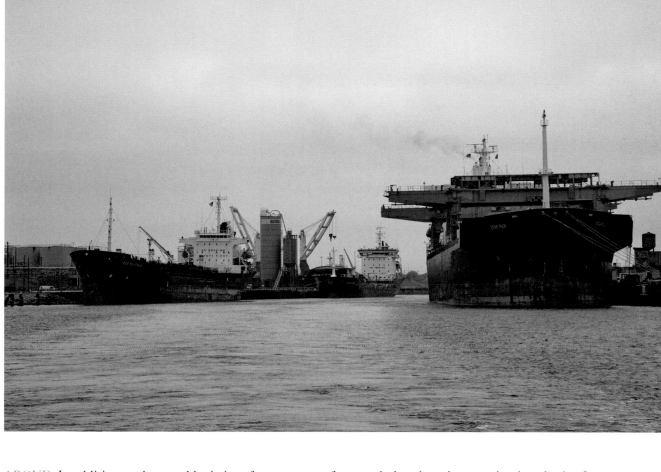

ABOVE A freighter outbound from the port of Houston.

ABOVE: In addition to the usual logistics of a deep-water seaport, the ship channel helped give Texas the industrial synergies that played off each other to make a big impact. Oil from Texas fields made its way to refineries on the ship channel, and specialty fuel and chemical companies of all kinds. By the 1940s, oil refineries, factories and shipping companies had grown along the ship channel like barnacles. In 1964, the Federal and local governments pooled their money and invested $92 million in its development. Today, the Houston Ship Channel's fifty-two miles are the Madison Avenue of industrial production. The businesses on its banks generate enough money to form a whole other city, creating hundreds of thousands of area jobs. Property, berths, terminals, and docks are in hot demand all along the channel driven by Houston's position as an energy leader and increasing levels of globalization.

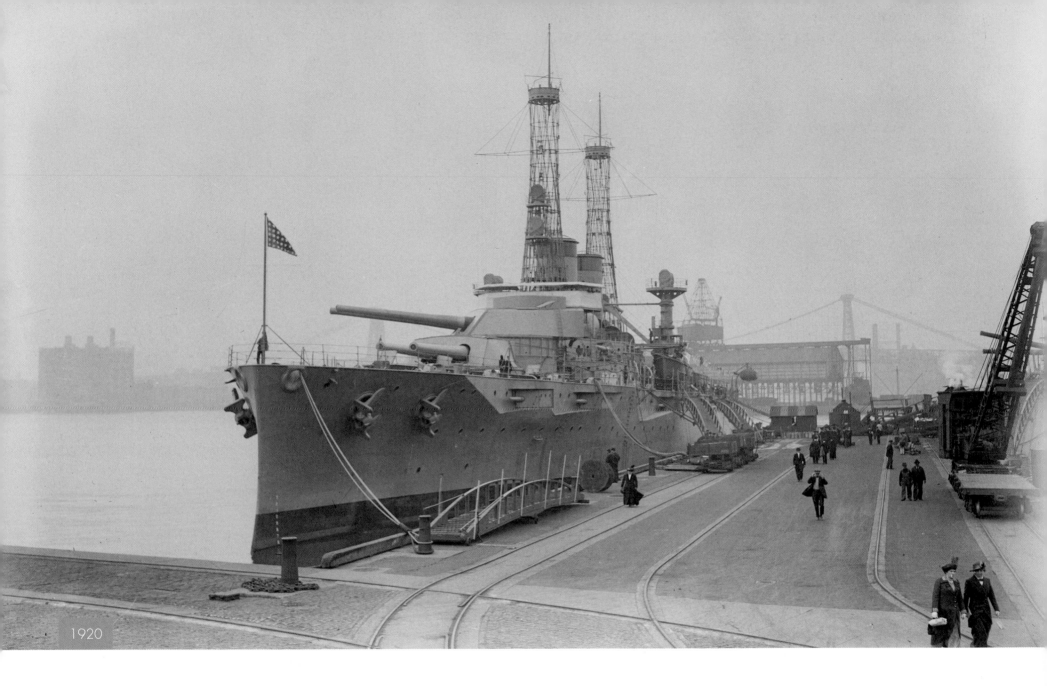

1920

USS *TEXAS*
The old warhorse is facing its toughest fight yet

ABOVE: The USS *Texas* was launched in May of 1912 (pictured right on launch day). Built in Newport News, Virginia, the *Texas* is a New York-class battleship that saw service in both World War I and World War II. It was the first US Navy battleship to use a 14-inch 45-caliber gun (ten of them, actually). The *Texas* served in the Atlantic Fleet during World War I and was present when the German Imperial Fleet surrendered in 1918. In World War II, the *Texas* served as the flagship for Allied landings at Omaha Beach on D-Day, supporting further landings in North Africa, Southern France, Okinawa, and Iwo Jima. After three decades of service, USS *Texas* became America's first memorial battleship and national park at the Battleship Texas State Historic Site.

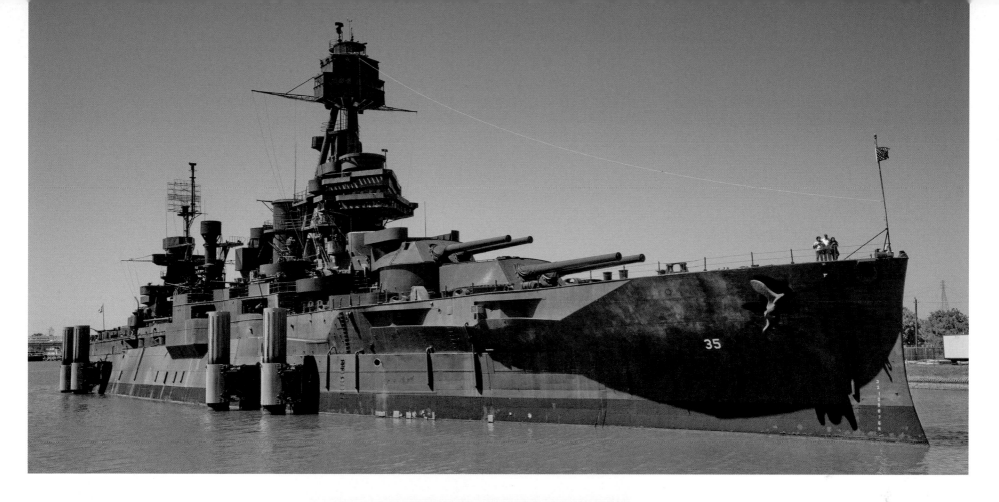

1912

ABOVE: Today, the USS *Texas* faces the most relentless adversary of all: time. In 1983, the *Texas* fell under the aegis of the Texas Parks and Wildlife Department. Part of a vast parkland complex surrounding the ship and San Jacinto Monument and Museum (as well as the surrounding grounds), it was restored as a museum. By 1988 it had been ravaged by rust and was towed to a Galveston shipyard for restoration, but was back in service by 1990. Millions have been spent on maintenance, repair, and restoration. A series of leaks in the 2000s plagued the ship's minders and generated a bit of negative press for the old warhorse. Fortunately, the Battleship Texas Foundation has taken the helm and is leading the *Texas* through a massive restoration, including total replacement of the hull. The *Texas* has become not only a cherished landmark in the region, but an irreplaceable part of American naval history and an icon of Texas fighting spirit.

1912

SAN JACINTO MONUMENT
The amazing structure that commemorates the Republic's defining moment

ABOVE: The Battle of San Jacinto was fought on April 21, 1836. Its outcome shifted the region's power structure, creating the Republic of Texas and eventually stretching the United States to the shores of the Pacific. The San Jacinto Battleground, twenty miles from downtown Houston, has been a sacred place for Texans ever since. A popular pastime for early Houstonians was to catch a boat down Buffalo Bayou to the battlefield. Construction began on the centennial anniversary of the battle.

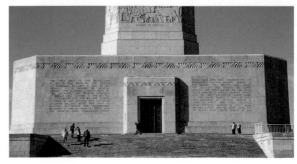

RIGHT: Twelve feet taller than the Washington Monument (if you count the base), the monument houses a theater, museum, library, gift shop, and observation deck. The surrounding park, conference facilities, a nearby golf course and its proximity to the renowned San Jacinto Inn restaurant make it an attractive place to spend a day.

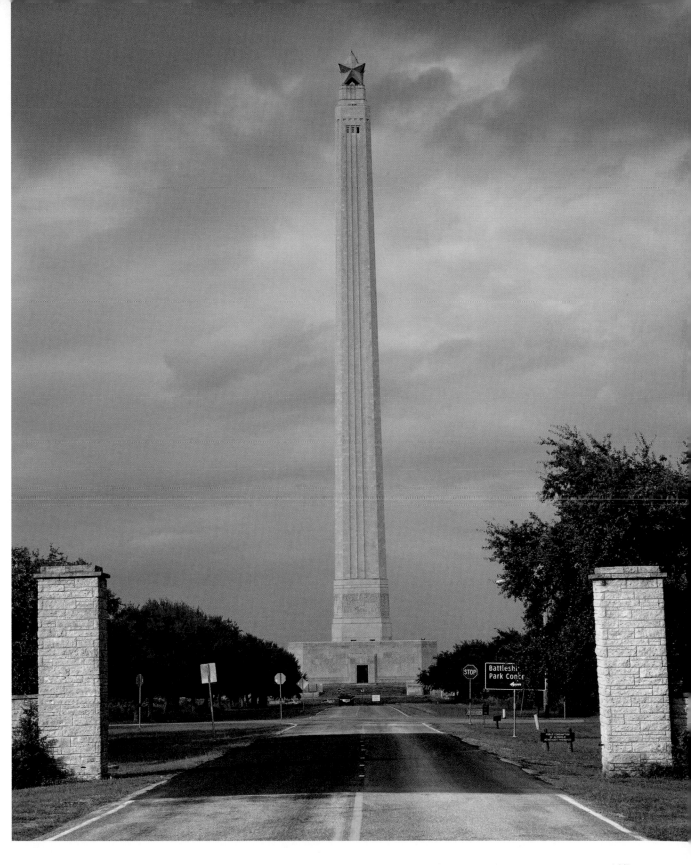

LEFT AND ABOVE: Modern close-ups of the base and star. The star is thirty-five feet tall and designed to have nine points—so it can be seen as a star no matter which direction you're looking from.

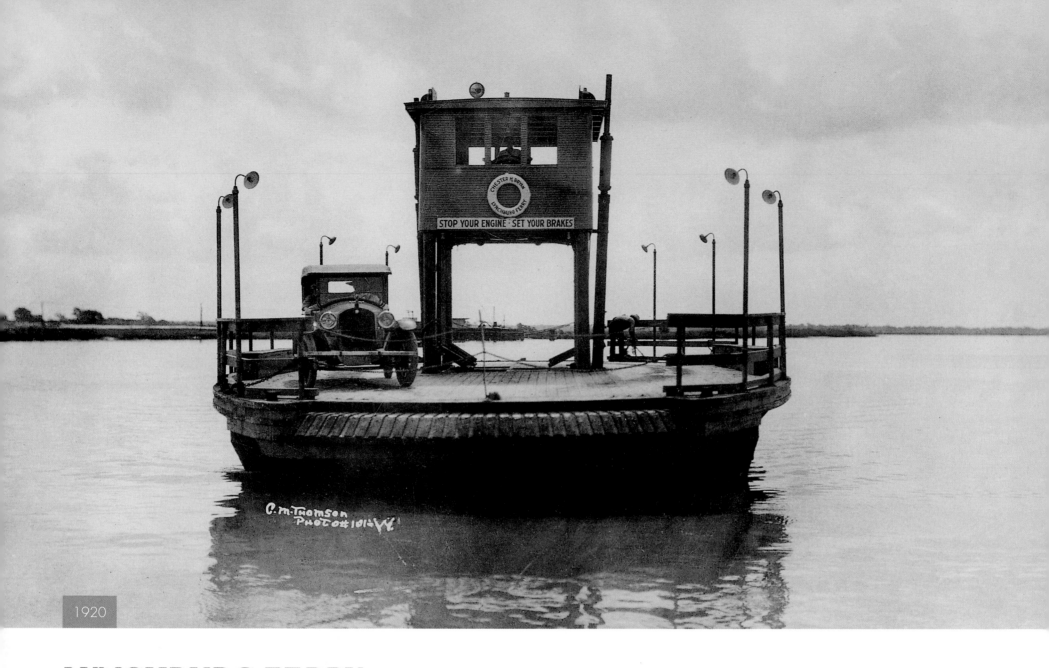

1920

LYNCHBURG FERRY

Still providing a free service for those who want to cross the ship channel

ABOVE: Nathanial Lynch was one of Stephen F. Austin's original "Old 300" colonists, moving to Texas from Missouri in 1822. At the time, the area was still under Mexican rule. The same year he settled in Harris County, he began a pull-rope flatboat ferry service at the confluence of the San Jacinto River and Buffalo Bayou. It was a smart move; the location was right on the main route that led from South Texas to the border of Mexico. Around 1830, he got an official (Mexican) government license and Lynch's Ferry had become an

established regional landmark. During the Texas Revolution, Republic of Texas freedom fighters fell back northward from their Mexican pursuers in what was known as "the Runaway Scrape." This tactical retreat bottlenecked at Lynch's Ferry, where some report having waited as long as three days to cross. Naturally, Nathaniel Lynch did what any capitalist would have done. He raised his prices due to the increased demand.

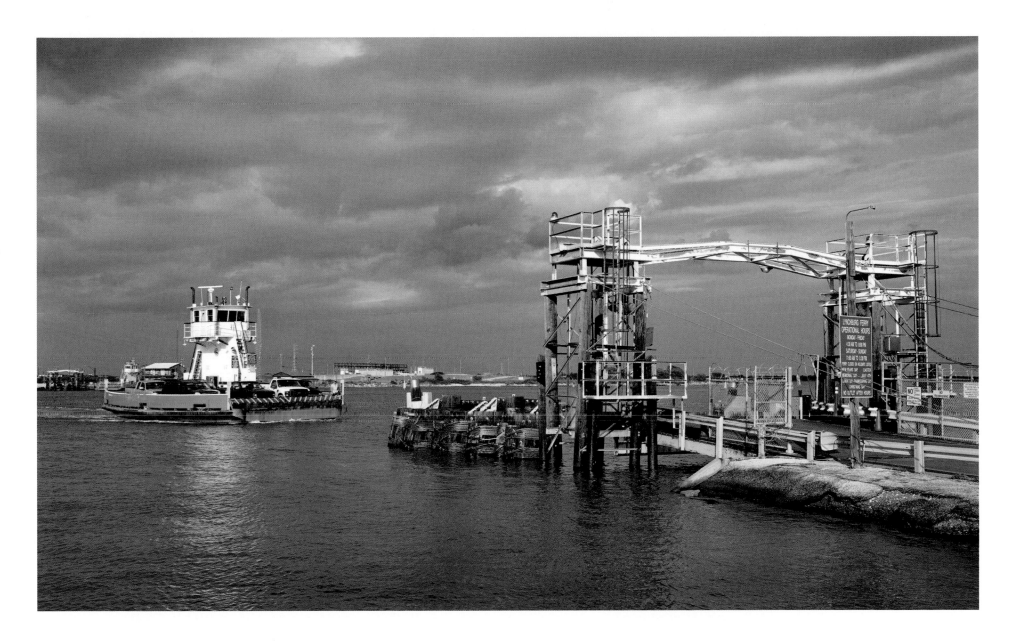

ABOVE: Nathaniel Lynch didn't make many friends with his sudden increase in prices. In fact President Burnet threatened to seize the ferry for government use but never did. Lynch died shortly after the Texas Revolution, leaving the ferry to his family. The operation changed hands a few times afterward, but in 1890, Harris County started providing the ferry service free of charge. Now known as the Lynchburg Ferry, the county ran two boats—the *William P. Hobby* and the *Ross S. Sterling*—twenty-four hours a day until 2004 when it cut back its service times in the interest of economy. Each boat can carry up to a dozen vehicles across the Houston Ship Channel. In 2008, Hurricane Ike walloped the Lynchburg Ferry (and the whole area for that matter). It was out of service for almost two months. Still free of charge, visitors to the area love taking the ferry across the channel and watching the porpoises that often follow the boats back and forth. The boat shown here is the *William P. Hobby*, built in 1964.

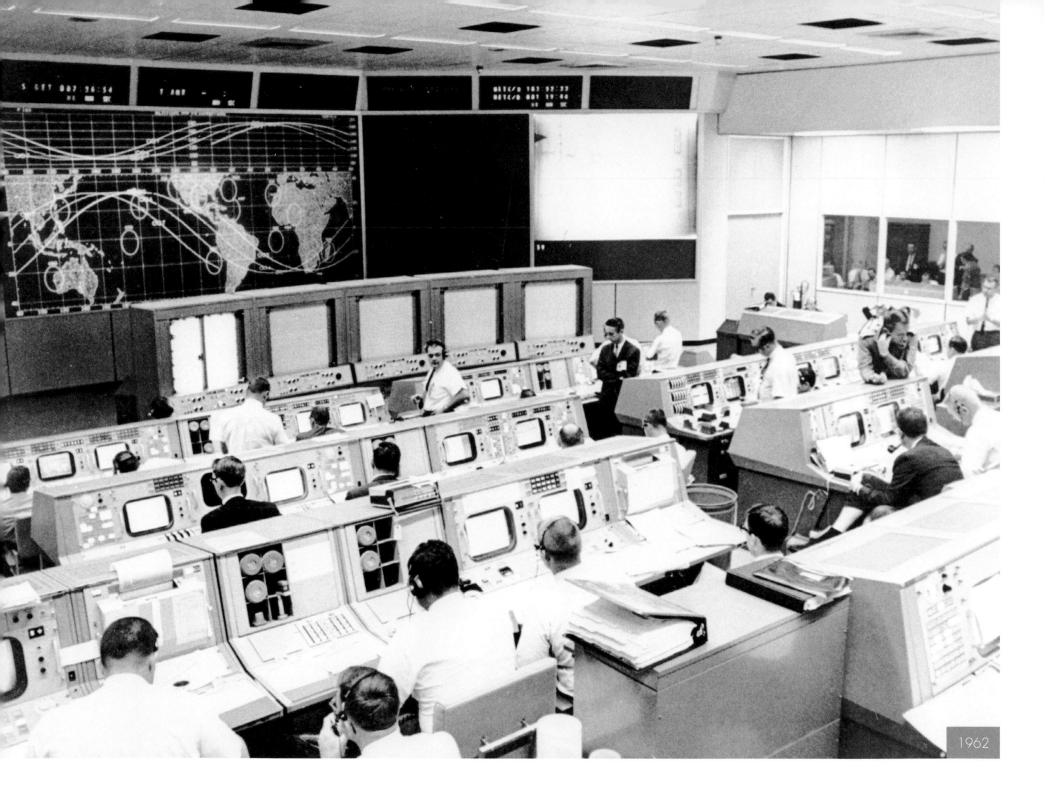

1962

NASA MANNED SPACECRAFT CENTER
Houston has long been the control center for NASA missions

LEFT: What is now NASA's Johnson Space Center (JSC) was once a barren piece of coastal prairie near Galveston Bay that was mostly used for grazing cattle. That all changed in 1961, when President Kennedy threw down the gauntlet to put a man on the moon by the end of the decade. His team would need a place to work—and they chose Houston because of its many technical workers, logistical infrastructure, mild climate, and proximity to both the San Jacinto Ordinance Depot and major universities such as Rice University. They chose this spot of land, in particular, because Rice University donated it for the effort. Originally, the facility was called the Manned Spacecraft Center. It was renamed the Lyndon B. Johnson space center in 1973. The facility was designed by architect Charles Luckman—who also designed Madison Square Garden in NYC and was at one time President of Unilever.

BELOW: Visitors to the Space Center can see a mock-up of the Space Shuttle along with the most comprehensive collection of space suits ever assembled. They include the suit worn by Apollo 12's Pete Conrad and the ejection suit that Astronaut John Young wore on the first shuttle mission in 1981.

ABOVE: Over the years, JSC served as the primary flight control center for NASA, supporting major American space initiatives including Gemini, Apollo, Skylab, the Space Shuttle and the International Space Station. The community around the facility became rich with intellectuals. The facility today is a complex campus of different facilities that include what is now called the Christopher C. Kraft, Jr. Mission Control Center (MCC-H), which has primary responsibility for coordinating and monitoring all manned American spaceflight. Its multiple rooms, computers, and controls used to handle that responsibility look like they come straight out of *Star Trek*. The site also houses extensive and elaborate training facilities, a moon rock lab, and directors of the White Sands Test Facility in New Mexico. Building 30, the famous Apollo Mission Control Center, is now a National Historic Landmark.

WILLIAM P. HOBBY AIRPORT
Sharing an architect with Houston's Art Deco City Hall

BELOW: In 1941 this Douglas DC-3 was state-of-the-art for the aviation industry, as was the new Houston Municipal Air Terminal completed the year before. People had been using what is now William P. Hobby Airport since the late 1920s, although it was merely a 600-acre pasture with a wooden terminal. In 1937, the city bought the land and replaced the old terminal with a new facility that would provide a better experience for those prosperous enough to travel by air. The Art Deco–style 1940 terminal was designed by Austrian-born architect Joseph Finger, who also designed Houston's City Hall. When the building was dedicated, the public were offered a tour of the facility; a lucky few won free local flights. Braniff Airways and Eastern Airlines were the only airlines that served the airport in its early years.

1941

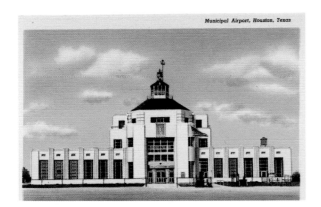

ABOVE: A postcard of the Art Deco terminal from the late 1940s.

BELOW AND RIGHT: The 1940 terminal didn't see service for long, as air traffic from Houston increased quickly and outgrew the building. In 1954 the airport was renamed Houston International Airport, and the old terminal was leased as commercial and administrative space. It was renamed William P. Hobby Airport in 1967 after the state's twenty-seventh governor. By the late 1970s, some wanted to demolish the old terminal, but many preservationists couldn't bear the thought of seeing it felled by the wrecking ball, no matter how badly airport administrators wanted the extra space. It now serves as the Air Terminal Museum. Hobby Airport grew around the old terminal as it became a major regional airport. Southwest Airlines is a major part of the airport's traffic, running over 120 flights to thirty

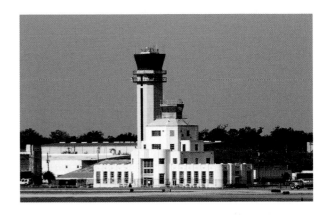

cities each day and taking up slots in seventeen of the airport's twenty-six gates. AirTran Airways, American Eagle, Delta Connection, and JetBlue Airways also service Hobby Airport.